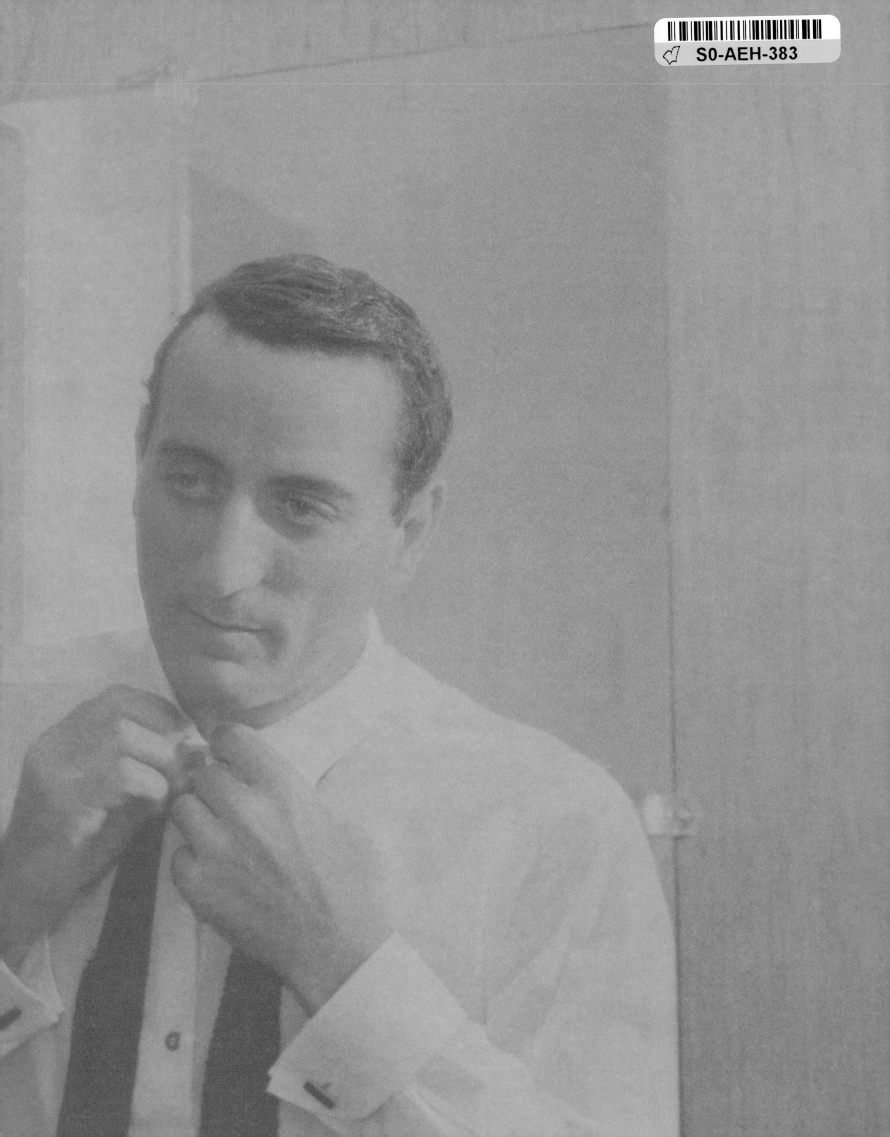

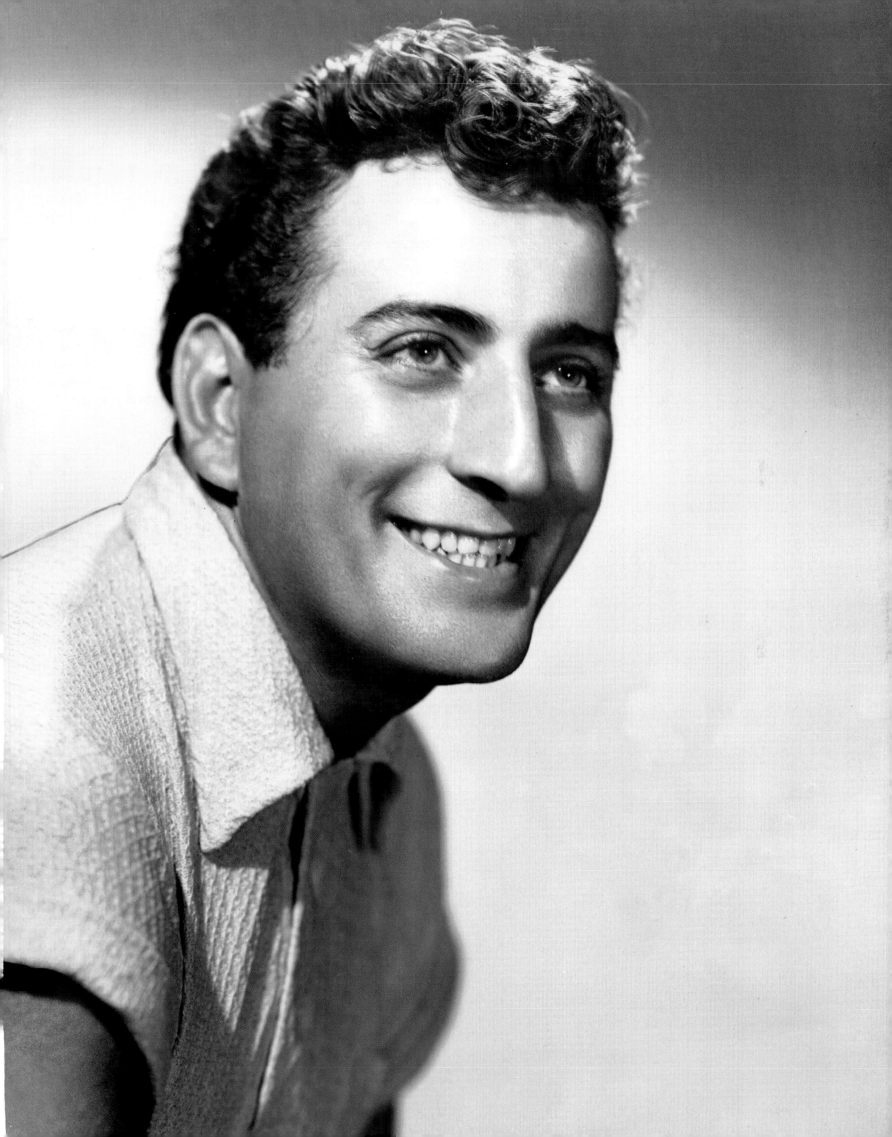

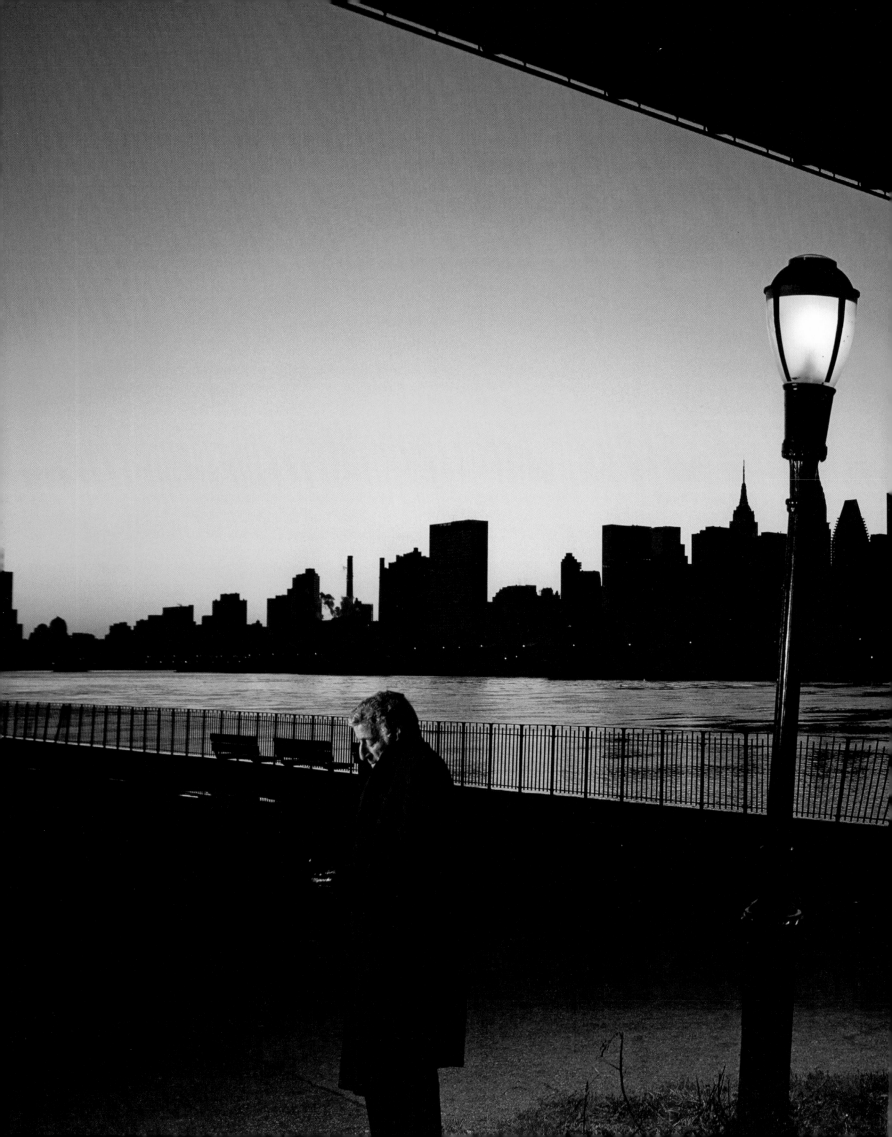

TONY
BENNETT

**Foreword by
Martin Scorsese**

LIFE BOOKS

Managing Editor
Robert Sullivan

Director of Photography
Barbara Baker Burrows

Creative Direction
Li'l Robin Design, Inc.

Deputy Picture Editor
Christina Lieberman

Copy Chief
Parlan McGaw

Copy Editors
Barbara Gogan, Joel Van Liew

Writer-Reporters
Marilyn Fu, Amy Lennard Goehner
Daniel S. Levy

Associate Photo Editor
Sarah Cates

Editorial Associate
Courtney Mifsud

Photo Assistant
Caitlin Powers

Consulting Picture Editors
Mimi Murphy (Rome),
Tala Skari (Paris)

TIME INC. PREMEDIA
Richard K. Prue (Director), Richard
Shaffer (Production), Keith Aurelio,
Jen Brown, Neal Clayton, Charlotte
Coco, Liz Grover, Kevin Hart, Mert
Kerimoglu, Rosalie Khan, Patricia
Koh, Marco Lau, Brian Mai, Po
Fung Ng, Rudi Papiri, Barry Pribula,
Clara Renauro, Vaune Trachtman

TIME HOME ENTERTAINMENT

Publisher
Jim Childs

Vice President and Associate Publisher
Margot Schupf

Vice President, Finance
Vandana Patel

Executive Director, Marketing Services
Carol Pittard

**Executive Director, Business
Development** Suzanne Albert

Executive Director, Marketing
Susan Hettleman

Publishing Director
Megan Pearlman

Associate Director of Publicity
Courtney Greenhalgh

Assistant General Counsel
Simone Procas

Assistant Director, Special Sales
Ilene Schreider

**Senior Marketing Manager, Sales
Marketing** Danielle Costa

Senior Book Production Manager
Susan Chodakiewicz

Senior Manager, Category Marketing
Bryan Christian

Associate Prepress Manager
Alex Voznesenskiy

Associate Project Manager
Stephanie Braga

Editorial Director
Stephen Koepp

Art Director
Gary Stewart

Senior Editor
Roe D'Angelo

Managing Editor
Matt DeMazza

Copy Chief
Rina Bander

Design Manager
Anne-Michelle Gallero

Assistant Managing Editor
Gina Scauzillo

Special thanks: Allyson Angle,
Katherine Barnet, Brad Beatson,
Jeremy Biloon, John Champlin,
Ian Chin, Rose Cirrincione, Assu
Etsubneh, Mariana Evans, Christine
Font, Alison Foster, Hillary Hirsch,
David Kahn, Jean Kennedy, Amy
Mangus, Kimberly Marshall, Nina
Mistry, Danielle Prielipp, Dave
Rozzelle, Matthew Ryan, Ricardo
Santiago, Divyam Shrivastava,
Adriana Tierno

ENDPAPERS Front Backstage in
December 1957. Back Recording
"Smile" in 1959. *Photographs by
Don Hunstein/Sony Music Archives*

PAGE 1 The budding pop star, circa
1950. *Photograph from Michael Ochs
Archives/Getty*

PAGES 2–3 A resurgent star in
twilight time, shot for LIFE in
Queens, New York, in 1994.
Photograph © Joe McNally

THESE PAGES Performing at the
Town & Country Club in Brooklyn in
1958. *Photograph by Guy Gillette*

TONY BENNETT

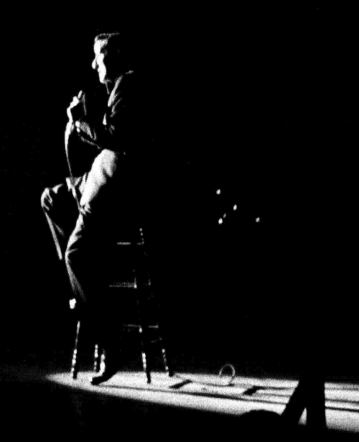

6 Introduction

8 Foreword

10 A Kid from
Queens:
1926–1943

20 You're in the
Army Now:
1944–1946

28 Pop Star:
1947–1964

114 Between
Rock and a
Hard Place:
1965–1979

146 "I Wanna
Be Around":
1980–1990

158 "The Best in
the Business":
1991–2014

192 Just One More

OUR FRIEND TONY

BY ROBERT SULLIVAN

DURING THE PAST 15 YEARS, we have presented scores of LIFE books with a third-person narrative. Of course we have; that was the proper way to do it. We would look into a topic, distill our research and try to offer a story objectively to you, our readers. That was the right way to do these books, we figured.

I first met Tony Bennett when profiling him for the monthly LIFE in 1995 and have stayed in relatively close touch through the years. I've worked on an extra project or two with him, and even had the privilege of writing liner notes, and my wife and I have been happy to attend Tony's Christmas parties. We were very happy to go to a truly extraordinary birthday party one year at the Temple of Dendur room at the Metropolitan Museum of Art, Tony swinging a couple of tunes in front of this huge Egyptian sandstone ruin from 15 B.C. That was wild.

Tony, his wife, Susan, and their dog, Happy, dropped by our house last year en route to a concert in Danbury, Connecticut. Our spaniel, Daisy, got along fine with Happy.

All of this is mentioned here, right off the bat, by way of disclaimer.

Two things presented themselves as pointless when LIFE Books decided to do this volume on the great singer Tony Bennett: It would be pointless to hire another writer for this one, and it would be pointless and in fact a bit dishonest to hide behind the third person, as if I didn't know the guy. I do know him, enjoy his company and his wife's, enjoy their dog. Therefore, much of the text that follows reflects a bias. I also hope it reflects at least a bit of the insight that comes with being acquainted with someone more than just casually.

Furthermore, there's scant risk in approaching this book this way, since we are LIFE—and particularly since this volume is one of our LIFE Unseen books. The pictures are the point more so than the words. Tony (and he has always insisted on being called that, from our first meeting) has, for most of his very long career, been a Columbia Records (now under the Sony banner) artist. Even the recordings made for others—for instance, the wonderful pairing with the pianist Bill Evans—are now part of his record company catalog. And in the archives at Sony here in New York City, there are files upon files of photographs, many of which have never been published. As we did with our LIFE Unseen book on Johnny Cash, LIFE has again partnered with Sony to present a new, intimate look at an entertainer we all feel we know. If you're a fan, you reasonably think that, after 65 years, you've seen everything you're ever going to see regarding Tony Bennett. Well, you haven't . . . until now.

Not even Tony has seen all of this stuff—the Sony pictures or those from our own LIFE collections—or he hasn't seen the stuff for a long time. A quick anecdote: A few years back LIFE Books produced an illustrated biography on Tony's dear friend Frank Sinatra. Tony agreed to contribute the foreword, and his tribute was fun and fine. A centerpiece of that book was the trove of pictures taken by LIFE's John Dominis on the occasion of Frank's 50th birthday in 1965. The book was published, and Tony called me. "Where'd that photo of me and Frank eating the hot dogs come from?" Formally dressed for entertaining, they were grabbing "dinner" on the go in Miami. Tony had never seen the shot, as LIFE had never run it, till just then. (We run it again on pages 116 and 117 of this book.) We got a print of it over to Tony's apartment for him, and we'll probably be running some more of these up there after he and Susan see the new book.

In LIFE in 1965, Sinatra himself called Tony Bennett "the best singer in the business." Remarkably, in 2014, at age 88, Tony still is. He's not only a remarkable singer but a remarkable man with a life story that can now be fairly called a saga.

Here is that saga, as you've never seen it before.

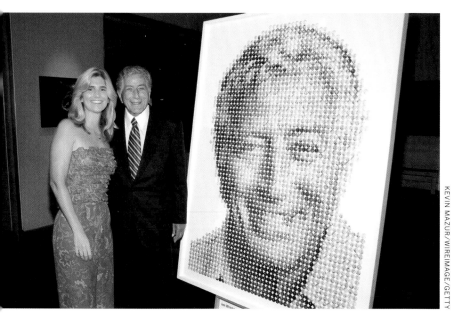

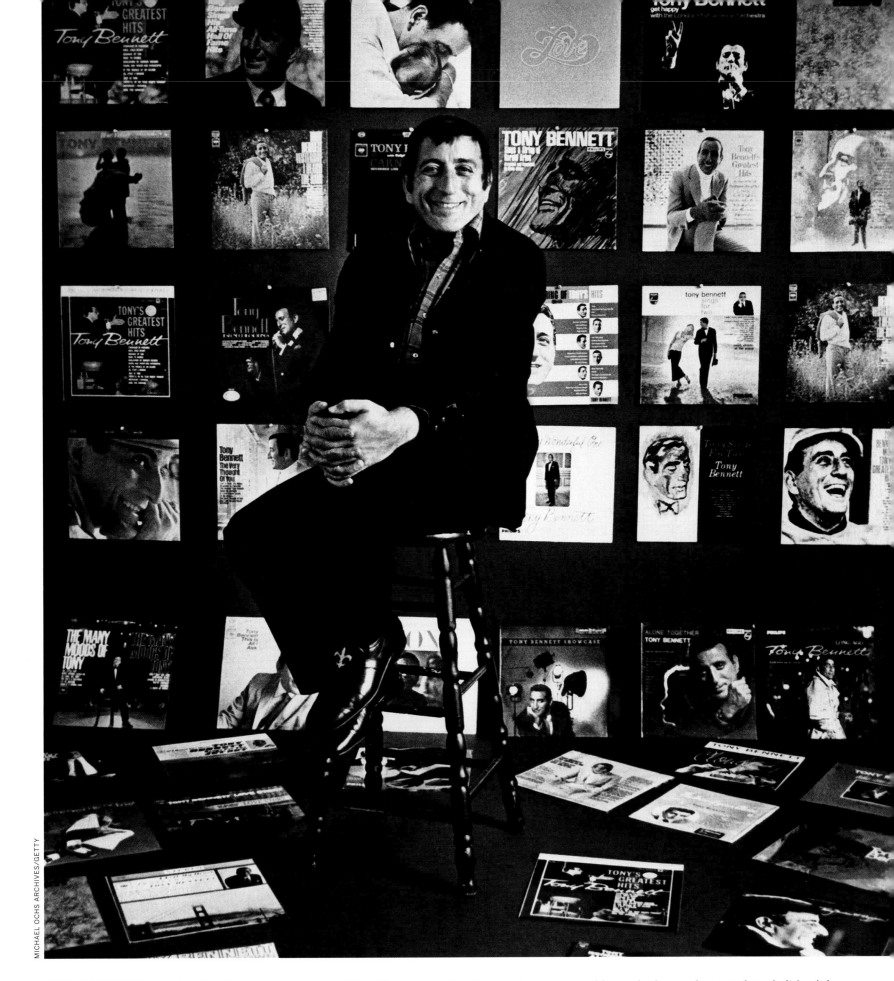

THE ALBUMS are already piling up in 1970. *Because of You* was released in 1952. There have been some 80 albums since, including compilations, as well as the new collaboration with Lady Gaga, *Cheek to Cheek.* As I wrote for the liner notes of the 2013 disc, *Live at the Sahara: Las Vegas, 1964*: "You will find no agreement as to when Tony Bennett was (or is or will be) at his best . . . Impossible to say. He may be better tomorrow. He would wager that he will be. How wonderful is that? A man who made this music that we hear, and made it back in 1964 in the Congo Room at the Sahara, is still seeking, night after night, to be just as good— or even better. There has never been anything like Tony Bennett." Opposite: Tony and Susan at the Metropolitan Museum of Art.

WHAT I SEE WHEN I HEAR
TONY BENNETT

BY MARTIN SCORSESE

On the occasion of the birthday party mentioned on the pages immediately previous—the grand affair at the Metropolitan Museum of Art in New York City—various comments and tributes were offered. The ones by film director Martin Scorsese were particularly eloquent and, in leading into a book of photography, apt. He has graciously allowed them to be reprinted here as the foreword to our volume.

AUGUST 2, 2001

In acting it's called "sense memory." That's what Tony Bennett's voice is for me.

When I hear his music, a certain time and place come alive for me again. Whenever I hear that wonderful voice, that voice that's as familiar and intimate and accessible as the voice of someone from your own family, it all comes back to me in a flash.

When I was growing up in Little Italy, music drifted in from everywhere. I watched everything that went on outside the windows of our apartment. The good, the bad and the mundane—it was all scored by music coming from radios in passing cars, from storefronts or out of other apartment windows. It was as if my life itself was scored by these songs. I suppose that's why music has always been so important to me as a filmmaker. Because in fact, it was that music which inspired me to interpret the world around me.

When I hear "Rags to Riches," I really *see* that world gone by.

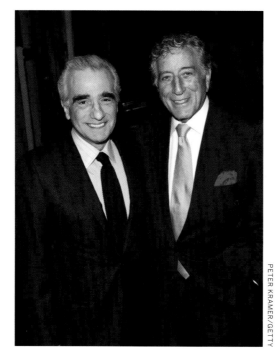

PETER KRAMER/GETTY

I *feel* it, the neighborhood where I grew up, in all its particulars—the texture of the paint on the walls, the clothes people wore (and the way they wore them), the way people moved, spoke, behaved. I hear the song, and I relive the essence of a specific time and place, in a particular community and in American culture.

I was eight or nine when "Rags to Riches" became a hit. It had this instantly commanding sound—the brass, the haunting reverb effect, and, of course, the soulful, wonderfully authoritative voice that cut right through it all.

When I started making films, I often found that once I heard the music, I could see the picture. In many ways, this started for me with Tony Bennett's music. His songs made the picture clearer for me—they helped me to visualize when and how the camera should move, where an actor should be in the frame, what the light should be like. Creating the worlds of *Mean Streets, Raging Bull* and *GoodFellas* would have been unthinkable without Tony Bennett.

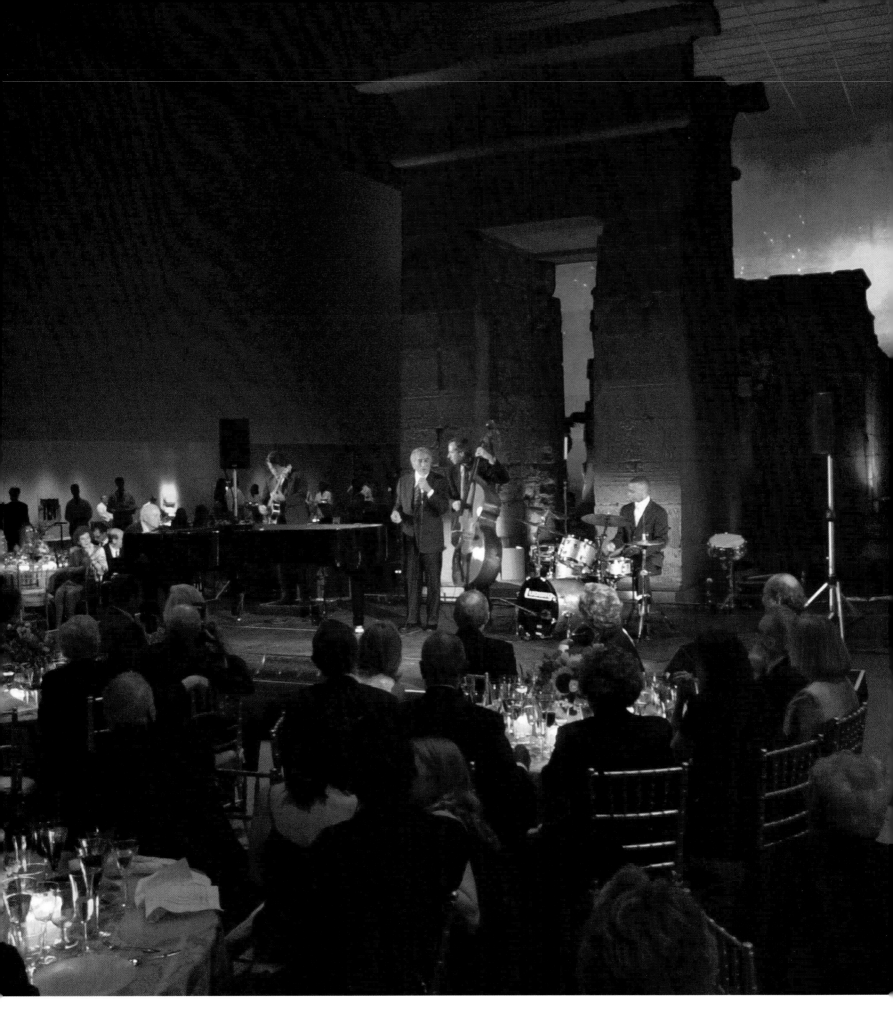

MARTIN SCORSESE and his friend
Tony Bennett are all smiles in 2004 (left).
Above: The 2001 party in the Temple of
Dendur gallery at the Metropolitan Museum of
Art in New York City, upon which occasion
Scorsese salutes Tony, and scores of
Bennett's friends raise a glass to his 75th
birthday. He has celebrated 13 more since.

A KID FROM QUEENS: 1926–1943

ANTHONY DOMINICK BENEDETTO (opposite, easily recognizable as an infant) was born at St. John's Hospital in Long Island City, New York, on August 3, 1926, to parents of less-than-modest means. As it happened, he was the first person in his family, American or Italian (his widowed grandmother was the immigrant), to be born in a hospital. Tony's parents, who were first cousins, and his older brother and sister, John and Mary, lived in an apartment above a grocery store where Tony's father was

employed. But the father, John Benedetto, was already seriously ill at the time of his third child's birth, and within a year he was unable to work. The store was sold, and the Benedettos were forced to look for a cheaper place to live. They found one in the same neighborhood, which was in Astoria, Queens. In his 1998 autobiography, *The Good Life,* written with Will Friedwald, Tony remembered, "They found an apartment in a four-story apartment house on Van Alst Avenue and Clark Street. It was a typical

four-room railroad flat: The rooms were lined up in a straight row, like train cars, and you had to go through one room to get to the next. We were on the second floor of the building, above a candy store."

Several years after that reminiscence he shared with Friedwald, Tony said to me, in that pensive, soft way of his: "I grew up in poverty." A pause, just there. "Another thing that makes where I landed so unbelievable," he added—hardly an afterthought.

**"A VERY POETIC, SENSITIVE
MAN,"** Tony remembers of his father, "full
of love and warmth." The man, second
from left in the photograph at right (young
Tony is seated beside his father, with other
family members in Pyrites, New York), died
when Tony was but 10, and he himself
was only 41. "I couldn't believe that this
wonderful, beautiful man was really out
of my life and that I would never see him
again," Tony once wrote. "I was heartbroken.
My eyes welled up with tears and I wept."

Mary John & Tony

AT LEFT ARE MARY, John and Tony. Below is Tony with his grandmother, parents and John. Opposite: The children again, with a pony. All of the Benedettos made music, particularly the men. Tony's older, opera-loving brother was a sensational singer of arias. He performed solos at the Metropolitan Opera as a young teen and was dubbed "Little Caruso" by the New York press. Tony, for his part, deferred to his brother on the Verdi material and chose to entertain his parents, aunts and uncles (one of whom was a tap dancer in vaudeville) with popular tunes of the day—Eddie Cantor songs and Al Jolson numbers.

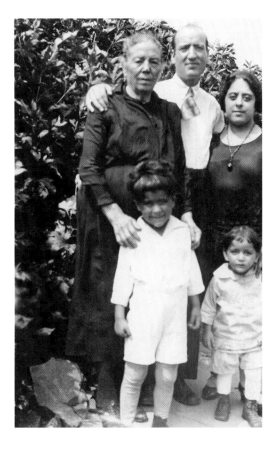

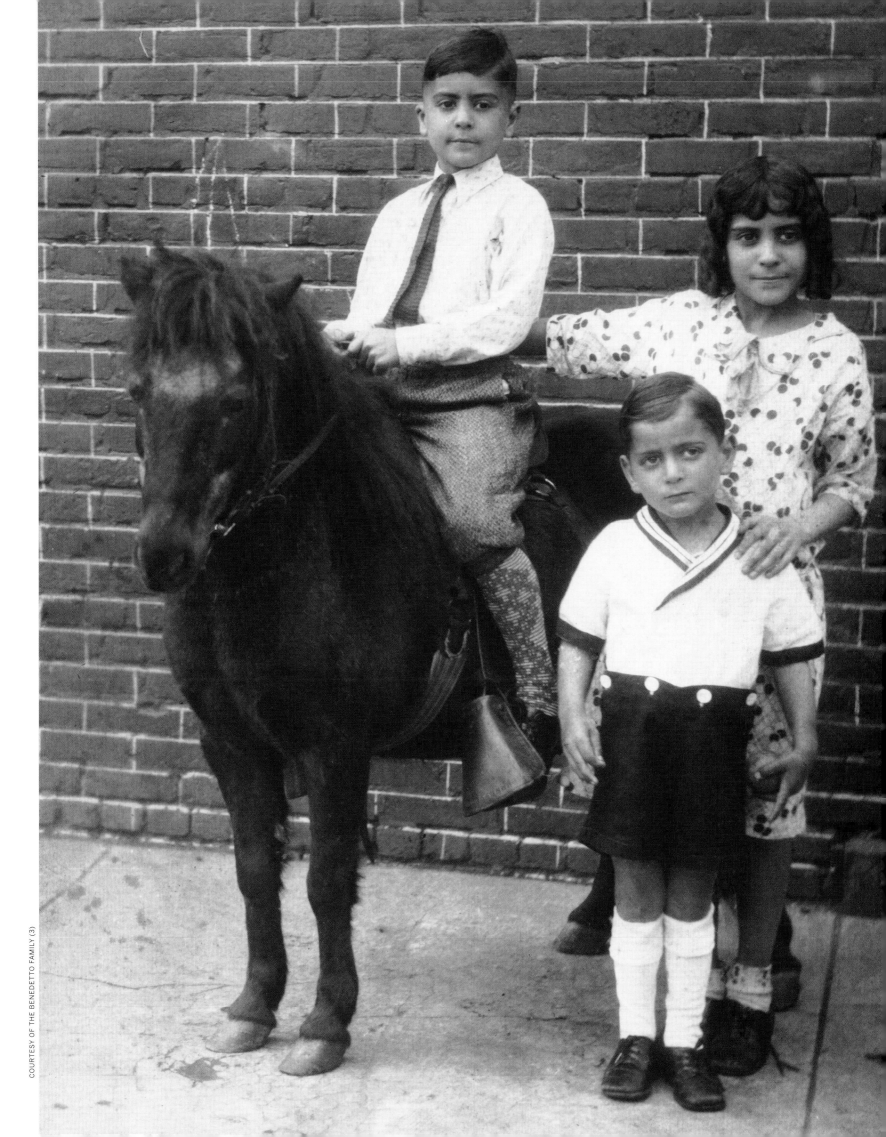

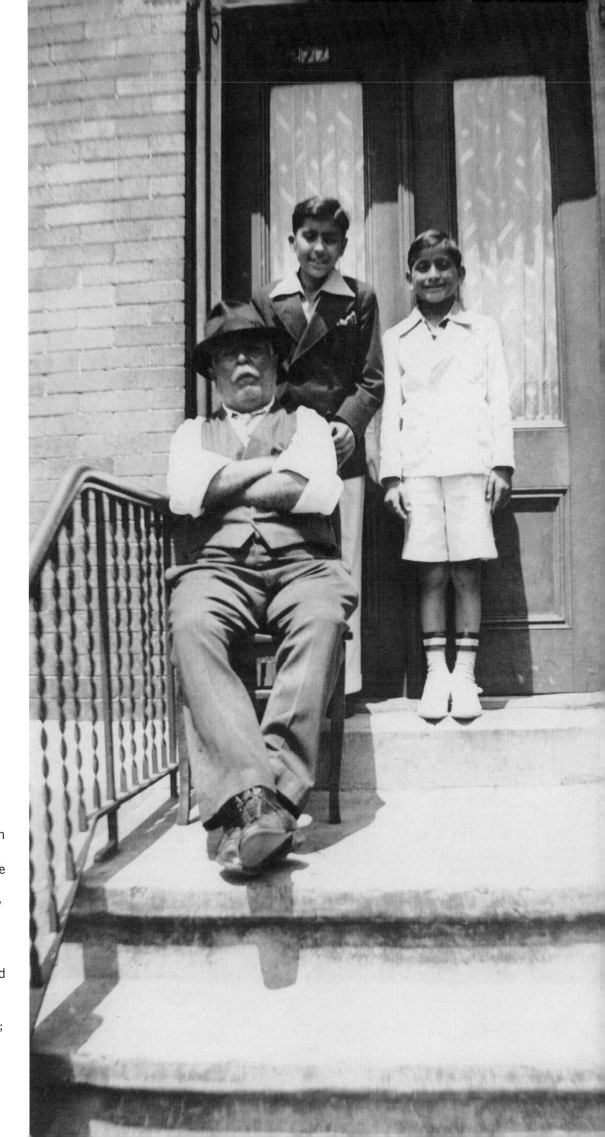

ON THE OPPOSITE PAGE are Mary, Tony, John and their father. At right are John and Tony with Grandpa Suraci. As said, the family sang often, with the kids taking the stage during Sunday evening gatherings. "I had a beautiful family," Tony recalls warmly during a conversation at his apartment in Manhattan. "We'd make a circle, and the entertainment was my brother, my sister and myself. We'd stand inside the circle, and they're all sitting in a circle around us with guitars and mandolins, and they'd have us perform for them. It was all very positive; they used to have so much fun with us. Every week we couldn't wait for the next Sunday, then the next Sunday to come."

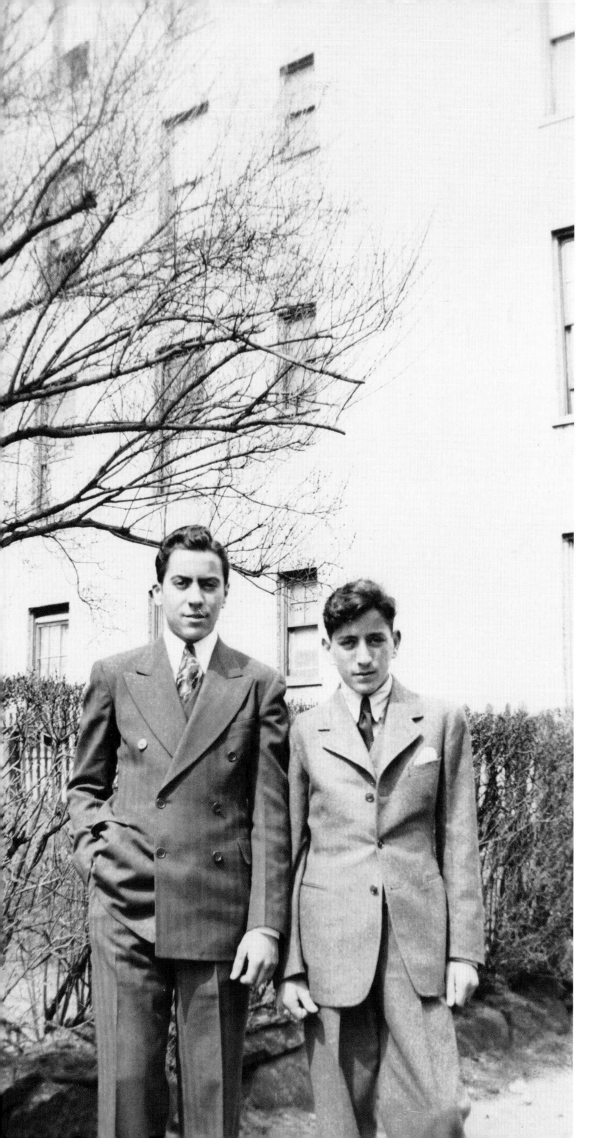

AT LEFT, the Benedetto boys are teenagers, and John is the taller. Opposite: The younger kid from Queens is dreaming his river-crossing dreams, not yet sure where art might take him but sensing that art might be the bridge. By the time he was 12 years old, Tony was an accomplished—and notorious—caricaturist of classmates and teachers at P.S. 141, and drawing had become his co-favorite pastime with singing. "I knew very early that somehow I would sing and draw and paint my whole life," he says today. Pianist Ralph Sharon, Tony's longtime accompanist, once wrote about the years immediately after Tony's father's death: "With his mother going to work and his siblings busy with their own lives, Tony found himself alone for many quiet hours. Drawing, sketching and even cartooning became important afternoon activities for him. While other children would doodle, Tony would try to 'get the picture right.'" Tony would apply the precise same ethos to all his creative endeavors in the several decades to follow.

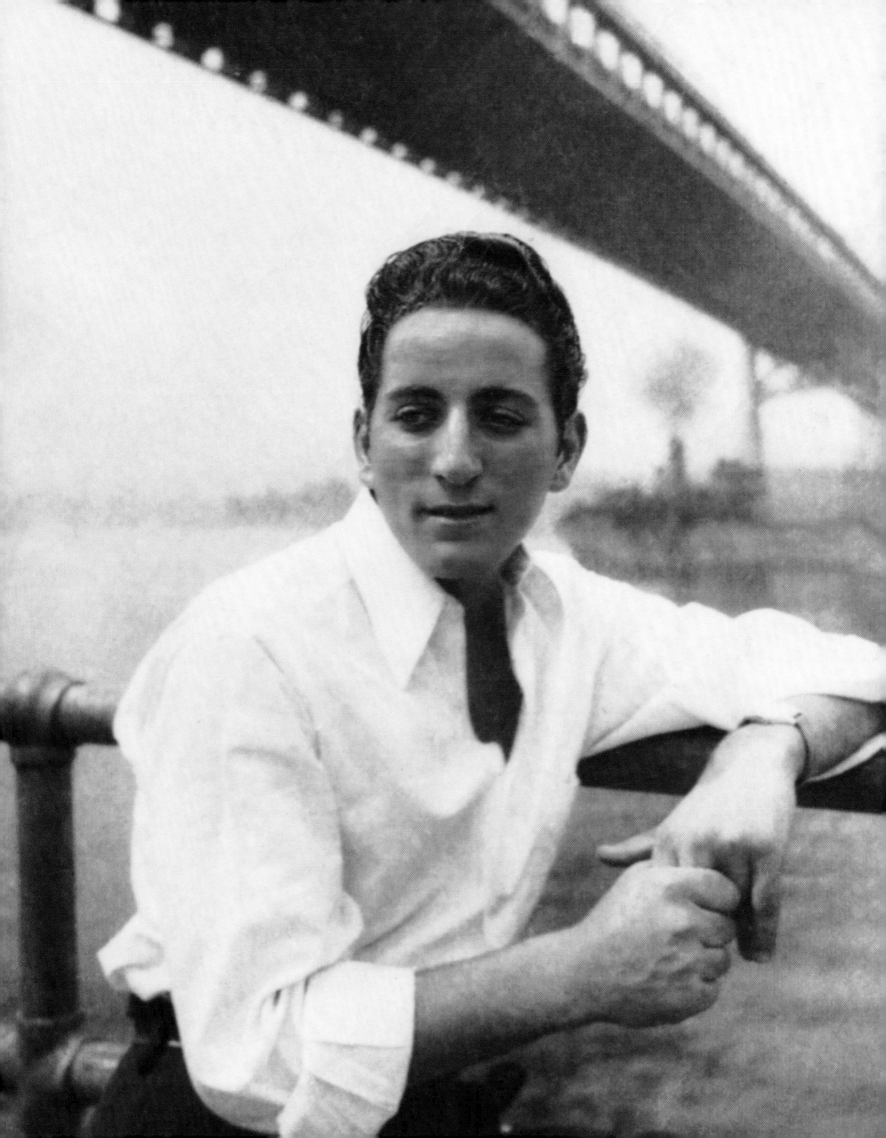

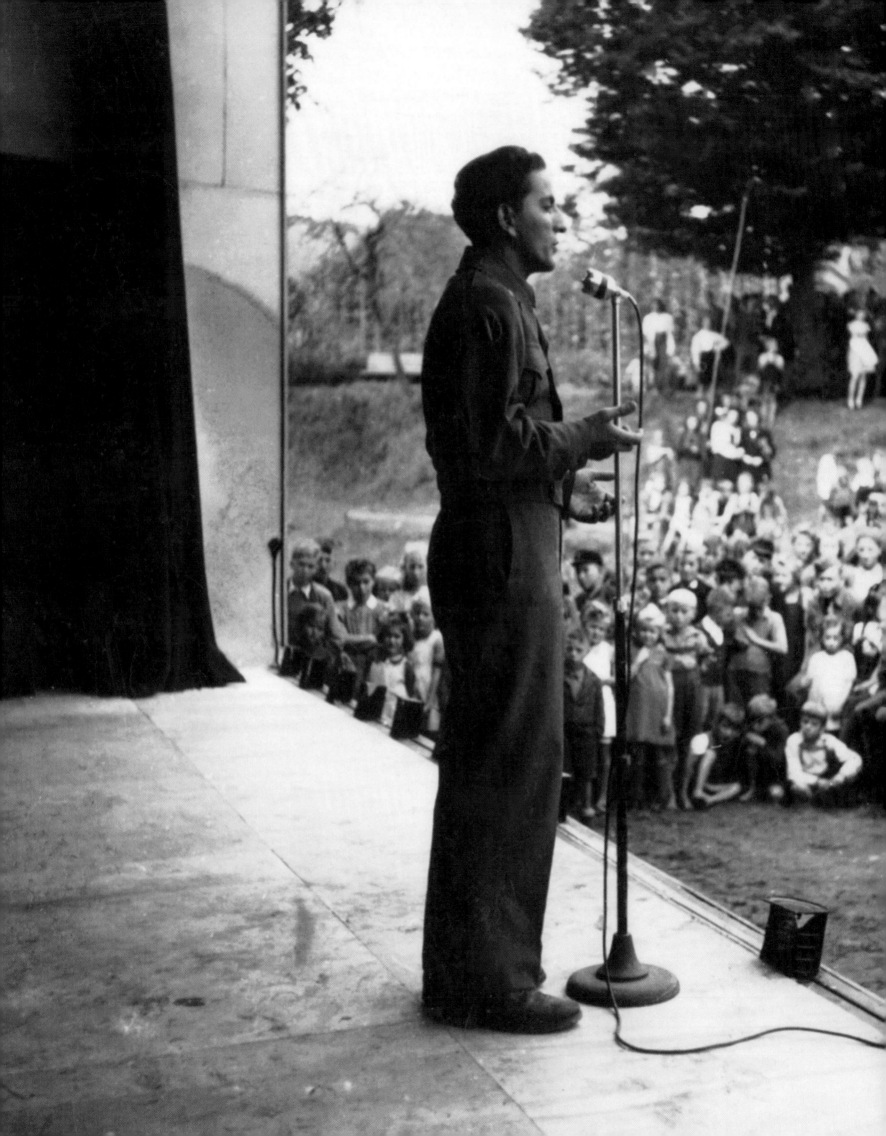

YOU'RE IN THE ARMY NOW: 1944–1946

HE'S SINGING, which is what he would continue to do for his fellow Americans for the next half-century and more. He had wondered about his artistry—singing, drawing—but as happened to so many Americans in the 1940s, the larger world intervened: Tony was drafted into the Army in 1944. He wound up with the 63rd Infantry as it moved through France and Germany near World War II's end. Tony, today, downplays his military career, but the fact remains: He saw some things. He was nearly killed more than once and was in on the liberation of the Landsberg labor camp in Germany. It wasn't a time for singing—except when he was entertaining others, as here—but to distract himself in arduous times, he drew. "There was a guy who was on the line with me in Germany," he recalls, "and he said to me later after the war, 'Do you remember when we were in the trenches, with the bombs coming at us and everything?' I said no. He said, 'You were sketching all the time.' Crazy."

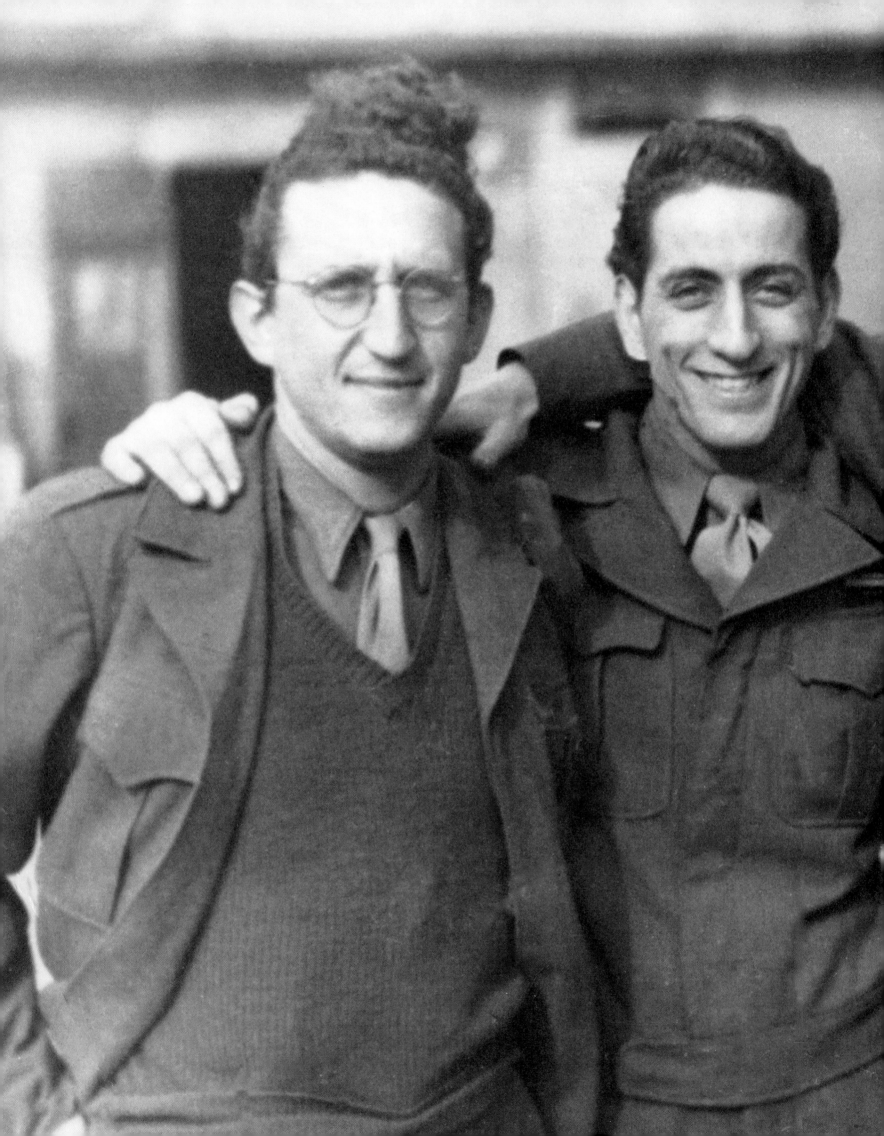

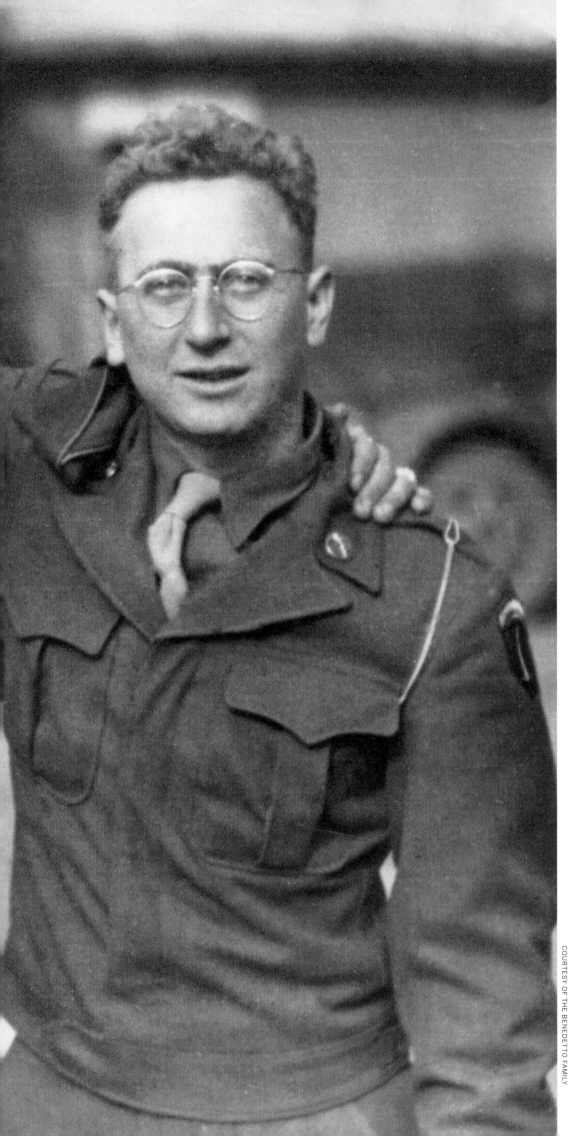

TONY IS A PATRIOT and he's proud, but he emphasizes today that he has long been a pacifist. He wrote in his memoir, "The main thing I got out of my military experience was the realization that I am completely opposed to war. Every war is insane, no matter where it is or what it's about. Fighting is the lowest form of human behavior. It's amazing to me that with all the great teachers of literature and art, and all the contributions that have been made on this very precious planet, we still haven't evolved a more humane approach to the way we work out our conflicts." Much later in life, when he was world famous, Tony's vigorously political comments—including on 9/11—would cause him controversy. But he would remain rigorously honest in what he said, and never shied from criticism. At left, Tony is flanked by brothers Freddy and Stan Katz.

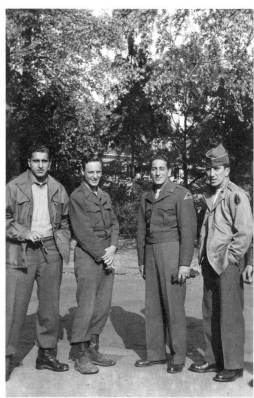

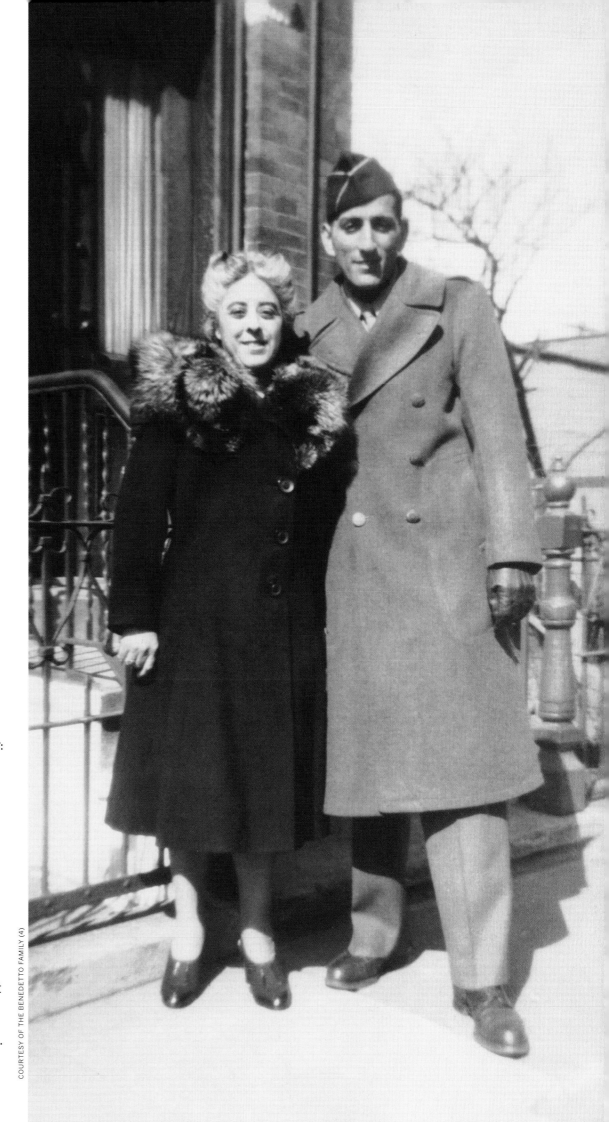

ON THE OPPOSITE PAGE, he's with the guys; at right, he's with Mom. She was always, and has always been in memory, Tony's life hero. (When asked if the term applies, he whistles—and no one whistles like Tony Bennett—and drops his eyes, then says, very quietly, "Absolutely.") From his memoir, which is dedicated to her: "My most vivid memory from my childhood is of myself as a 10-year-old boy during the Depression, sitting at my mother's side in our modest home as she worked as a seamstress. Her salary depended on how many dresses she could make and I remember the constant hum of the sewing machine that stopped only long enough for her to cook our dinner." He remembers further in a conversation, "One of the early gifts I got was from my mother. She always insisted on top quality. She would make those penny dresses, and the more she made, the more money she would earn. But even still, she'd throw away a bad dress. Always quality. Ever since, I never wanted to do a song that would insult the audience. That's the way to make music that lasts. Like a dress that lasts."

AFTER GERMANY surrendered, Tony stayed in Europe as part of the occupying force, singing regularly with a Special Services band that entertained the troops on Army bases. Earlier, in New York City, he had found work as a singing waiter—a gig he absolutely loved—and now he was getting to sing again. But, war being war and the service being the service, he was also finding out about himself: real world issues. One thing he learned was that he would be a lifelong opponent of any kind of discrimination, an instinct perhaps nurtured on the sidewalks of New York City, which, for others, might as readily have nurtured prejudice. Thanksgiving, 1945: Tony is stationed in Mannheim, Germany. He had made the rank of corporal in Special Services, and his assignment is, essentially, to sing with the band. Tony is walking the streets and bumps into Frank Smith, a fellow serviceman but also an old buddy from the High School of Industrial Arts, which Tony had attended, back in New York. Frank is a singer too; he and Tony used to harmonize. "I couldn't believe it. Frank Smith in Mannheim, Germany! I was thrilled!" So was Frank, and he took

his old friend to Thanksgiving services at a Baptist church he's miraculously found. Tony in turn invites Frank to join him for a holiday meal at the mess. The two of them get as far as the lobby. An officer in Tony's company approaches in a fury, shouting, "Get your gear, you're pulling out of here!" The superior takes out a razor, cuts Tony's corporal stripes from his shirt, throws them to the ground, spits on them and continues in his rage: "Get your ass out of here! You're no longer a corporal, you're a private again!" The demotion sticks, for Tony indeed has been caught in blatant defiance of a military rule that is in full force in the European theater. Frank Smith is black, and the mess hall is segregated. Tony would have been allowed one guest for Thanksgiving dinner, but it was impossible that this might be a black man. "No question that incident changed my life forever," says Tony today. "Frank Smith was just a wonderful guy, and then that ridiculous thing happened—a human nightmare is what it was. I was ready for the change, and that did it. To have that happen, in the Army, where you're supposed to be fighting against injustice . . ."

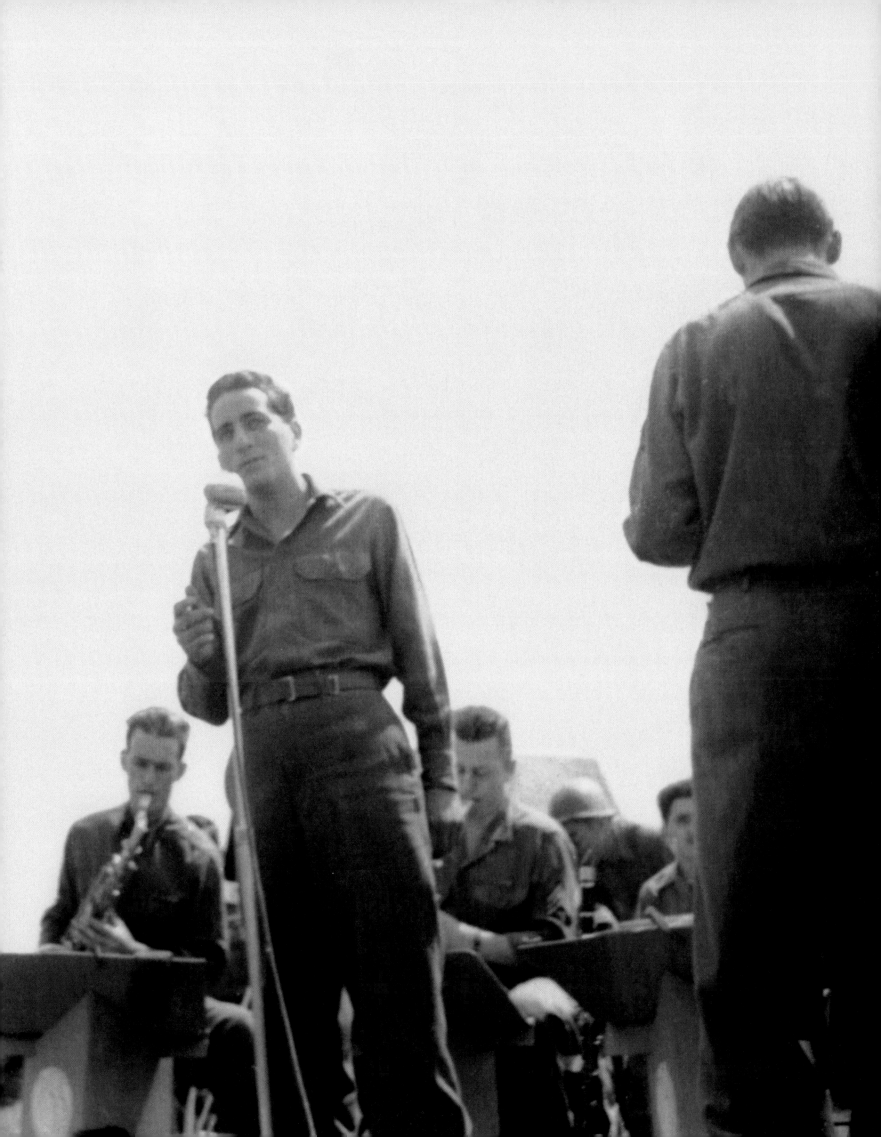

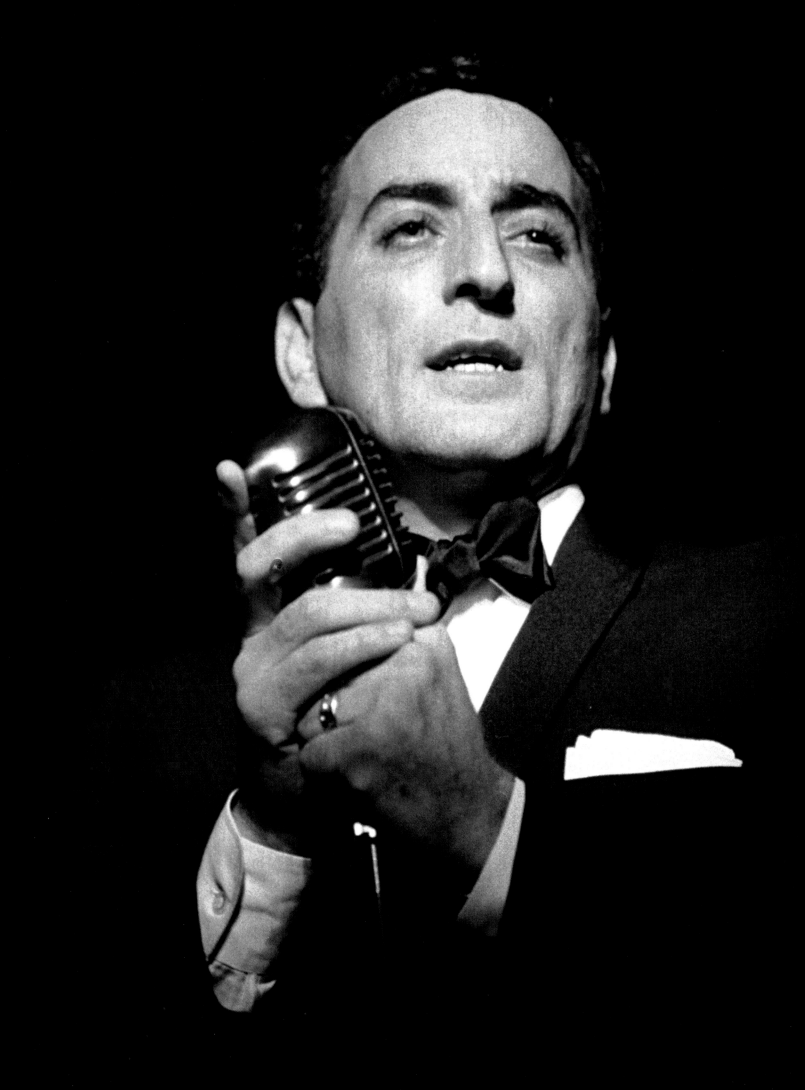

POP STAR:
1947-1964

"I LOVED THE JOB," Tony says of that first stint as a singing waiter. He is sampling his elegant lunch, served by effusively attentive, nonsinging waiters in a private dining room in New York City's Metropolitan Museum of Art—of which Tony is a patron. He has traveled uptown this day with Susan from Central Park South in a black limousine. "I loved the job," he repeats. "I figured if I do this for the next 20 years—fine. I get to sing." But he would move on to better rooms from the $15-a-week gig at Pheasant Tavern in Astoria, Queens. As we've seen, during the war he sang for his fellow enlisted men on Army bases in Europe, and when he returned stateside he took bel canto singing lessons on the G.I. Bill, and sang into the wee hours every night of the week at clubs in Greenwich Village and elsewhere in New York. The latter half of the 1940s, when Tony was honing his craft and style, set him up for the 1950s—the breakthrough years (at left, performing in 1958).

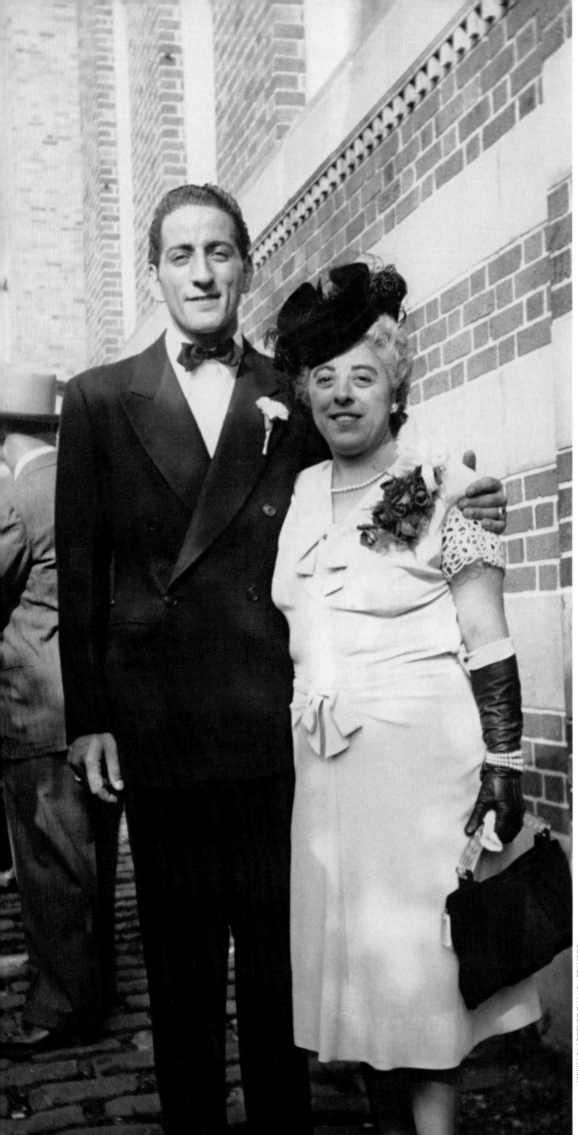

AS TONY'S FATHER HAD DIED, his mother, seen with Tony at left in 1945, asked that the kids contribute however they could to the family; every dollar was tight.

"I was an elevator operator during the day, but 'Joe Bari' in the clubs—that was my stage name," recalls Tony. He made his first recording for a small New Jersey label in 1947, and drew some attention when he placed second to singer Rosemary Clooney on an edition of Arthur Godfrey's popular television show *Talent Scouts.* "My break came in 1950"—the year the photograph opposite was made—"I got a job on Bob Hope's bill at the Paramount, and just before I'm going on Hope tells me the name's no good. He asks what my real name is. I say Anthony Benedetto. That doesn't do it for him either. So he goes out and says to the audience, 'And here's a new singer, Tony Bennett!' He had to introduce me twice 'cause I didn't know who he was talking about." A year later, on the heels of "Because of You," "I Won't Cry Anymore," "Blue Velvet" and "Cold, Cold Heart," everyone knew who Tony Bennett was; at 25 he found himself the hottest singer in the country, and a heartthrob on the order of Sinatra circa 1940. This was the first flowering of Bennettmania, something that would bloom and fade and bloom again no fewer than three times, in different hues, over the next six decades.

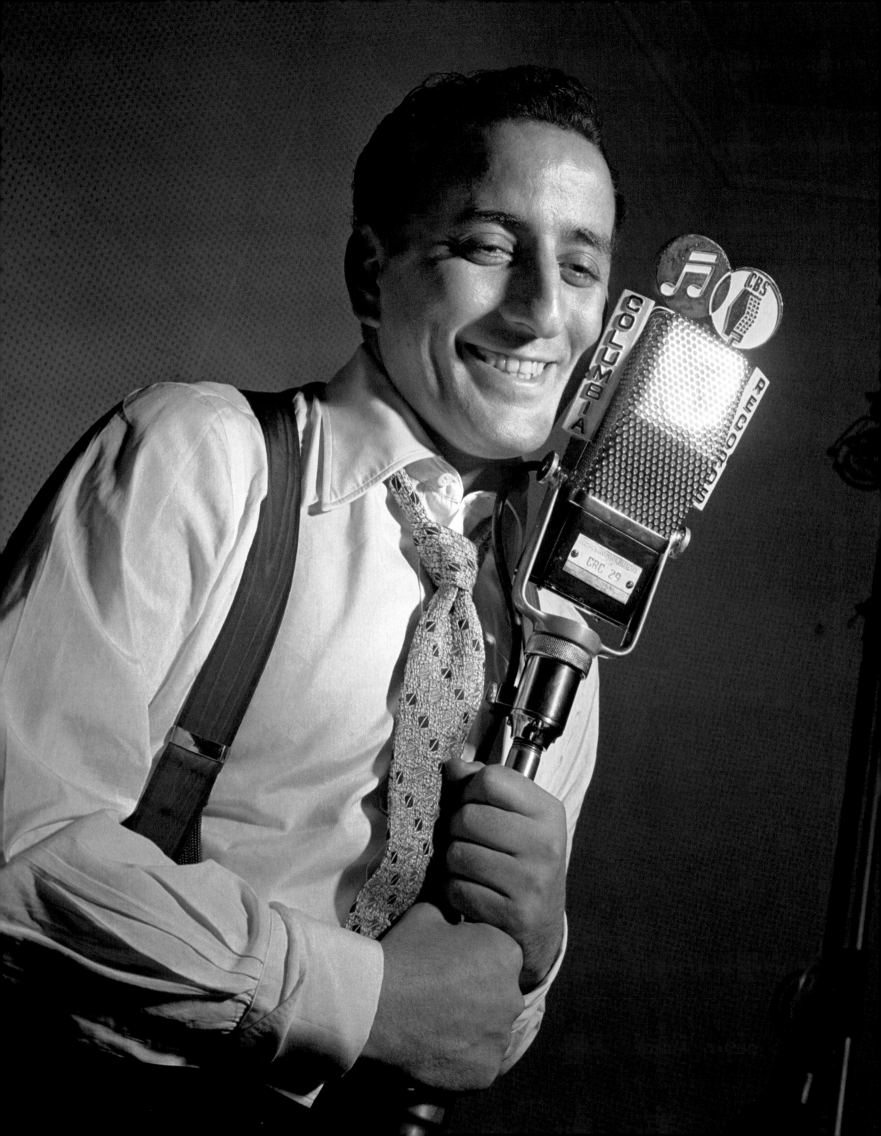

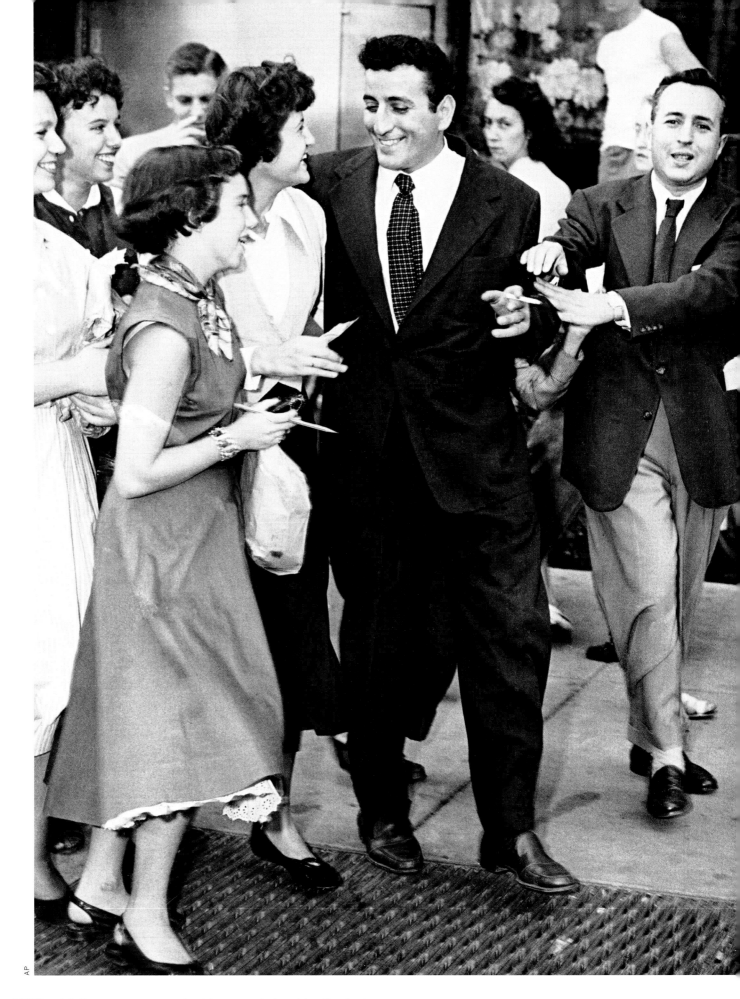

AP

OPPOSITE: In a 1950 publicity photograph made for his new and destined to be eternal label, Columbia Records. Above: Meeting the fans as he leaves a performance in October 1951. Tony is not a big man—he's a trim five-foot-seven—but he was positioned early as not just a talented singer but an idol: a handsome Italian capable of inducing swoons in the concert hall or on the sidewalk.

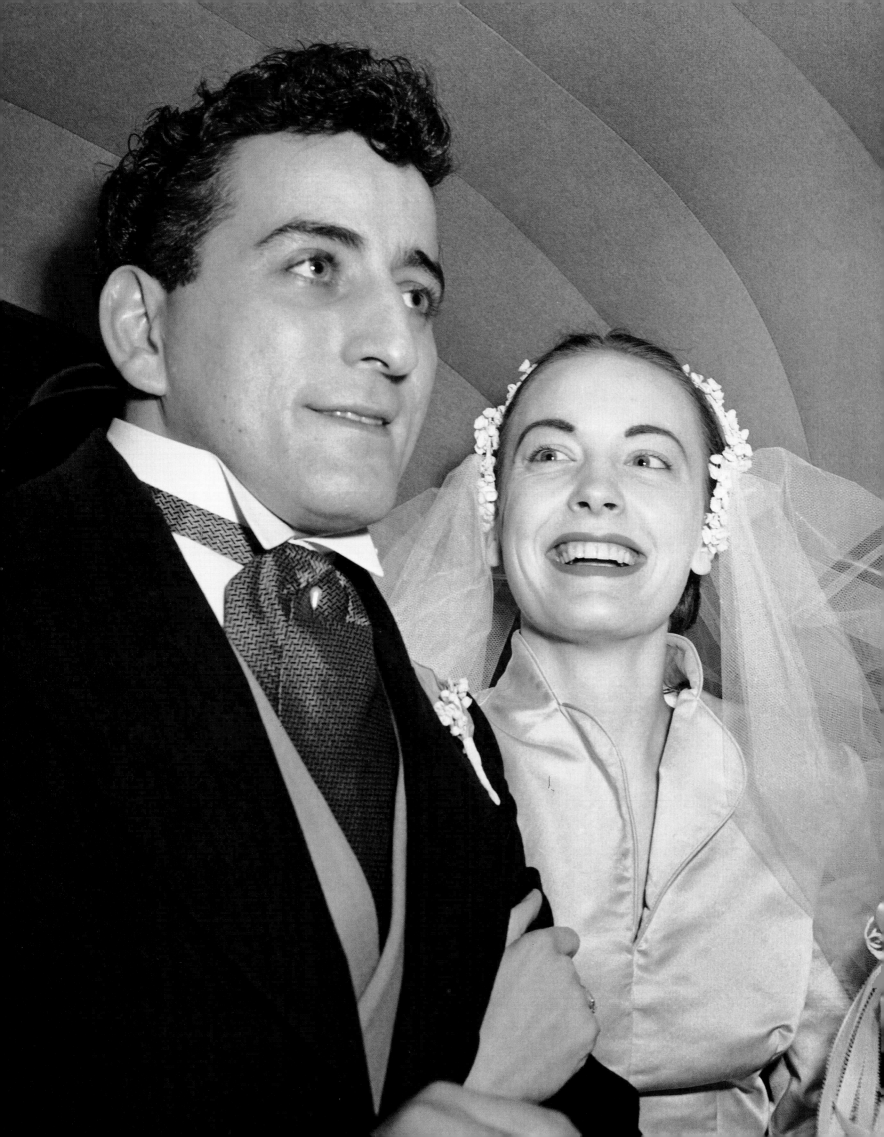

IN THE PERIOD of early stardom that was the 1950s and the first years of the '60s, Tony's principal concerns were his career, his friends and, certainly, his wife and kids. He had come from a tight and loving family, and he wanted the same for his children. At a club date in Ohio in 1951, he had met a fan who loved talking about jazz and aspired to attend art school. Tony courted Patricia Beech from afar, then urged her to move to New York. It's an often told story that when Tony and Patricia married at St. Patrick's Cathedral on February 12, 1952 (left), a substantial horde of teeny-boppers turned up in black veils to mourn the loss of their golden boy. What is not usually part of the anecdote: Tony was not amused, and Patricia was near tears as she struggled to get through the mob and up

the stairs of the cathedral. There's a story behind the story. Originally, Tony and Patricia had planned to wed on February 11, but Tony's manager, Ray Muscarella, who had been against the marriage from the first, worrying about its effect on Tony's image, urged them to push it back a day. February 12 was Lincoln's Birthday, and Muscarella was able to round up hundreds of high school girls on holiday for his publicity stunt; he supplied the mourning veils himself. Patricia never forgave him, and Tony wrote in his memoir, "Ray's attitude toward Patricia was one of the major reasons that Ray and I eventually split." That split would come in 1955, when Ray was replaced by Tony's sister, Mary—the first but notably not the last time that Tony would put his career in the hands of family.

PATRICIA AND TONY'S first boy, D'Andrea, was born in February 1954 in the Bronx, New York (right). When Tony heard his wife calling the baby Danny, he loved the sound—it reminded him of the pianist Art Tatum playing "Danny Boy" so beautifully at a nightclub years earlier. At three weeks old Danny, who is today his father's manager (and we'll get to that a bit later), hit the road with his parents. "I was determined that we stay together," says Tony today. Back then, Patricia certainly agreed.

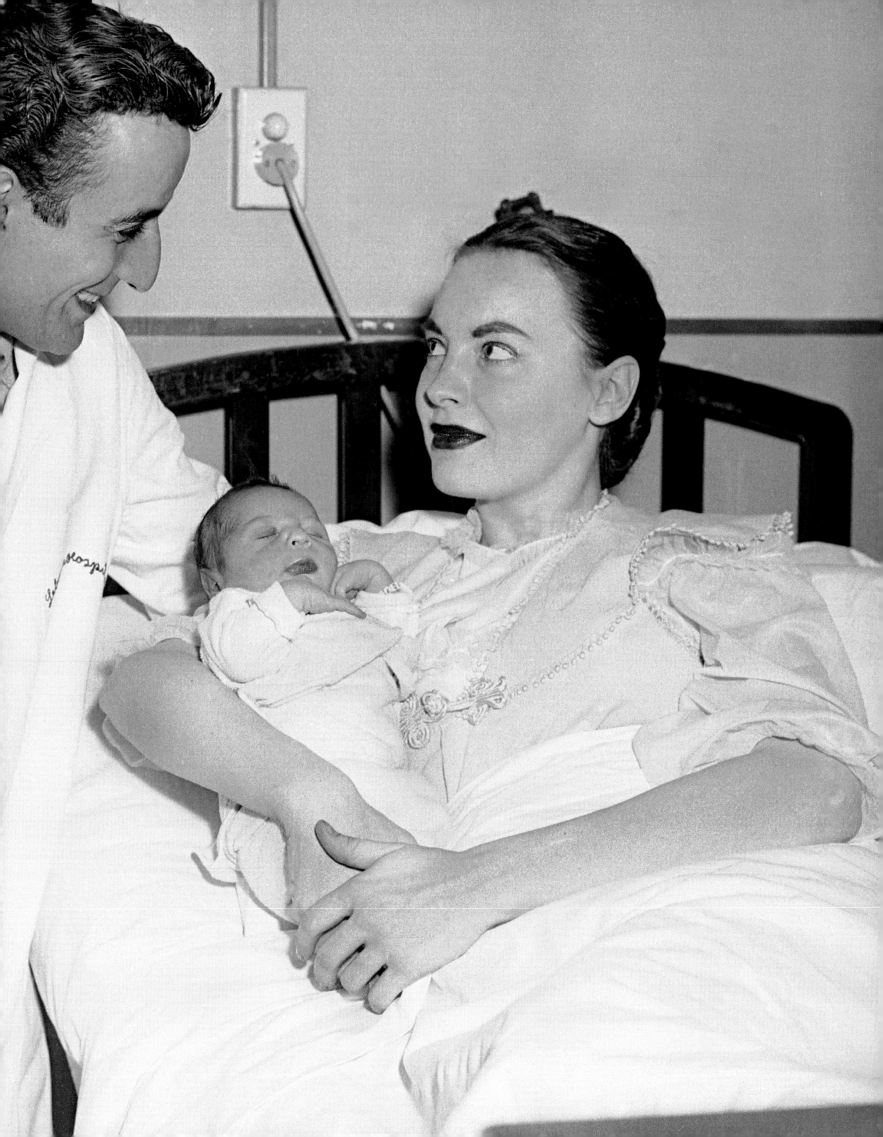

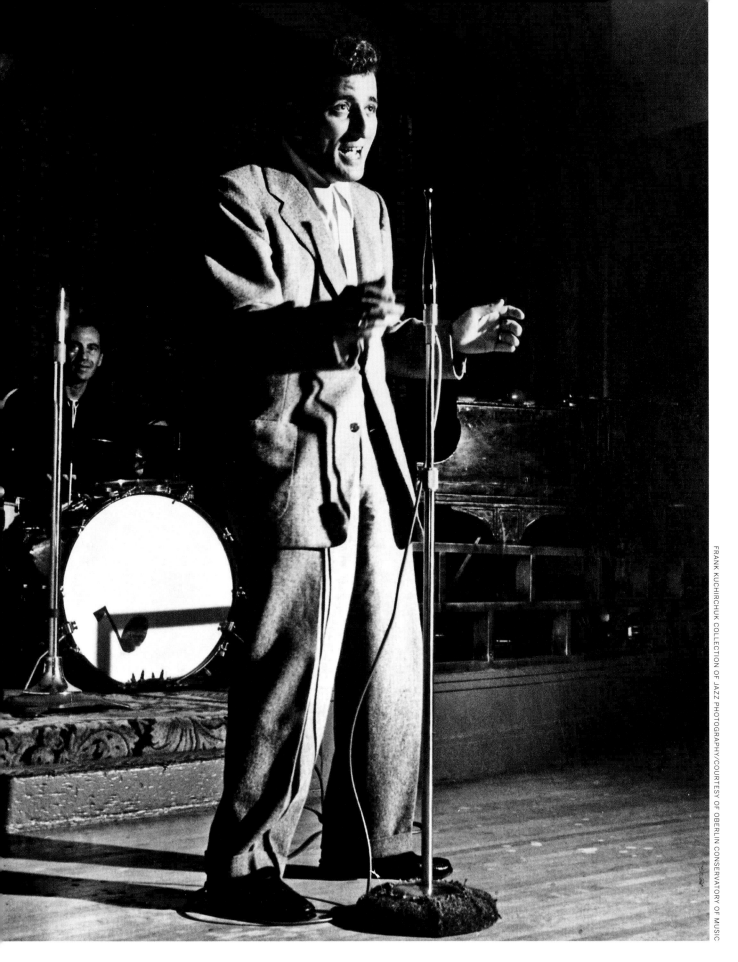

ABOVE: Performing in '53 and, opposite, posing in '54. The hits keep coming in this period: "Stranger in Paradise," "Rags to Riches"—of which Tony recalls, "This is one record on which I was way off, because I was against doing it. [Columbia executive and producer] Mitch Miller and [orchestra leader] Percy Faith practically had to tie me down to do it. I was wrong. In two weeks it sold a half-million records in Pittsburgh alone, and it stayed 25 weeks on the chart, including eight weeks at No. 1. As Confucius once said, 'You must learn not only to give advice but to take it.'"

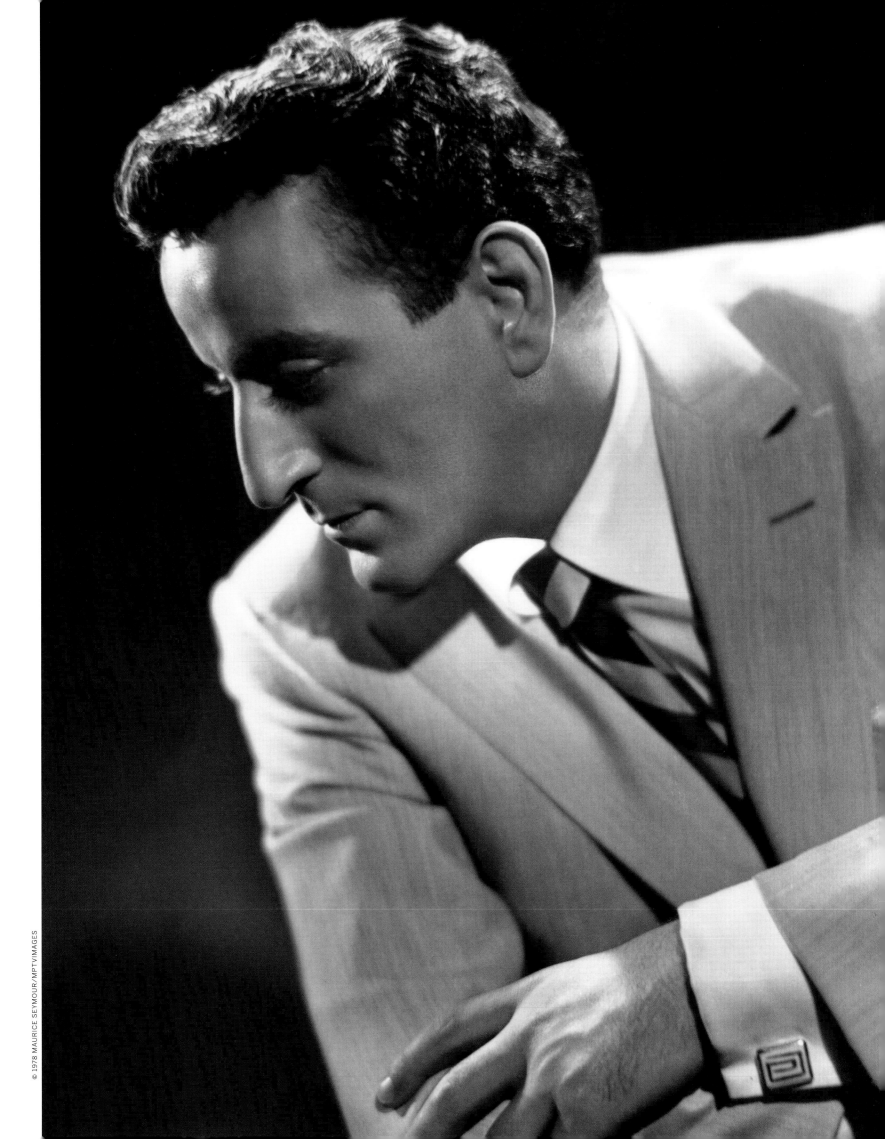

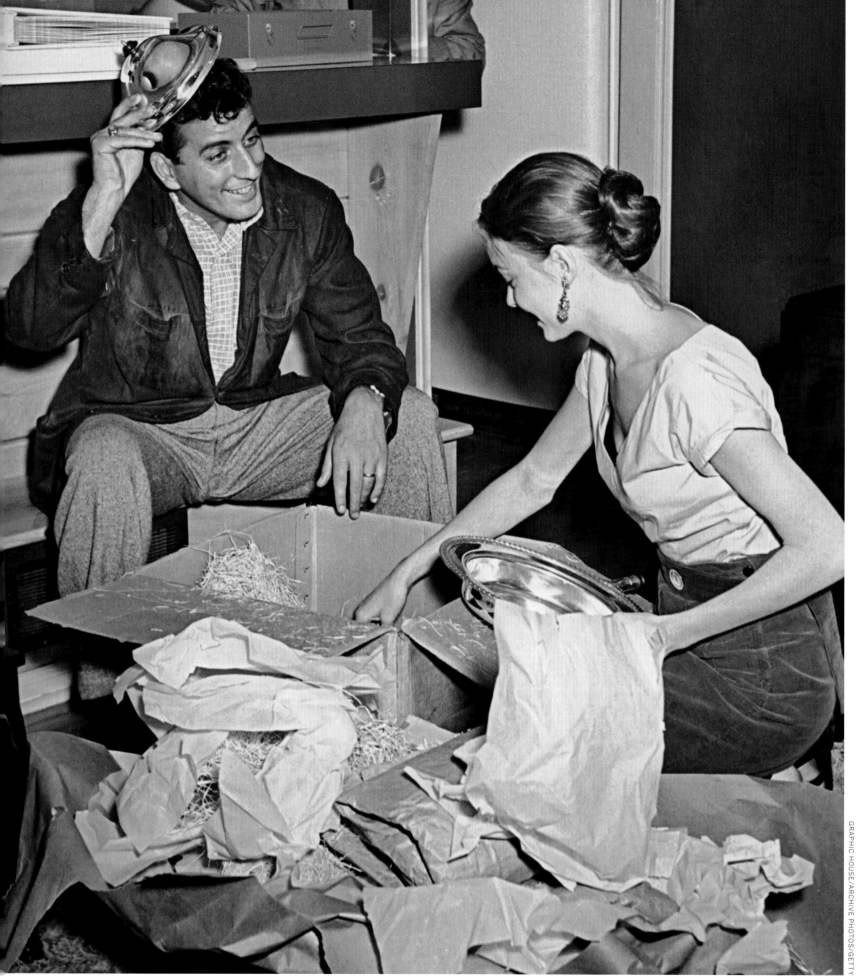

TONY AND PATRICIA unpack the silver (above) and play with their boy (opposite) in 1955. Their second son, Daegal, is born in October of this year. The apartment is in the Riverdale section of the Bronx, but the now larger Bennett family will soon be eyeing the suburbs. Tony had already crossed the East River to live here and sing on stages throughout Manhattan. He would next cross the Hudson to build a home in New Jersey.

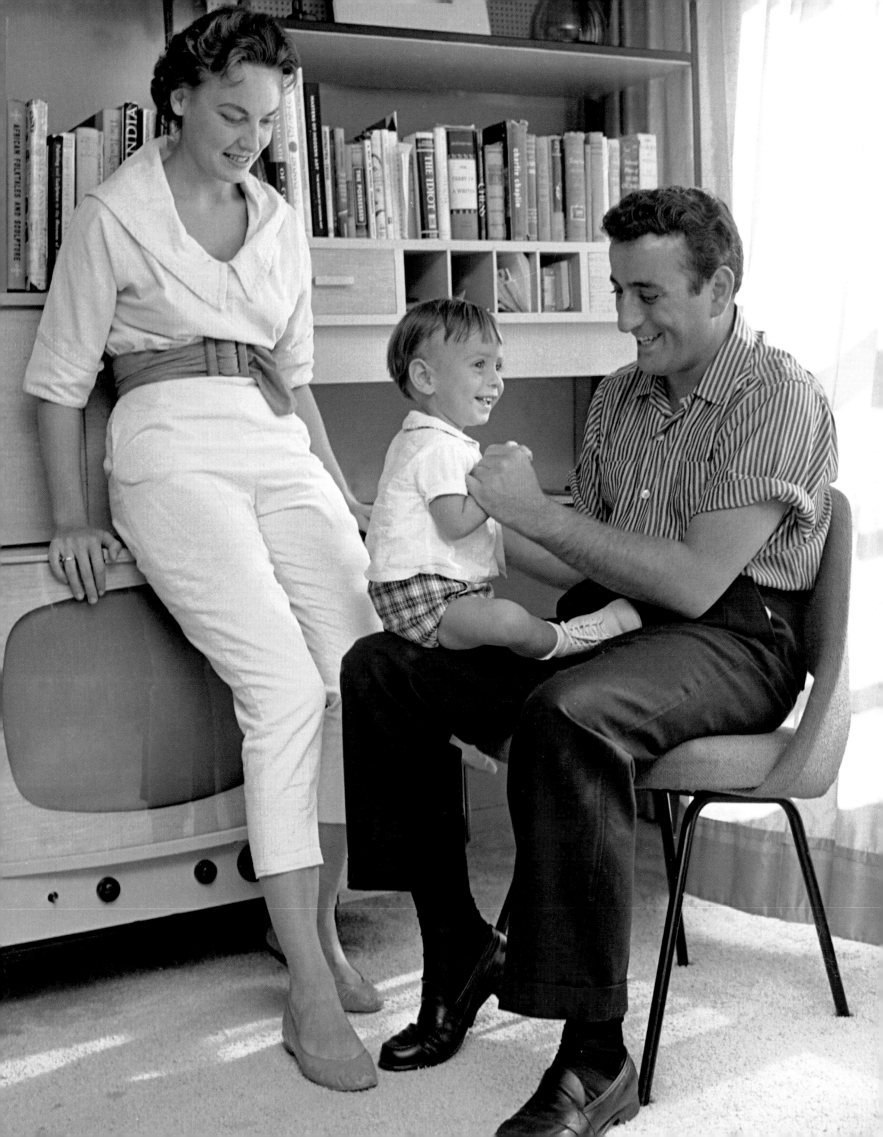

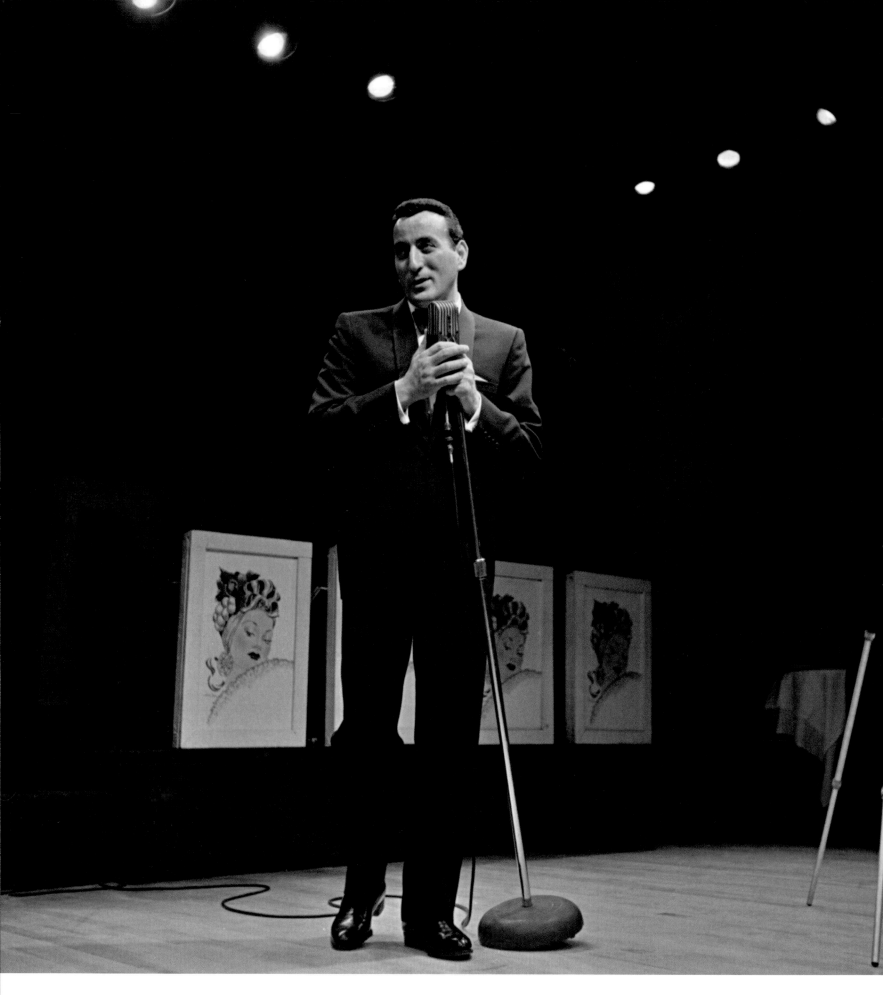

ON THESE NEXT SIX PAGES, Tony is at New York's Copacabana nightclub in March 1956. Later this year, he has a brief fling as host of a television variety show, when his hour-long weekly effort is one of three programs used as summer replacements for Perry Como's hit program. The small screen in the 1950s struggled to convey the excitement of Tony live. "I was always loud," he admits freely, "and always very dramatic. Back then,

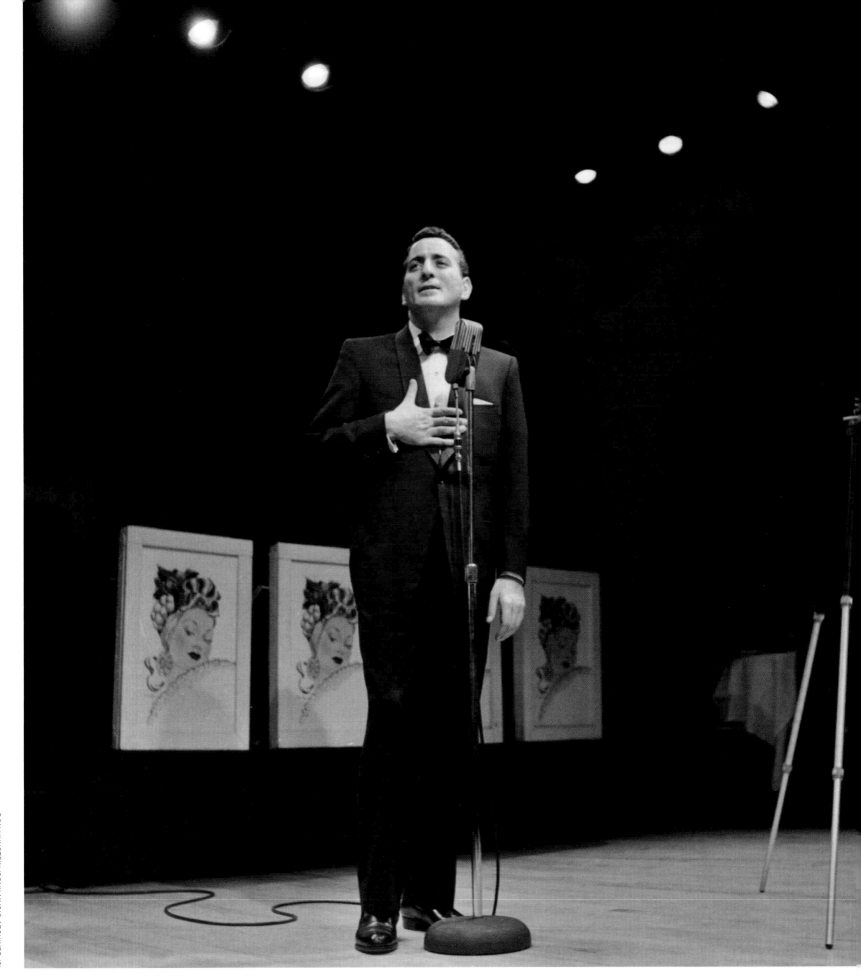

I was too much. The guys in the band would say to me, 'Hey, kid—what're you trying to do? Calm down.' But see, Ella [Fitzgerald] had told me to sing to the balconies. And also, I was nervous and I couldn't control myself.

I asked Sinatra one night how he keeps his nerves from killing him on stage. He told me it was okay to be nervous, people liked it. They could see you cared." The odd combination of vulnerability and volume blended perfectly in Tony; his frailty let the listener in, and the full-out vibrancy of his voice—he once burst a blood vessel in his throat, and even today he shouts, rather than sings, his top notes— absolutely thrilled them.

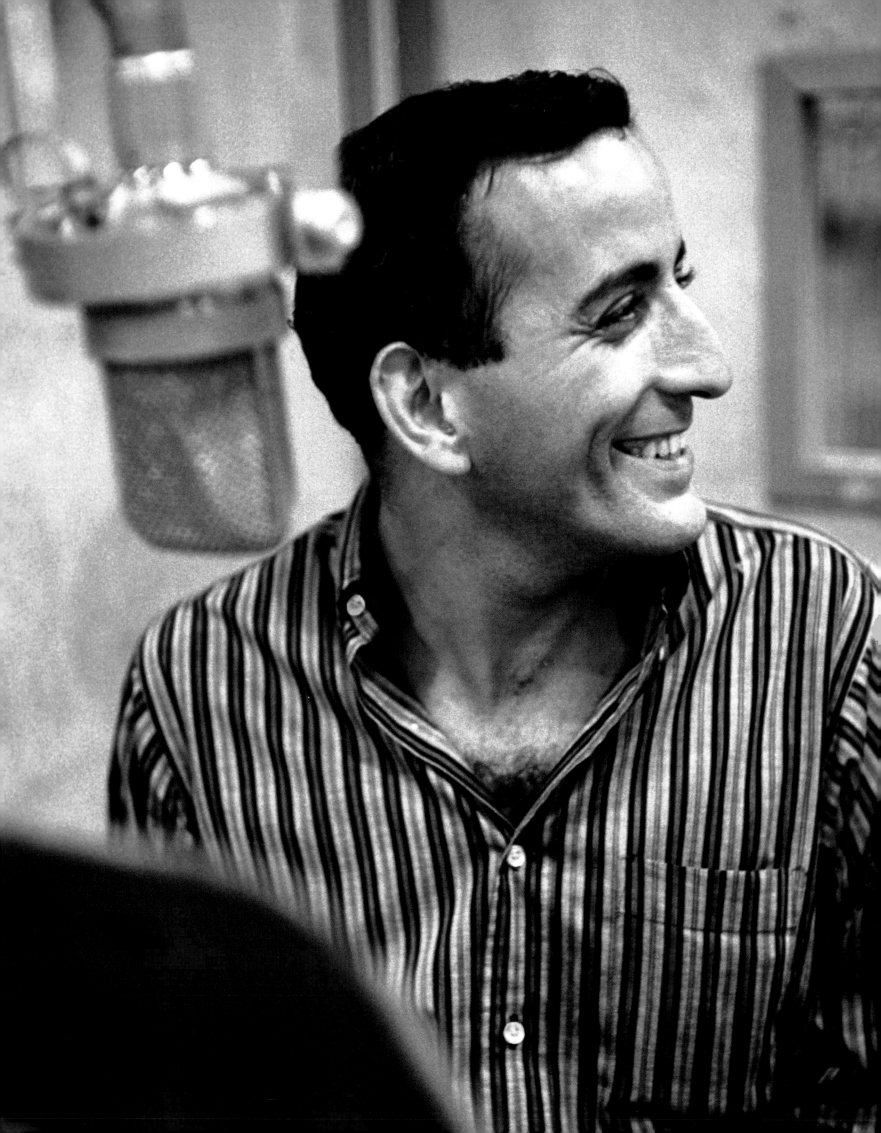

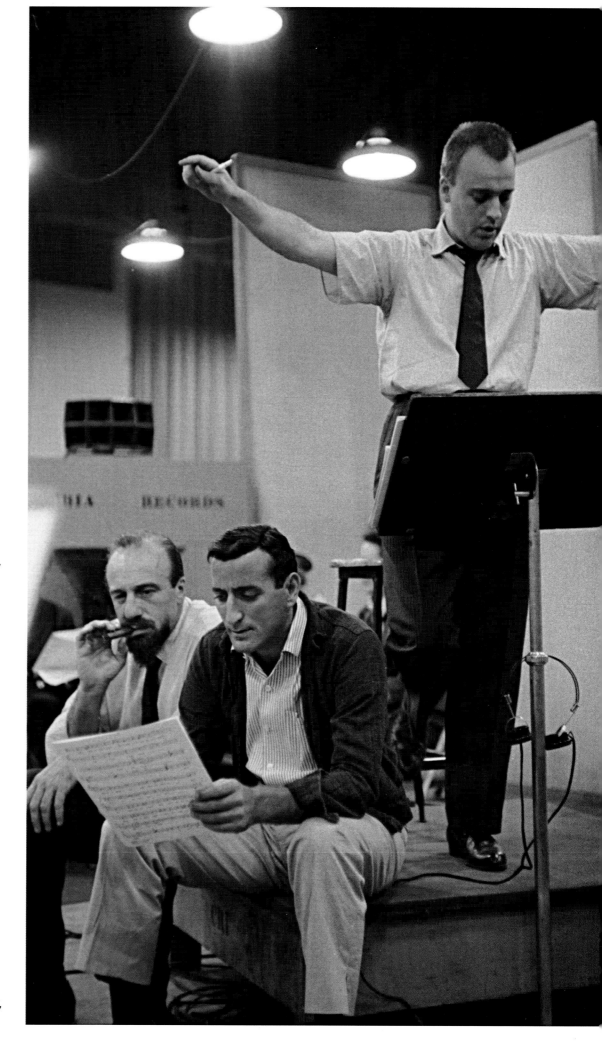

THESE ARE two photographs from 1957 recording sessions, in June (opposite) and September (right, sitting next to producer Mitch Miller). On the pages immediately following is one of Tony recording in July of '57 with Chico Hamilton on percussion. That year, he teams up with Ralph Sharon, the pianist and arranger who will stay with him, with one hiatus, for a half-century and who immediately makes an impact on his style. "Ralph Sharon said, 'Make sure you do some jazz,'" says Tony today. "Ralph knew how much I loved jazz. He knew that, really, I'm a jazz singer. In this commercial world, they put me in the traditional pop category because, well, I'm white and Italian, which makes it tough to be a jazz singer. But if you asked me what I was, once I'd learned how to sing, I'd say 'a jazz singer.'" Also in '57, Tony releases an early and rather fantastic example of just how right Sharon was. Tony gathers together a band of all-star jazz musicians, anchored by the finest percussionists on the scene—Hamilton, Art Blakey, Candido, Jo Jones—and records *The Beat of My Heart,* an album that endures today as a classic.

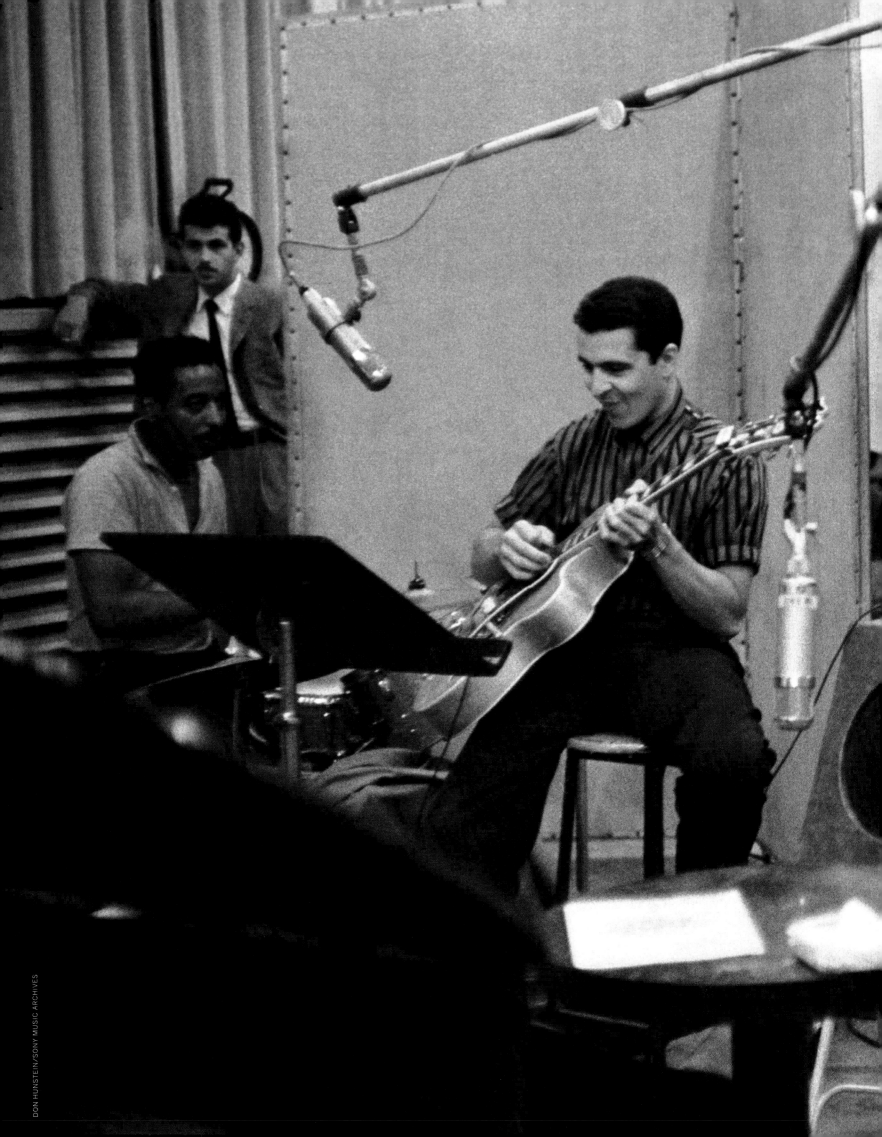

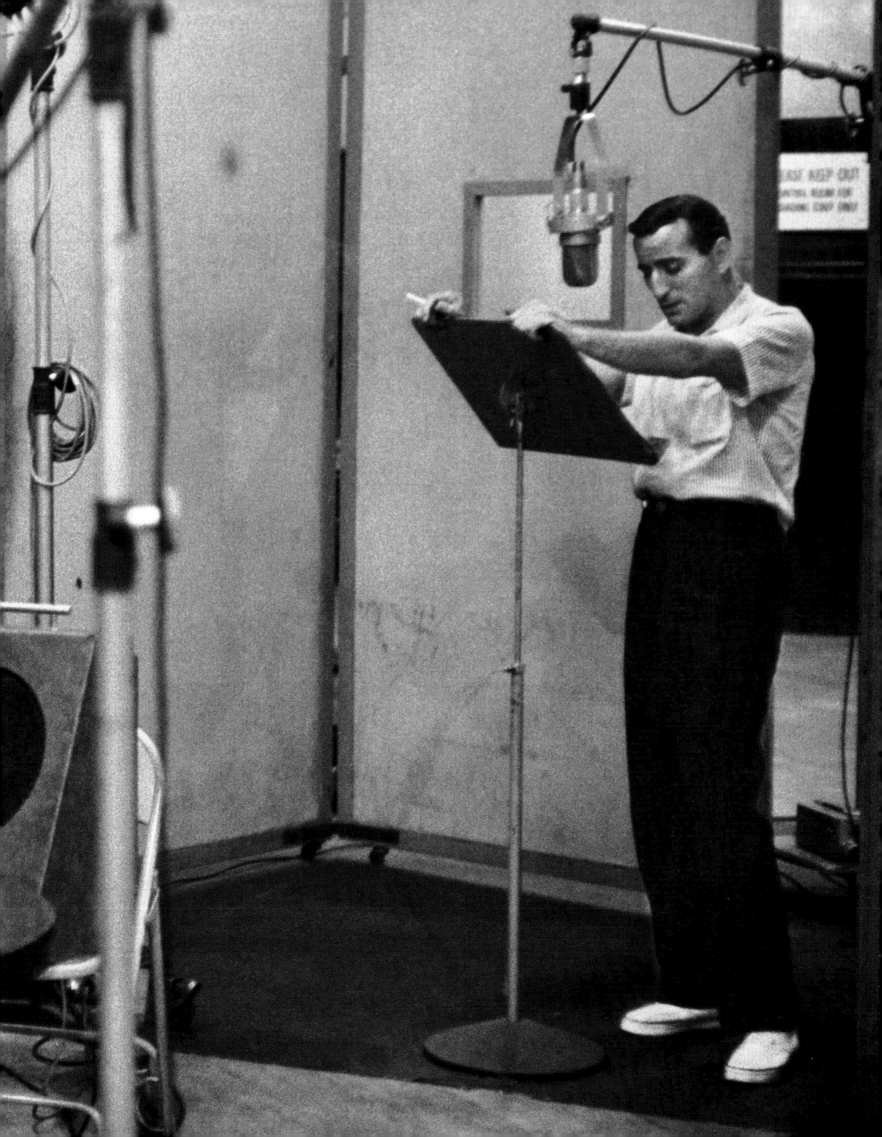

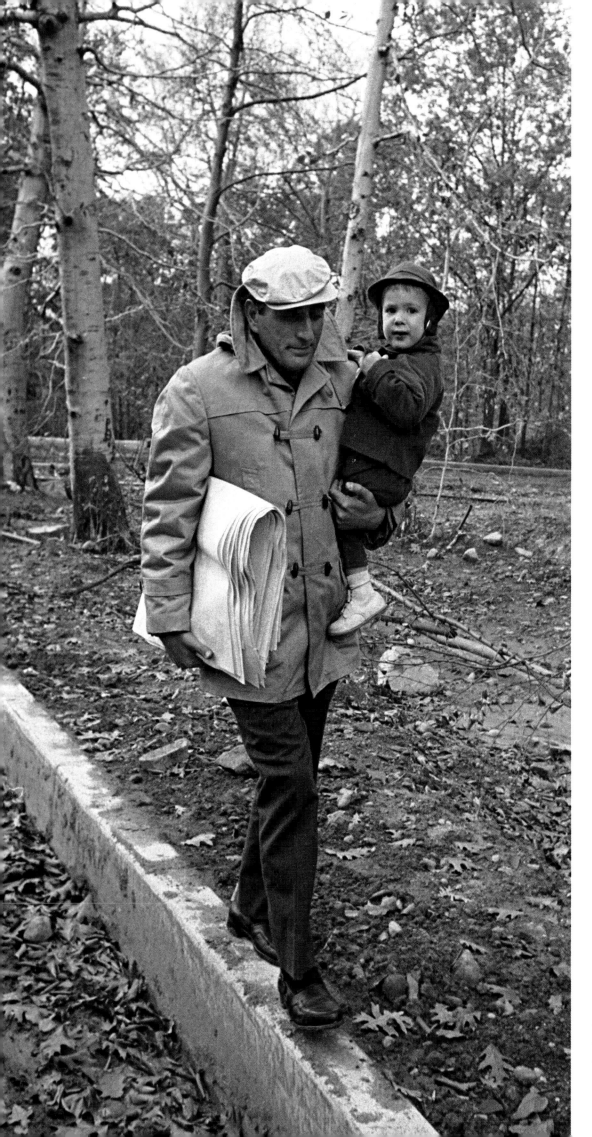

HERE AND on the next four pages are photographs of Tony and Patricia at home on October 1, 1957, with Danny and Dae. At left and on the pages immediately following, Tony carries the little one and shows him some tops; both boys would be musical, as so many Benedettos had been before and as other Bennetts would be in the years to come. The family has moved by this point from the Bronx to the suburbs in New Jersey; they will eventually build a house in Englewood—a town where Daegal, who serves as engineer on many of Tony's discs, will found a recording studio, aptly named Bennett Studios. That house will be designed in the Frank Lloyd Wright style, and Tony makes sure to have rooms in the basement designated for music and painting. His big hope for the house is that it might "do Patricia and me some good."

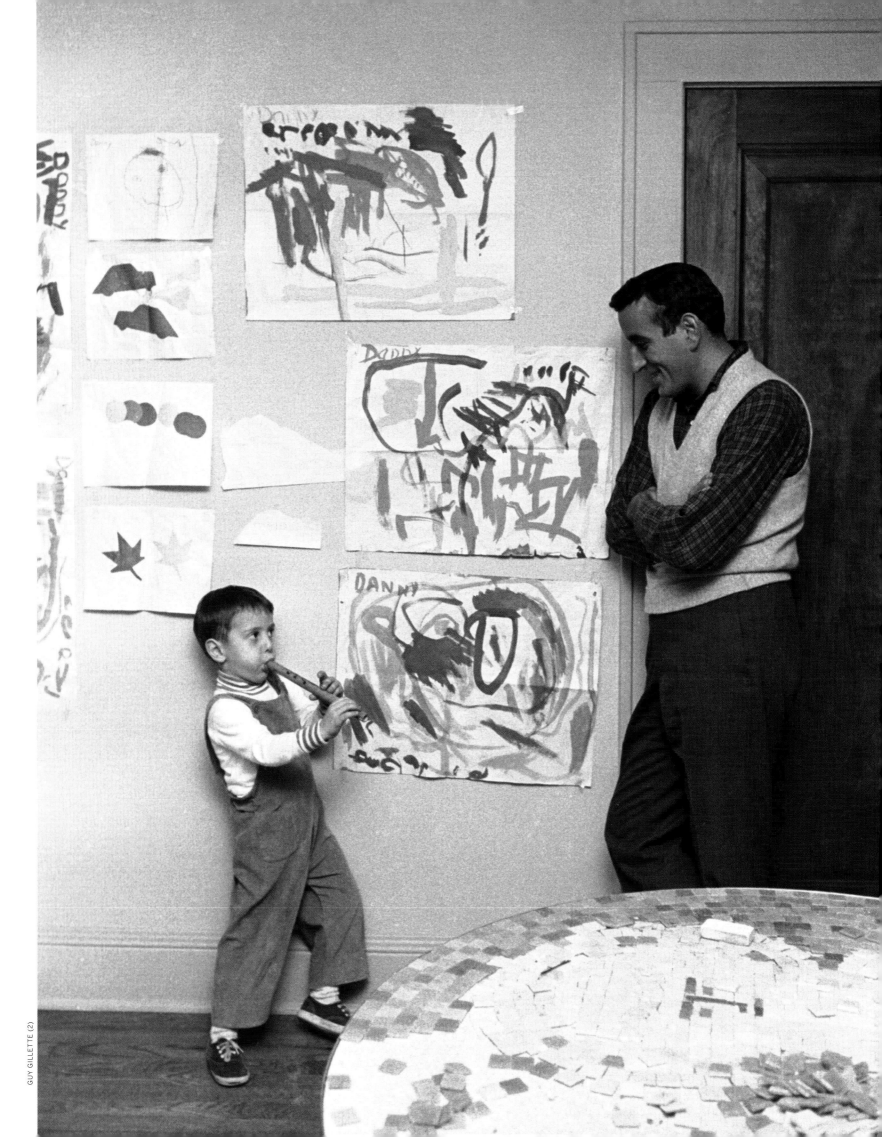

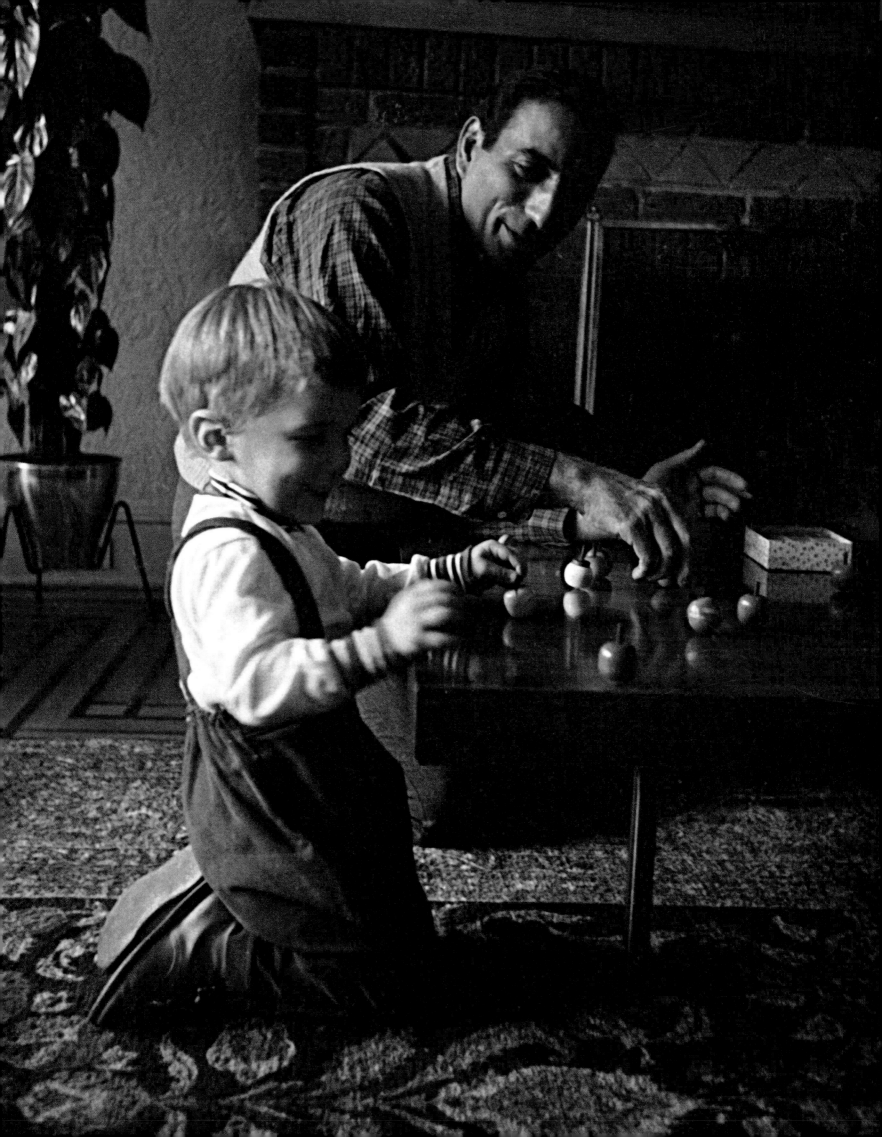

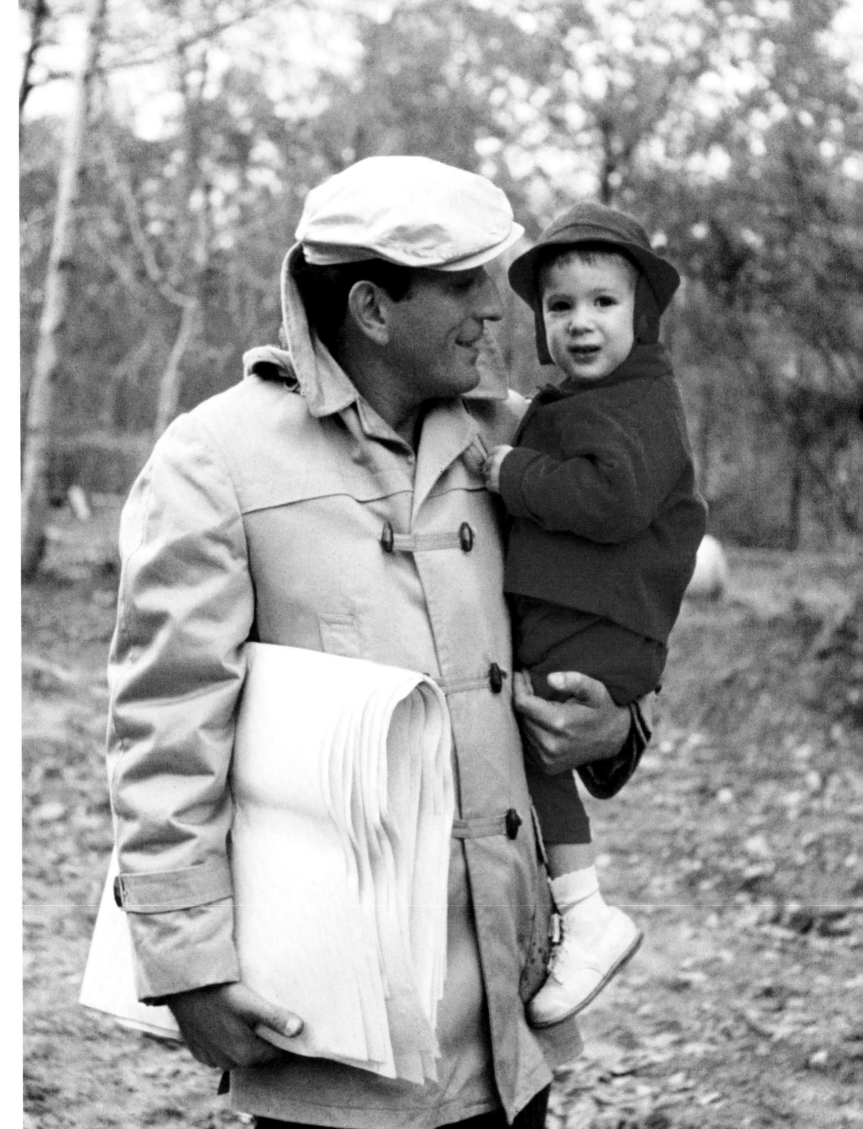

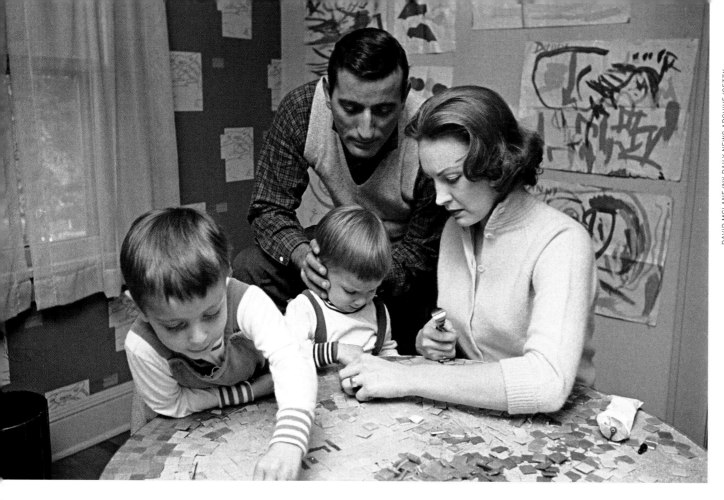

HERE IS THE APPARENTLY HAPPY FAMILY on that first day of October in 1957. Already, however, there are some strains in the marriage. After Daegal's birth, it was decided that Patricia should be home with the boys when Tony toured. The constant separations forced by his career seriously damaged their relationship, and Tony was realizing that you can't fulfill all your dreams just by dreaming them. He wanted the solid family life he remembered from Queens, but he too often was not there to make it happen. Patricia and Tony would separate and ultimately divorce under the strain, though he was

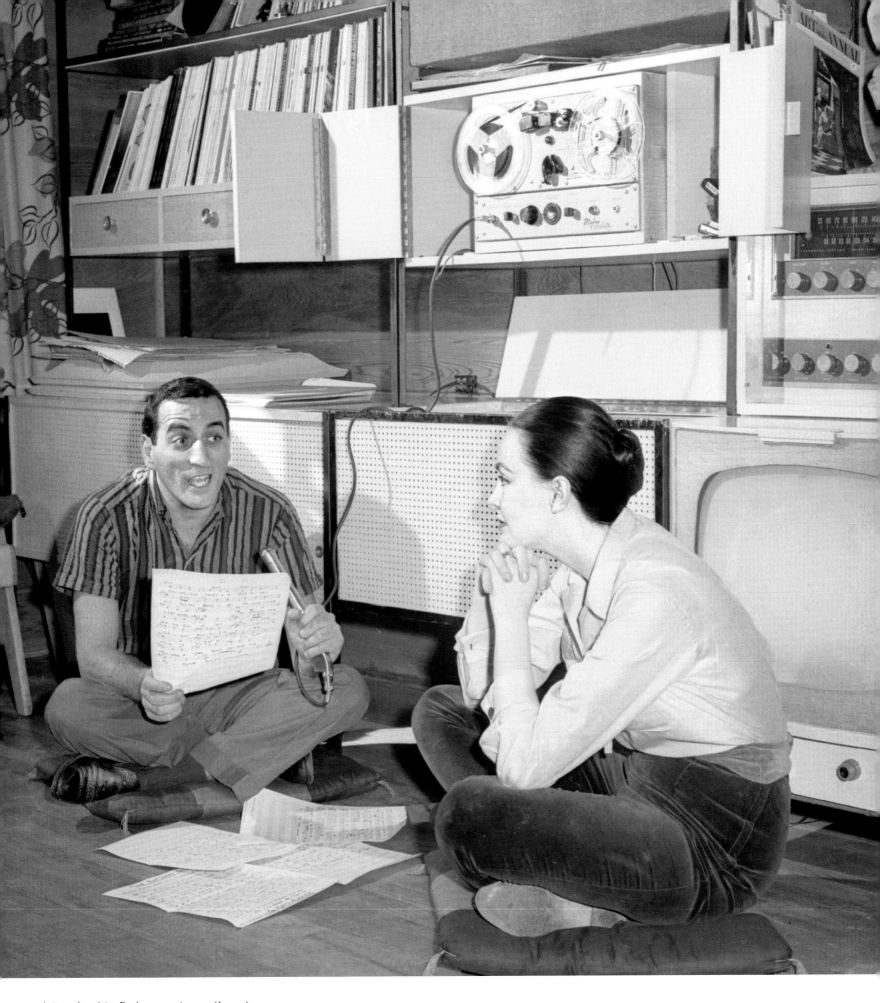

determined to find a way to continue to
be an important part of his sons' lives—
something he has clearly been able to
do. On the following pages: In December
of '57, still smiling.

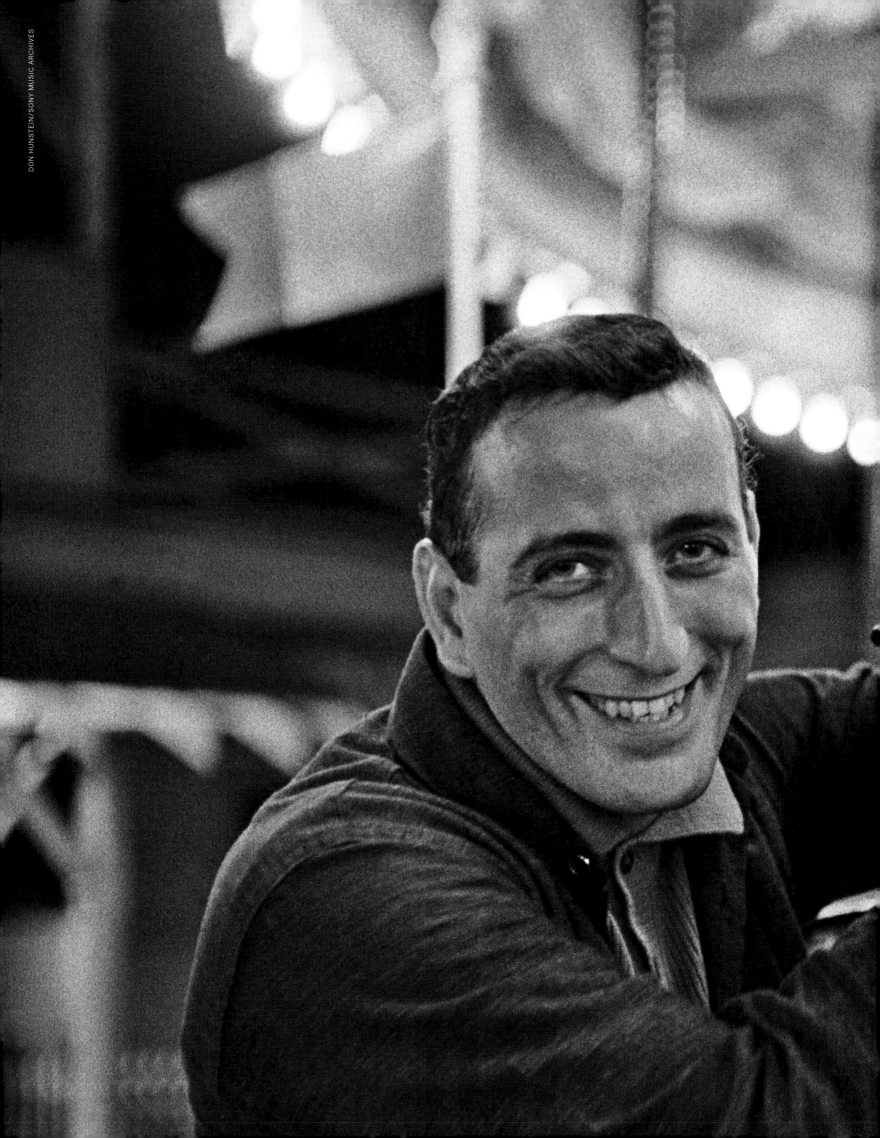

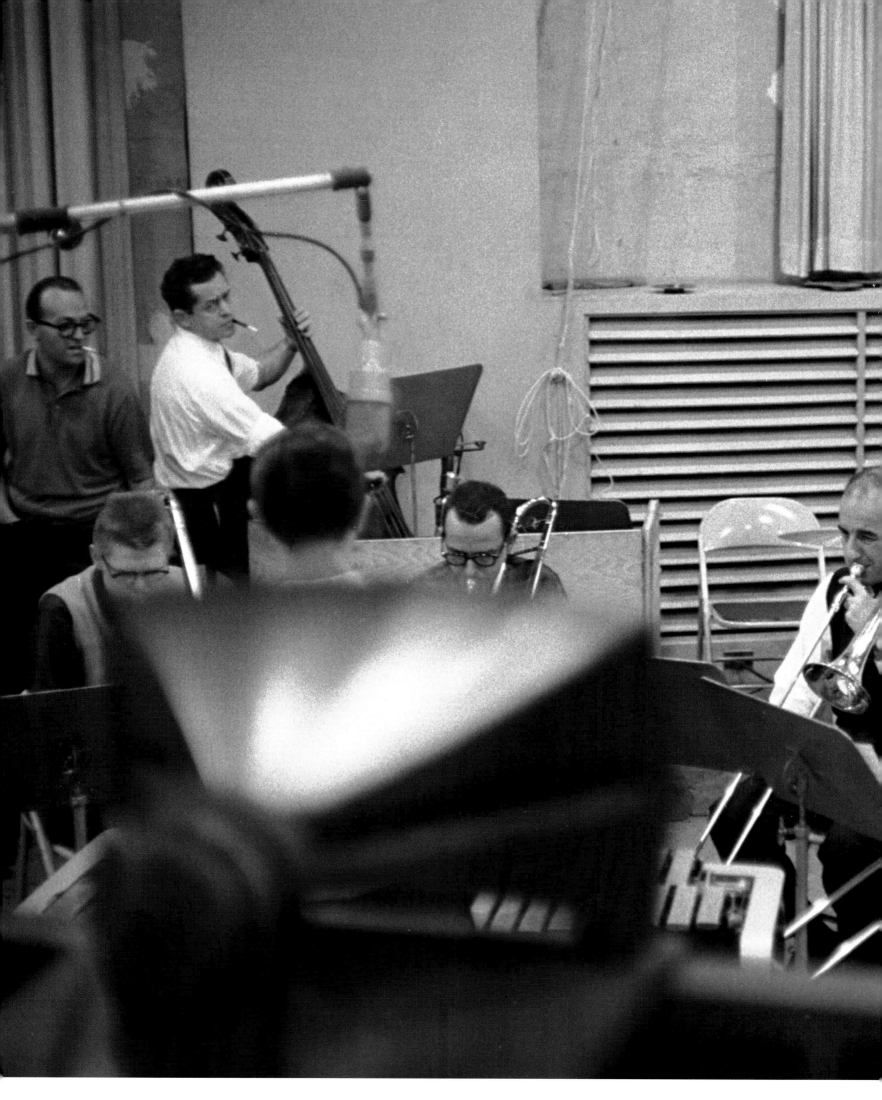

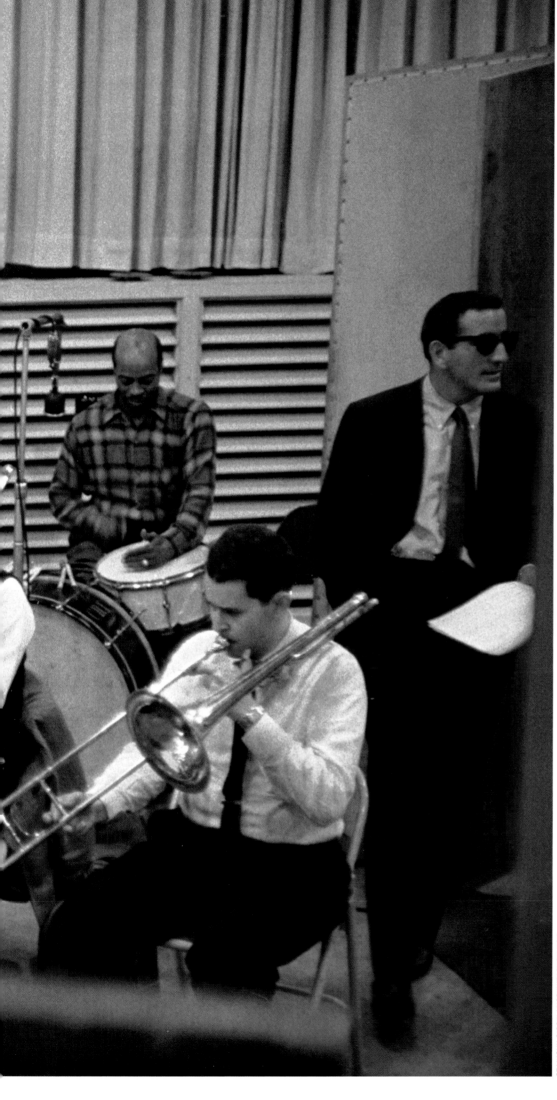

DON HUNSTEIN/SONY MUSIC ARCHIVES

ON THESE and the two pages immediately following are more pictures from late in that seminal year, 1957—a year of great stress, great art, and, with the *The Beat of My Heart* recording sessions, great change. "Ralph Sharon never played a wrong note for me through all those years," Tony says about his longtime pianist and partner in music. "And his advice [about jazz]! The music I made with Stan Getz, Bill Evans—the jazz giants—those are the best records I ever made in my life.

"I think what I was saying about music in 1950 is what I'm saying now," he continues. "I've never tried to follow a fashion."

In a way, he *couldn't*. The rhythmic colorations on *The Beat of My Heart* are, well, painterly. In evidence on almost every track is that bel canto technique that Tony had started working on at classes at the American Theatre Wing on the G.I. Bill, one that suddenly distinguished him from the pack. He would seek to imitate the sound of instruments. His drill in the 1940s was to try to sing like Art Tatum's piano, or Getz's tenor sax. The effort loaned his singing a dynamic musicality that he shared with no one.

At left he is in the recording studio on 30th Street in Manhattan in November 1957. On the following pages, he is backstage the following month, and back in the same CBS studio for other *Beat of My Heart* tracks with (clockwise from left) Ralph Sharon, Milt Hinton and Jo Jones.

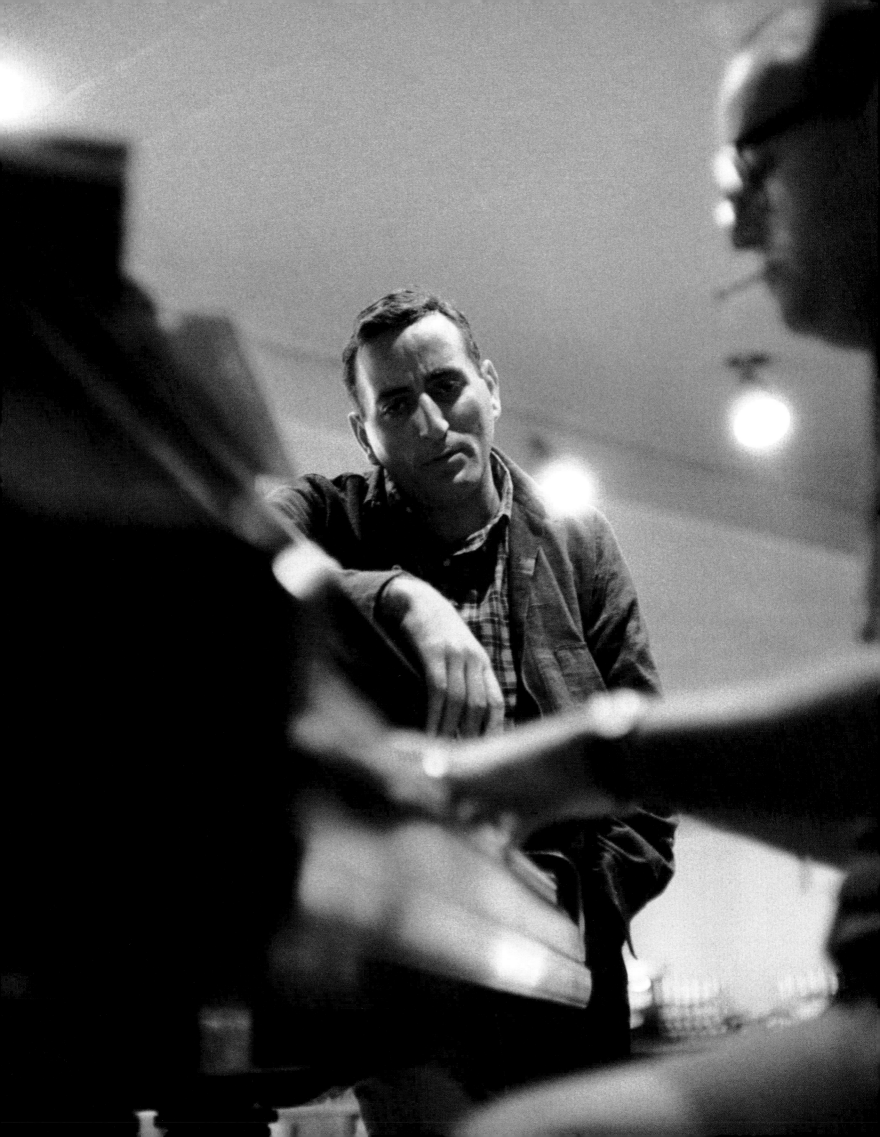

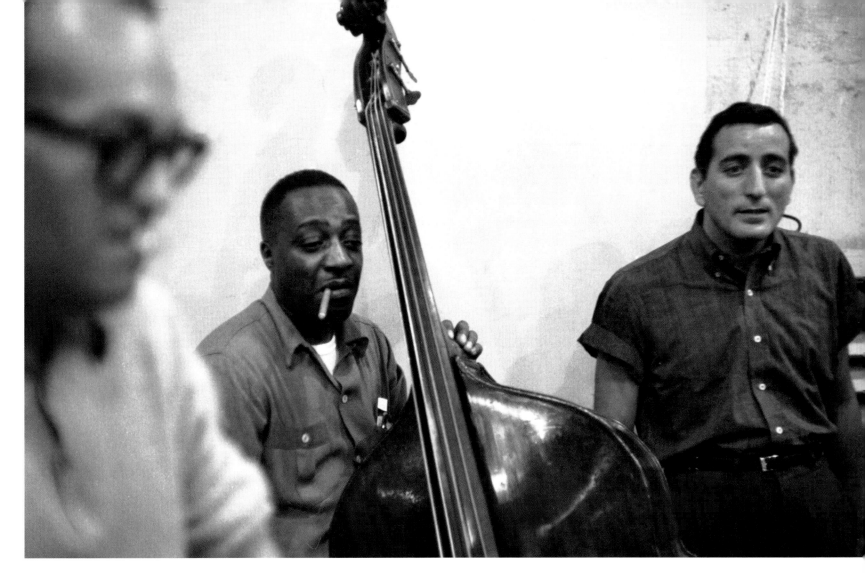

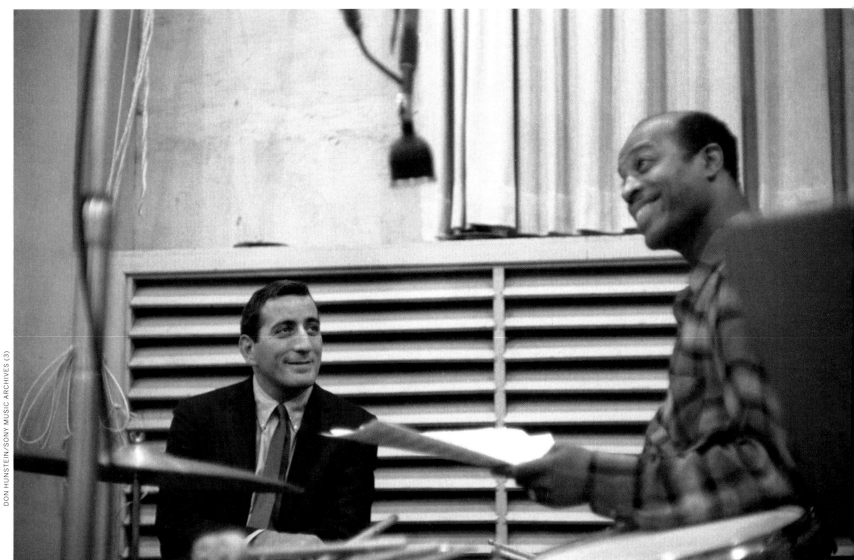

AS TONY HAS SAID EARLIER on our pages, he could sing loud—it is still his habit to do one song in concert, often "Fly Me to the Moon," a cappella and without amplification as an awesome demonstration of how a singer can project. During the years I have known Tony, I have seen this . . . I will not call it "a stunt," because it certainly isn't one . . . this feat several times now, even at an outdoor concert. So he had the voice and now the technique and he was singing adventurous music, but also—he was flying. As we'll see on the next several pages, Tony Bennett could be wild. And he would remain thrilling his entire career.

Fast-forward for a moment to the autumn of 1994. A pumped-up Tony is sailing through two and a half hours of standards—the same stuff he was singing in '64, and in '54, '74 and '84 too—before a packed house in Manhattan. This is the taping of his now famous *MTV Unplugged* special. Tony is, at that moment, among the hottest things in show business. His concerts are sellouts, and he has won Grammys for Best Traditional Pop Vocal Performance in 1992 and '93. The sound track of tonight's MTV show will go platinum overnight and will win the 1994 Album of the Year award, which will be given out at the March 1 ceremony in L.A.—a month after Tony sings at the Super Bowl.

At age 68, he becomes the darling of the green-haired alternative-music crowd. He's finger-snapping away, playing gallant host to the offspring of those very rockers who shunted him aside in the '60s. After a solo set, Bennett performs affecting duets with, among others, two modern singers who would become friends, K.D. Lang and Elvis Costello. After singing a Gershwin song with Bennett, Costello hangs out beneath the bleachers, watching, offering commentary to no one in particular. "The man's amazing," he says, shaking his head. "A pro. Truly great! His rhythm, his style, the way he grabs a tune . . ."

All of this was already there back when he was recording *The Beat of My Heart.* At right: In the studio with percussionists Candido and Sabu in October 1957. On the pages immediately following: The gang at a press party at the Latin Casino in Philadelphia in November of the same year.

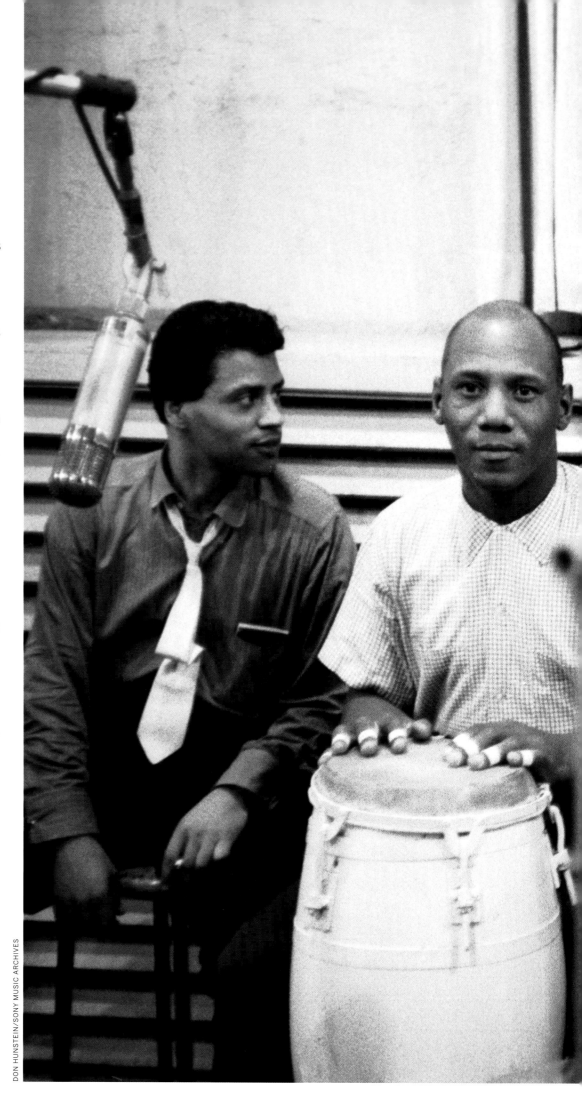

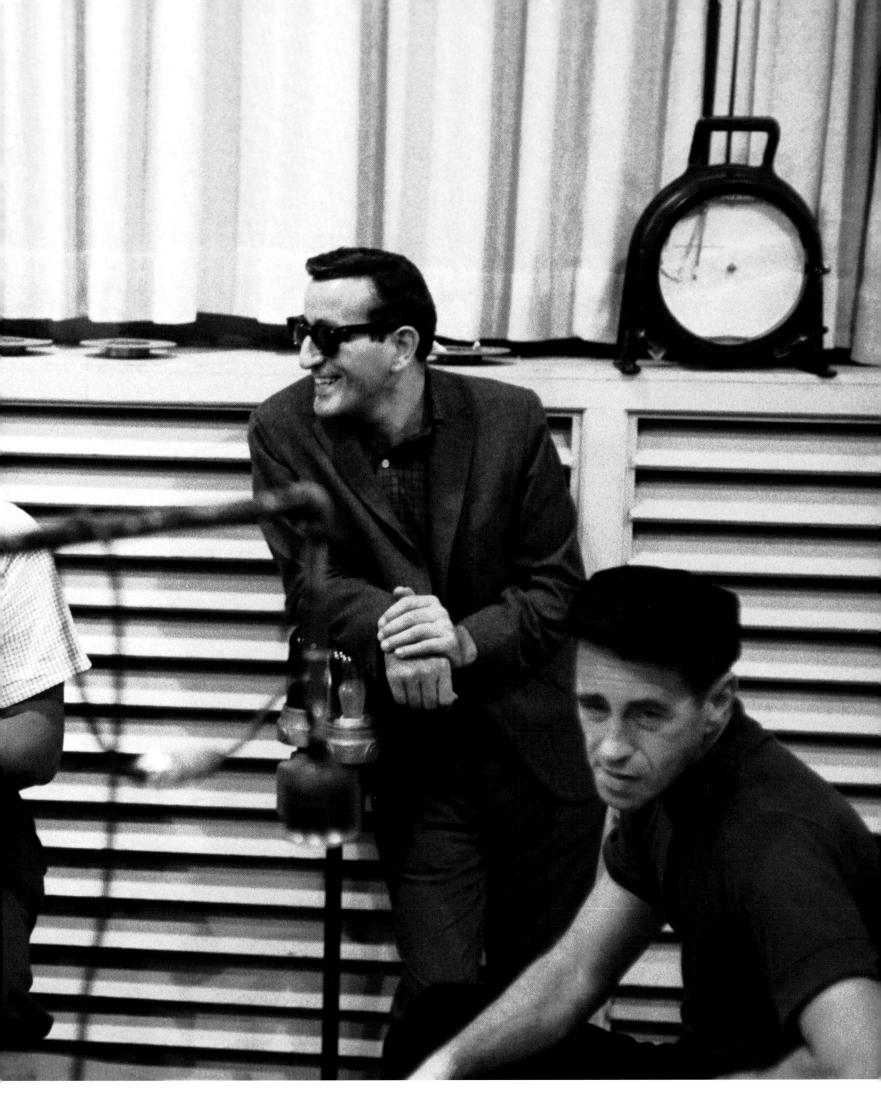

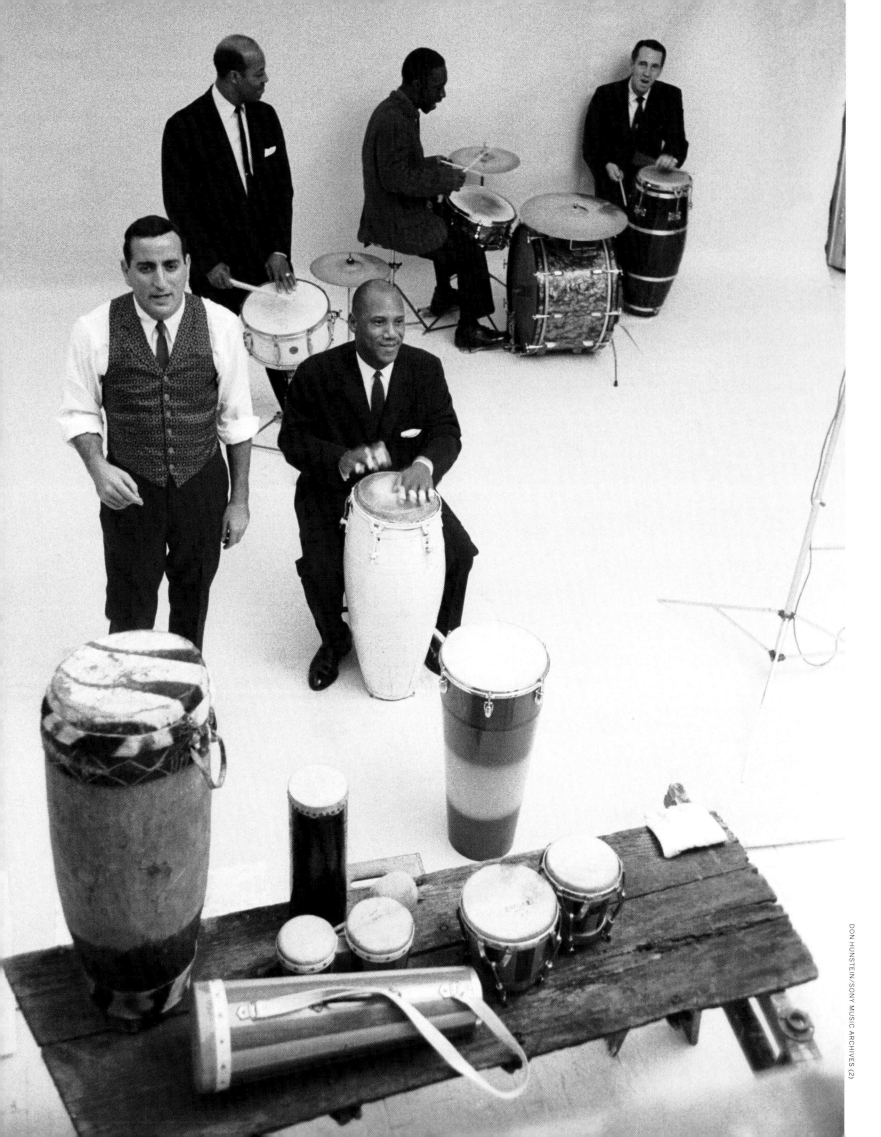

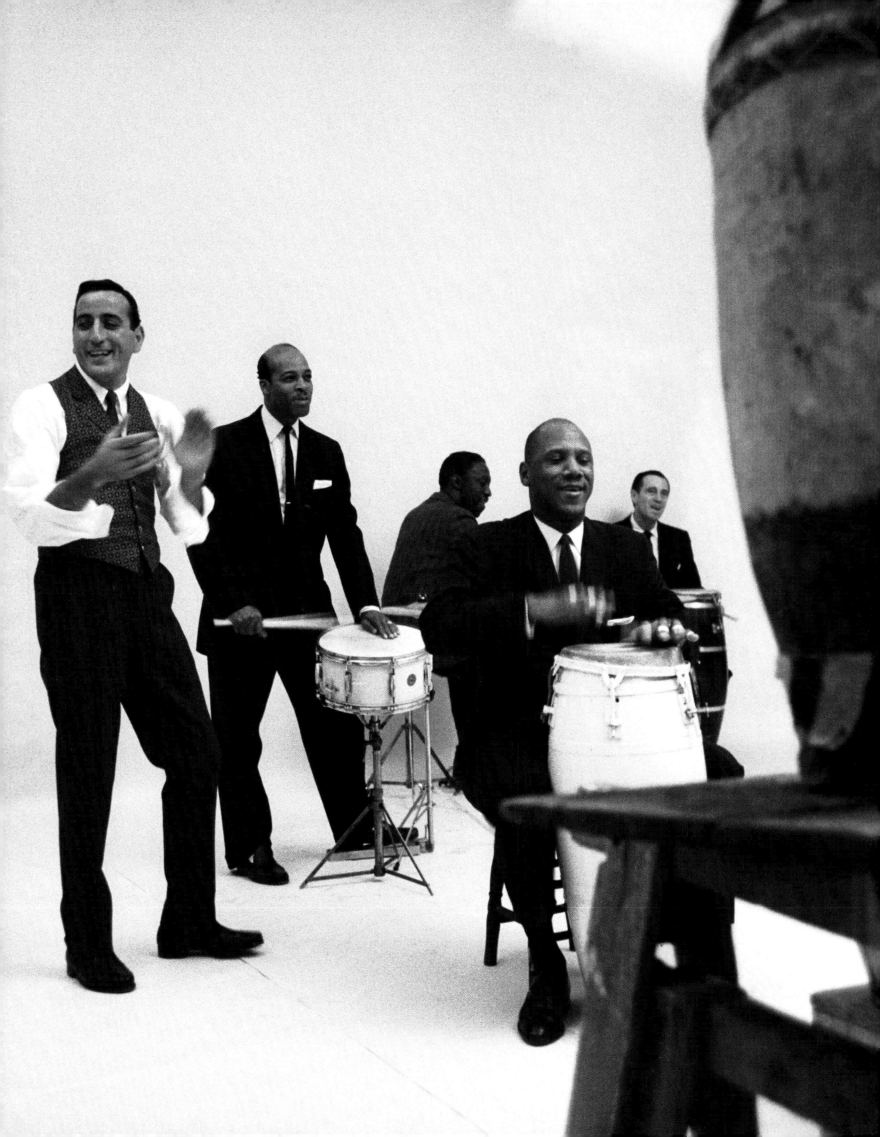

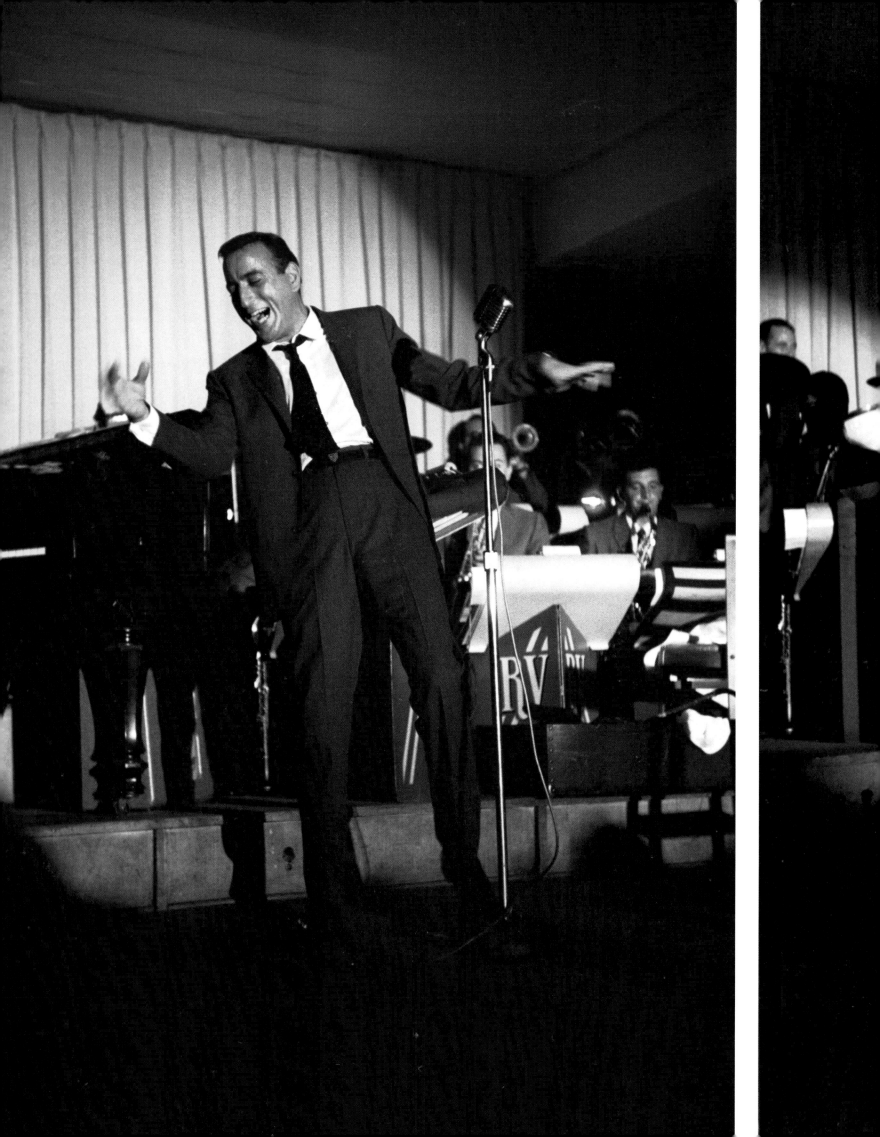

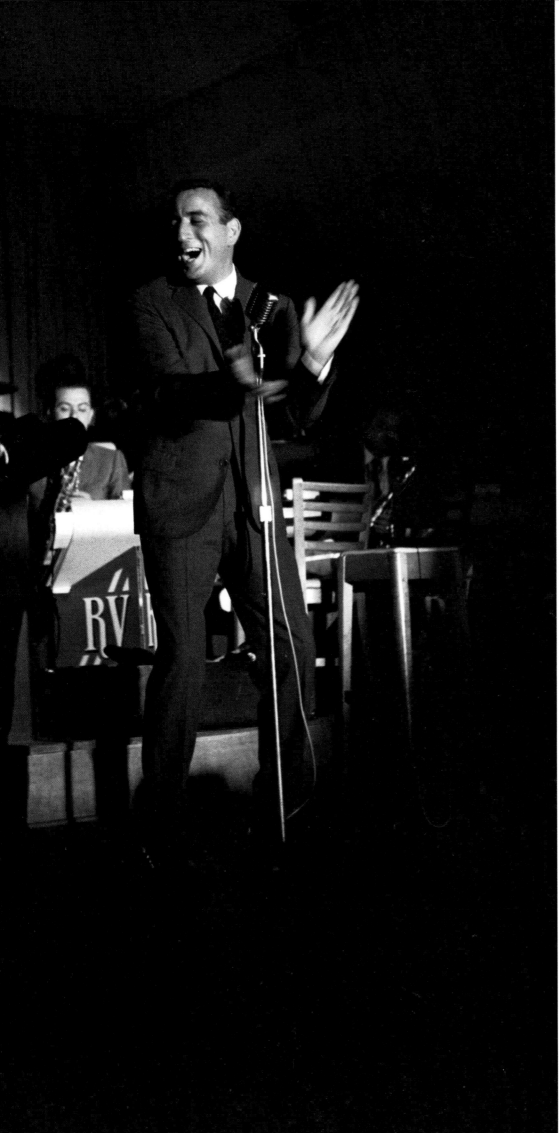

THE PICTURES on these two and on the following six pages capture just how exciting Tony Bennett was at the tail end of 1957—an excitement that he still stirs today, in perhaps a less knee-shaking, more debonair style. What isn't conveyed in the photography but was just as important to the audience was and is Tony's choice of material. He always wanted to stick with, as his mother had when making dresses, "quality," what he saw as "quality." As we will hear in later pages, this became a bone of contention when the fashion changed to rock music and Columbia asked Tony to change as well. But here, in these pictures from the late 1950s, where he's swinging like nobody's business, he's singing *standards.* And he's making them his own.

"I've always gone back to an old piece of advice," Tony says, during that first lunch we enjoy at the Metropolitan Museum of Art. "Fred Astaire told me, 'Look at the song through the composer's eyes. Then look at it again with a new idea, but one that's true to what was intended.' See, it's like this." He leans in, and sings lightly as he snaps his fingers. "The way you wear your hat!" It's amazing: His speaking and singing voices are so similar, yet this one floats and flies. The very moment he starts to sing, he becomes the guy on the stage, even as he sits here in an empty dining room. "Or you can think it through again, and do this." He pauses, downshifts. "The way you wear your *hat* . . ." It's a slow rendering with a backbeat, the last word emphasized—it's the version from his 1993 Astaire tribute recording.

"See?" he says.

He's happy. He has shown what he can do, a master's trick of the trade. "It breathes differently."

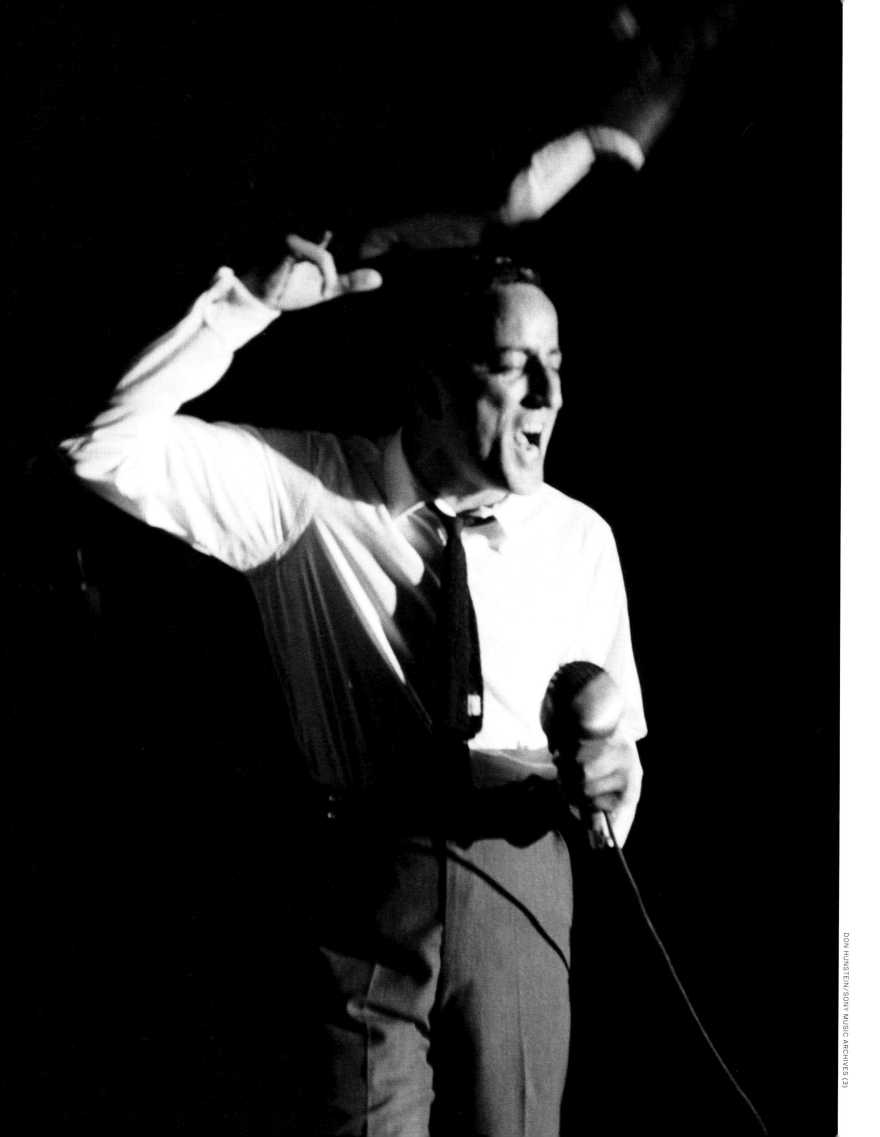

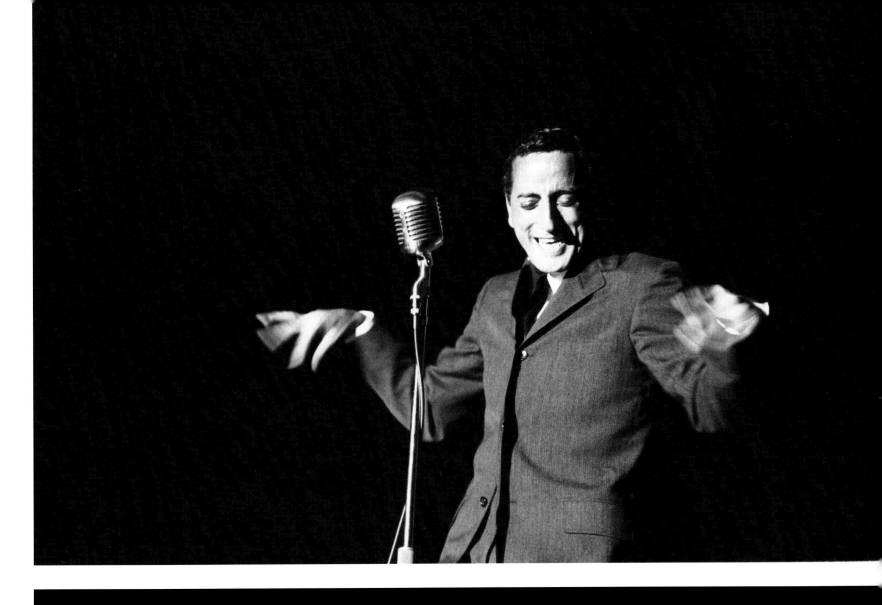
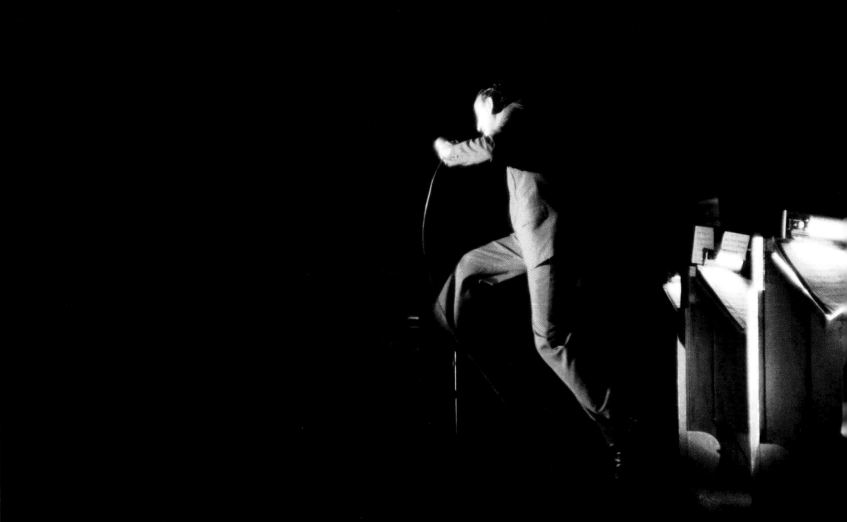

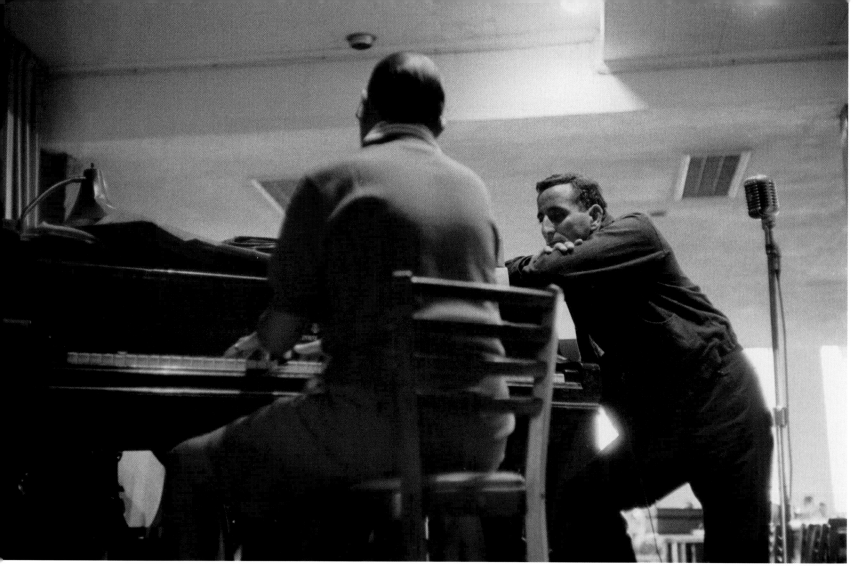

OPPOSITE, above and on the two pages following, where he's mobbed by fans: More from December 1957. We dwell on this year for many reasons: the arrival of pianist Ralph Sharon, the forthright foray into jazz, the continued ascent of Tony Bennett, the frenzy surrounding him and, unseen here but not unheard, Elvis Presley. In this year, Tony releases successful recordings of "Lazy Afternoon," "Ça, C'est l'Amour" and an all-time great version of "I Get a Kick Out of You." Elvis, meanwhile, blows up the charts with "All Shook Up," "Jailhouse Rock," and "(Let Me Be Your) Teddy Bear." Rock had been rumbling and now seems ready for a rumble. Tony isn't done yet, though, and never will be. But it will take perseverance as the chapters continue to unfold.

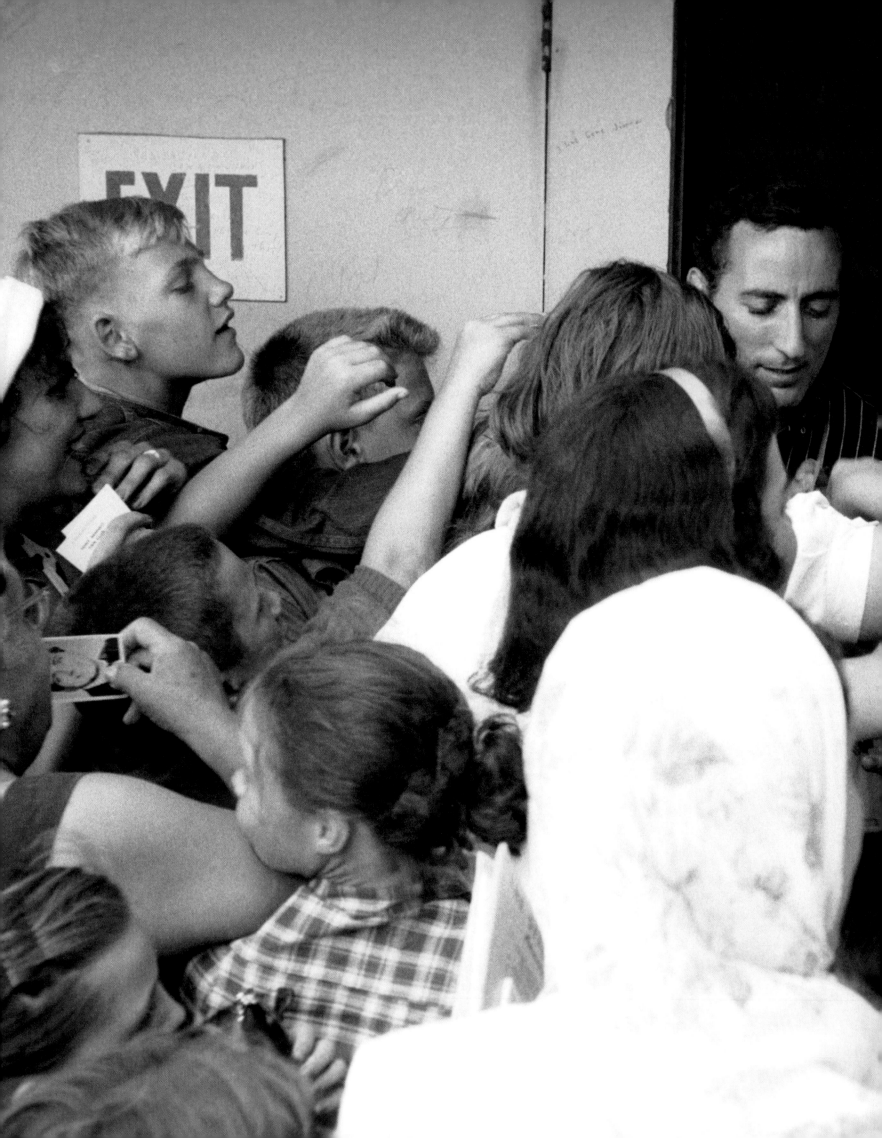

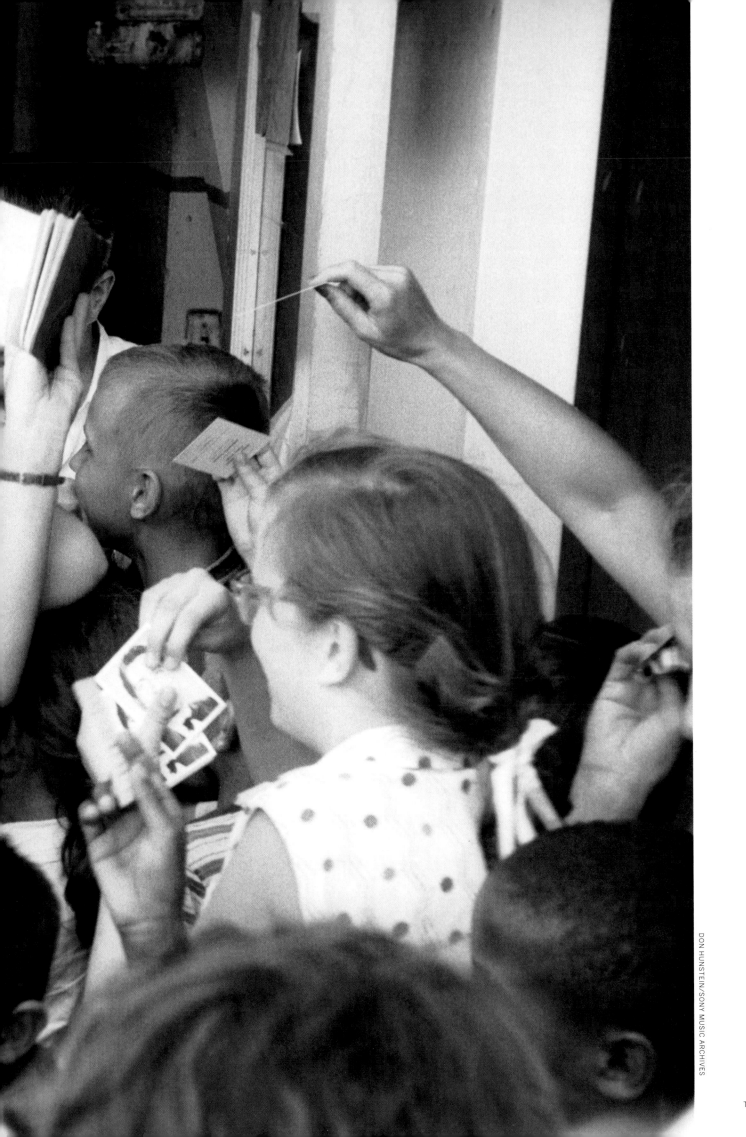

AS TONY LOOKS to the future in this period, what is he thinking? He's probably very happy and assured of the road ahead. "After I recorded ["Ça, C'est l'Amour"], I received a letter from Goddard Lieberson [head of Columbia Records], the first ever in all these years, in which he said how much he enjoyed my performance and, if it were up to him, he would like every Columbia record to sound like this." No one, not least Tony, could have anticipated that more than a decade hence he would be pressured by Clive Davis, the new head of Columbia Records, to change his sound—to develop more of a rock persona and sing covers of rock songs. For the moment in 1957, all is looking up, and if the head winds are stirring, they aren't yet any kind of serious worry.

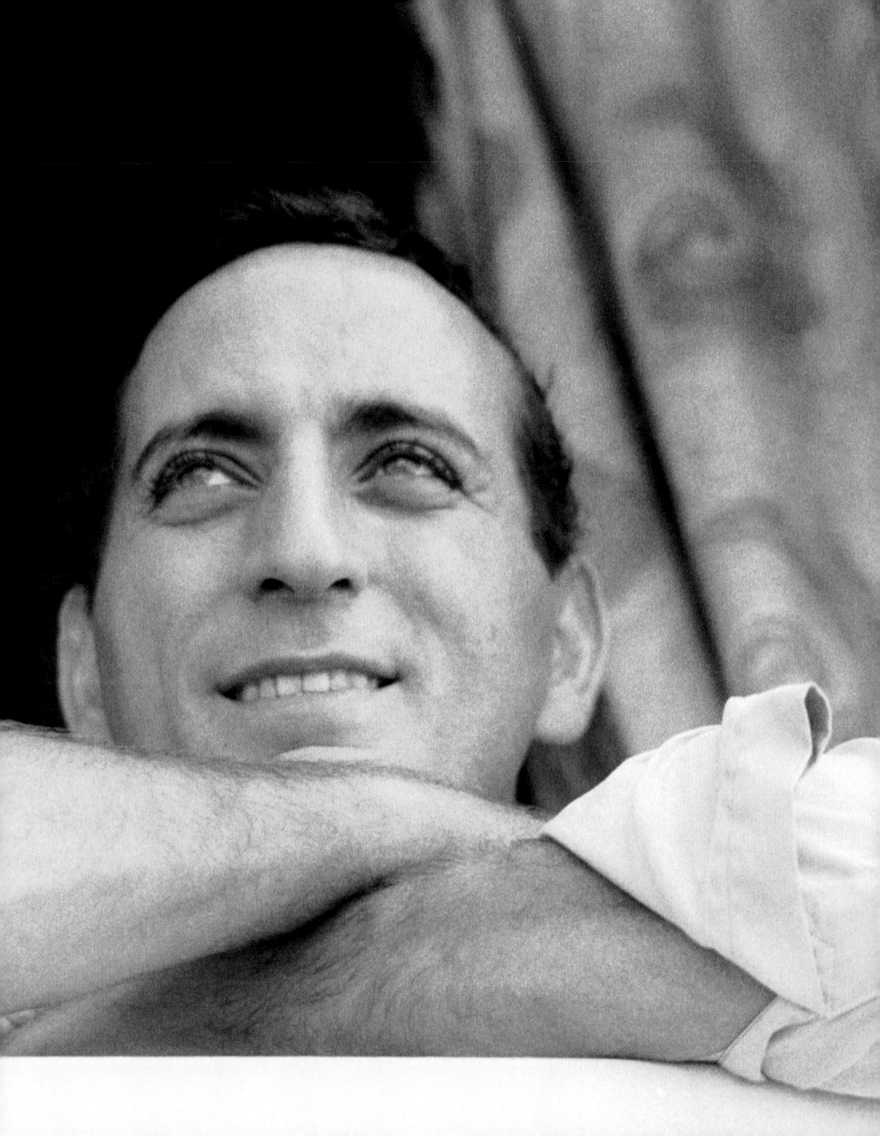

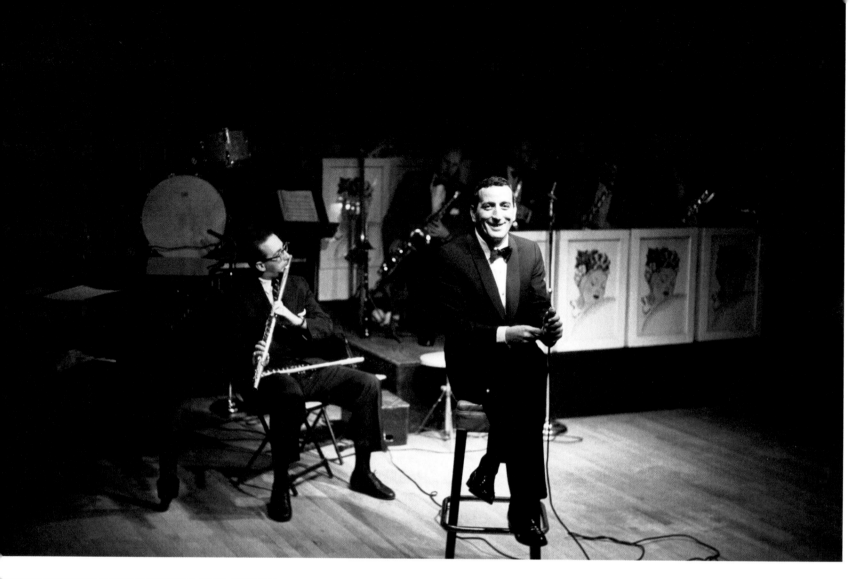

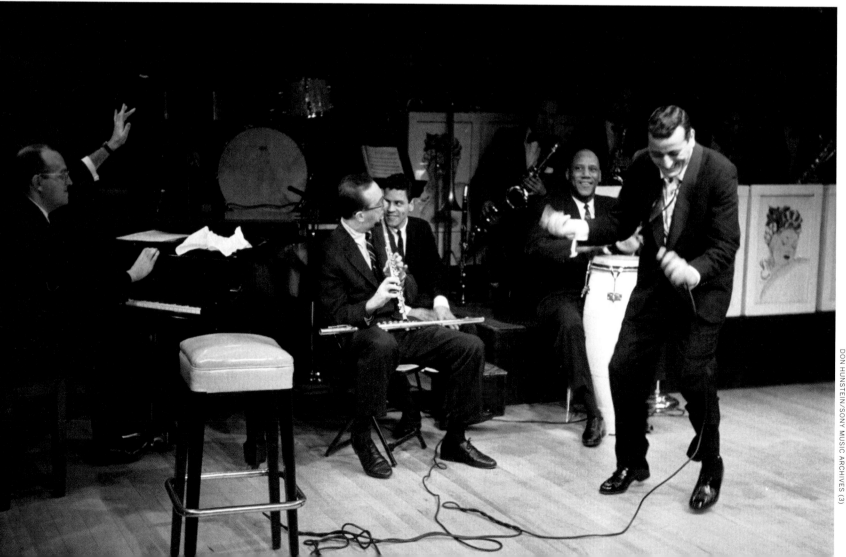

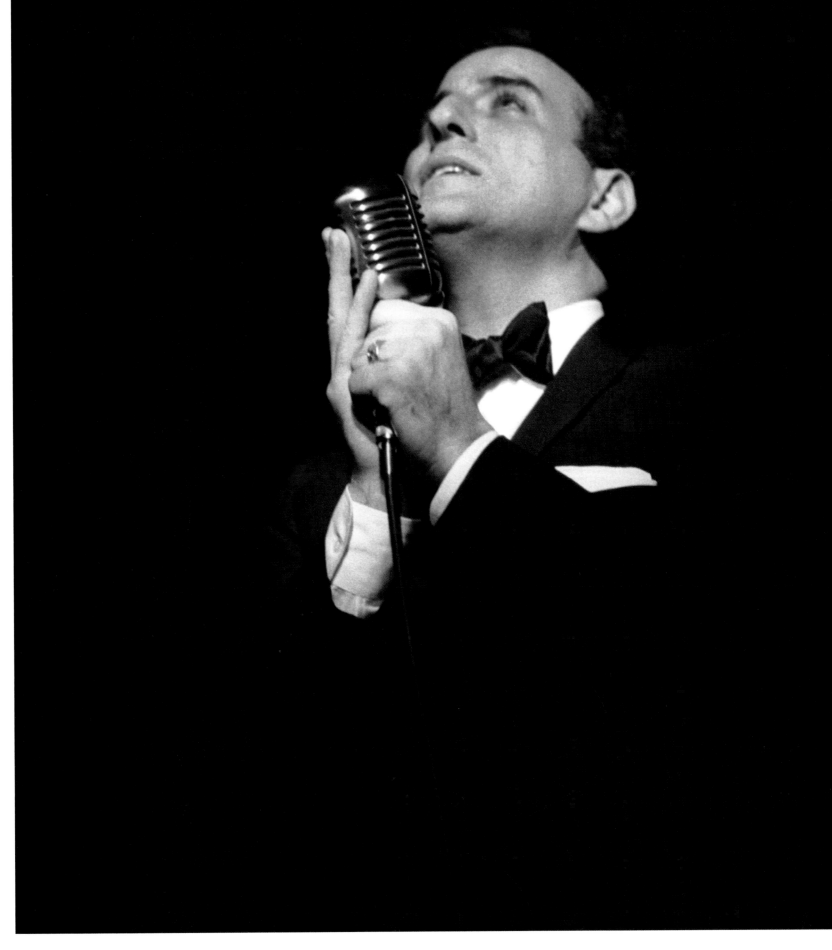

BACK AT THE COPACABANA in New York City, opposite, in March 1958, and above, in December of that year. Tony records just around then an interesting song, "Penthouse Serenade," too little heard at present, and he later says of it: "In the 1950s, Goddard Lieberson's premise was to search for lasting, timeless, top quality in the recordings that were released on Columbia. Because of this, I found myself surrounded with some of the best musicians in America. Among them, and the best ever at the time, were [conductor] Ralph Burns and his alumni, all graduates of the Woody Herman band. What an unforgettable group—Al Cohn, Zoot Sims, Urbie Green, Eddie Costa—all great New York musicians. I never felt freer or more natural than when I sang with these guys."

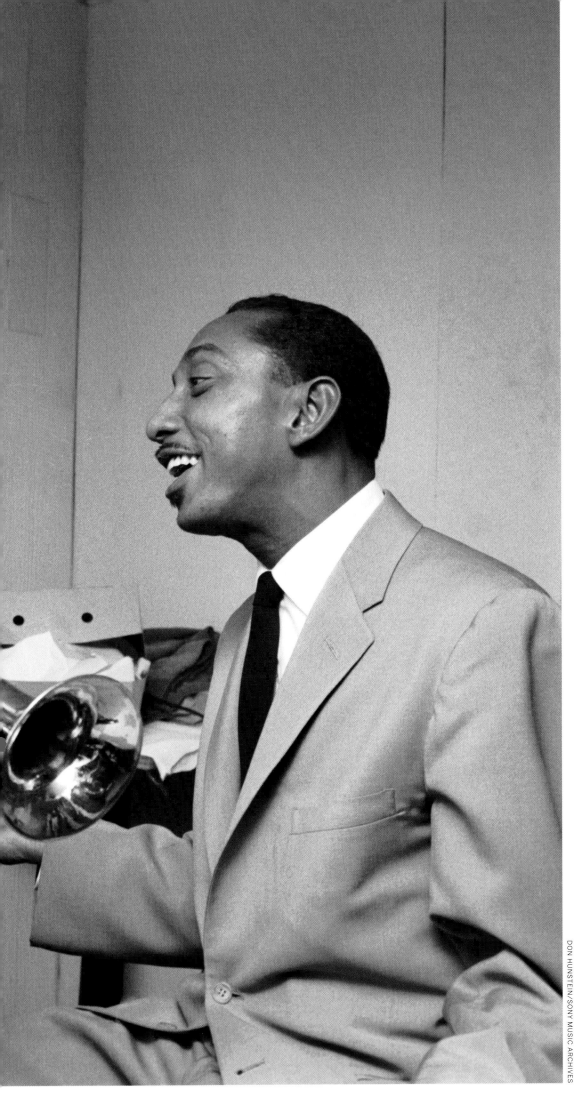

TONY SINGS with the Count Basie Orchestra at the Latin Casino in Philadelphia in December 1958, and hams it up backstage with trumpeter Joe Newman, left. "More and more my musical experiences led me to unexpected thrills, like being the first white singer to ever appear on stage with the great Count Basie. Talk about having fun, being with jazz greats like Sonny Payne, Joe Newman, Thad Jones, Snooky Young . . . Those were never-to-be-forgotten days." The days yielded an album, *In Person!,* that yielded Tony's renditions of "Lost in the Stars," "Lullaby of Broadway," "Firefly" and others. Jazz in this period was morphing just as "pop music" was, but the more avant-garde bebop players, too, appreciated what Tony brought to the table. Said the late trumpet giant Dizzy Gillespie, "Talking about Tony Bennett is the same as a finished musician playing a solo, you don't need 25 choruses to get your message across. I can tell you in a few words. I think Tony's spirituality is so profound in his performance that it cuts through everything superfluous, and what is left is raw soulfulness. Because his philosophy of life is so basic the moment he opens his mouth to sing you know exactly what he is—a prince. I really feel that guy." On the following pages: in January 1960, when he would record, among other things, a beautiful rendering of "Begin the Beguine" that would confirm every word of Dizzy's testimony.

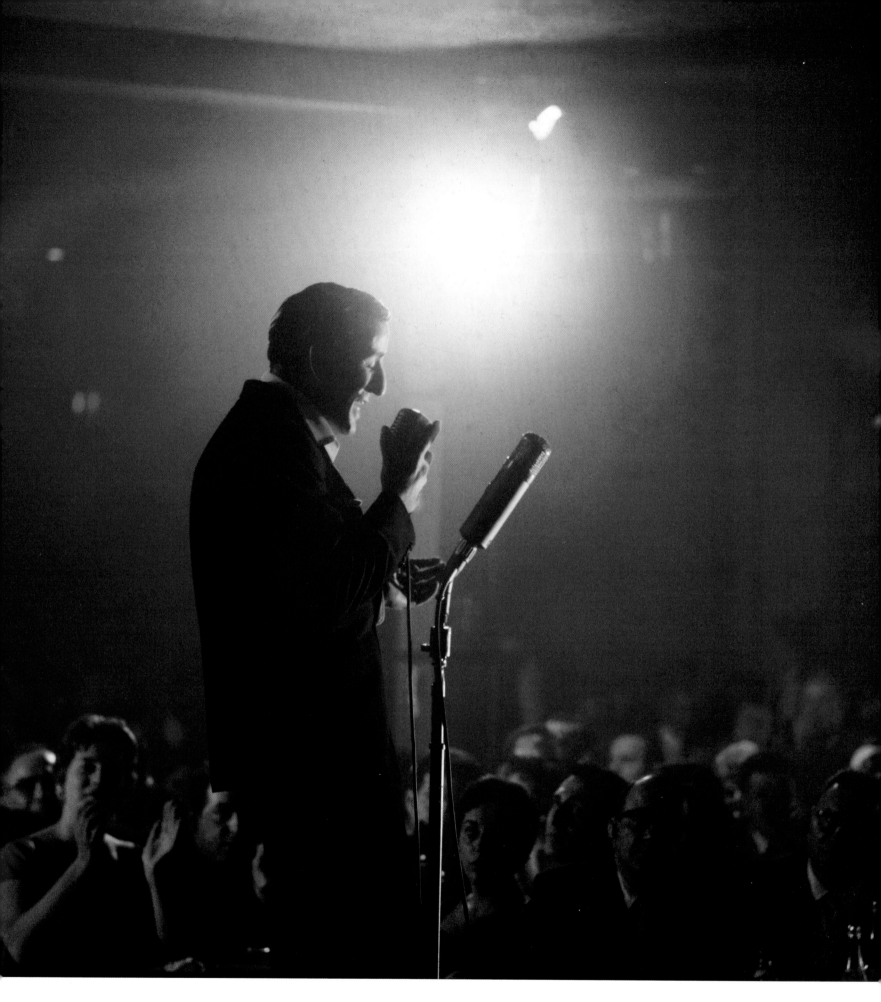

IN JANUARY 1960, Tony is still
fronting the Basie band and clearly, as these
two pictures testify, having a ball. On
the following pages, in the same year, he is
belting out at the opening of the Cloister, a

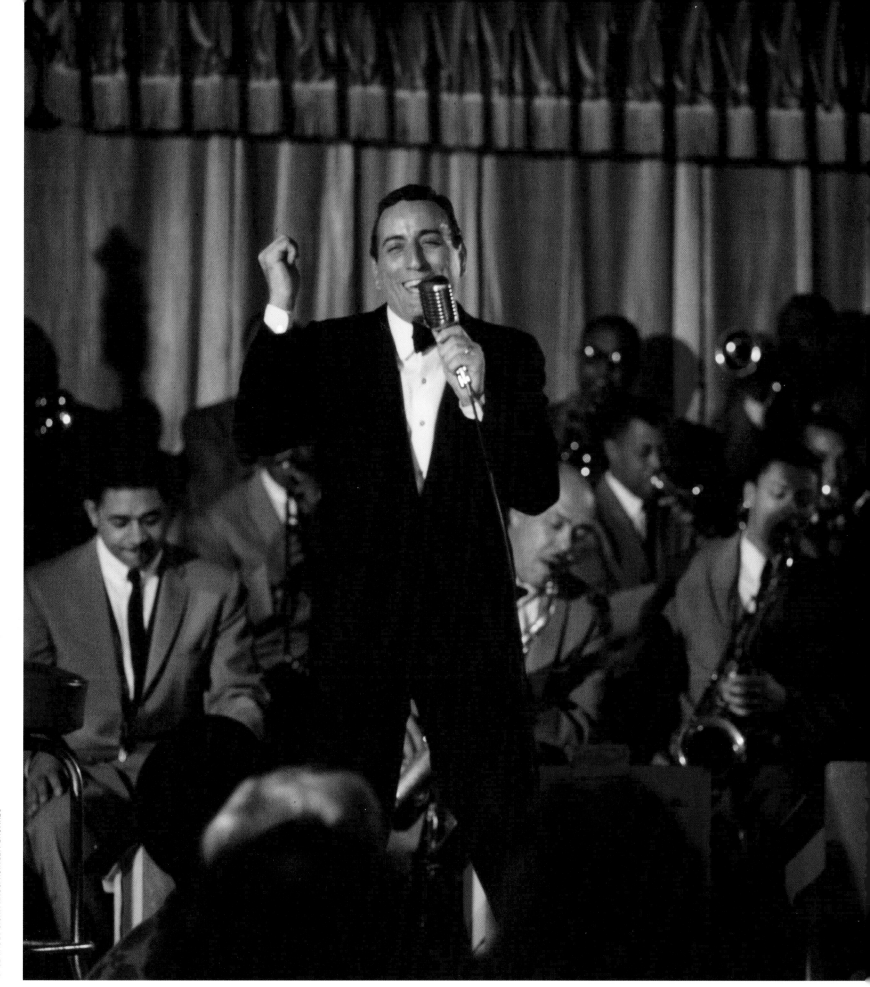

nightclub in Hollywood, in 1960. He records this year songs that would become staples in the performance: "Put On a Happy Face"— "one of the few happy novelty songs I enjoy singing"—"This Time the Dream's on Me"

and "The Best Is Yet to Come." He would say about that last record: "In Tin Pan Alley parlance, this is what we call a 'swinger.' When I recorded it, I had no idea what would happen with it until one morning, some years

later, I turned on the radio: The astronauts who were about to land on the moon were asked how they felt, and they played my recording of 'The Best Is Yet to Come' as an answer. Now, that was . . . far out."

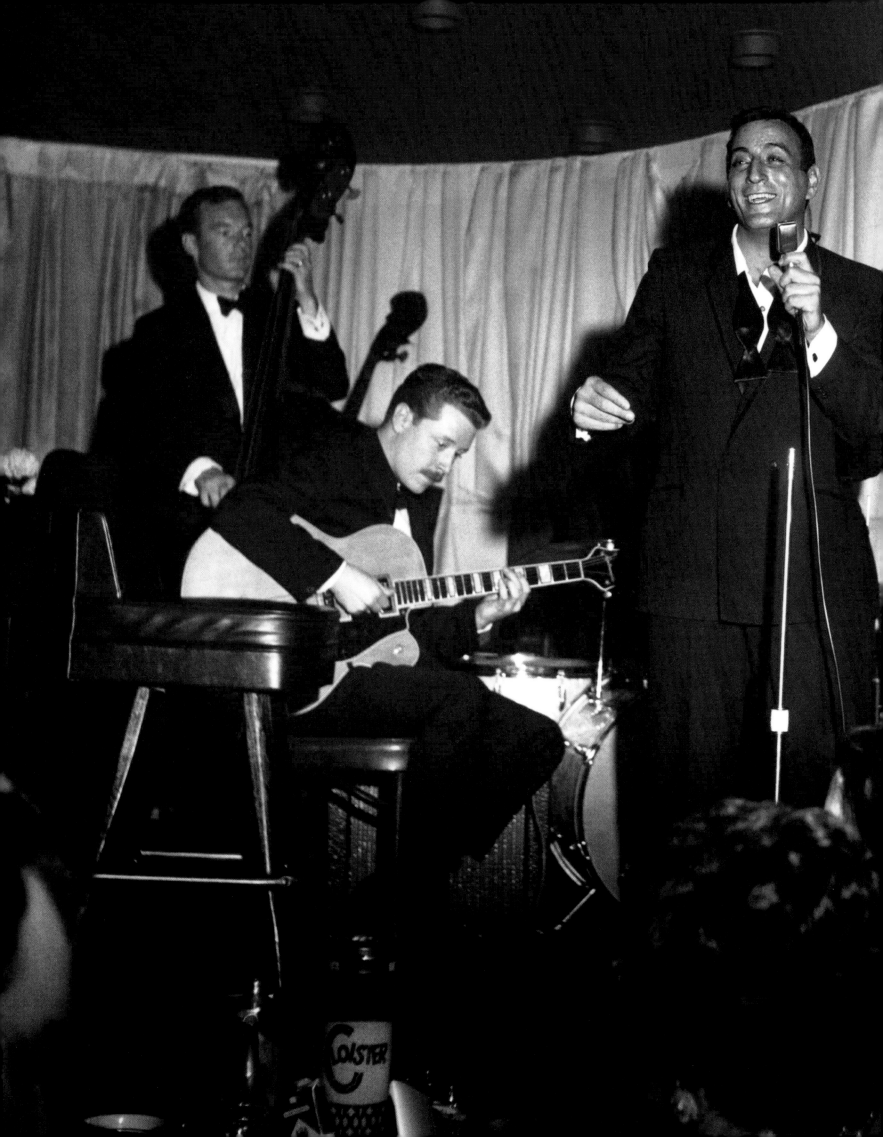

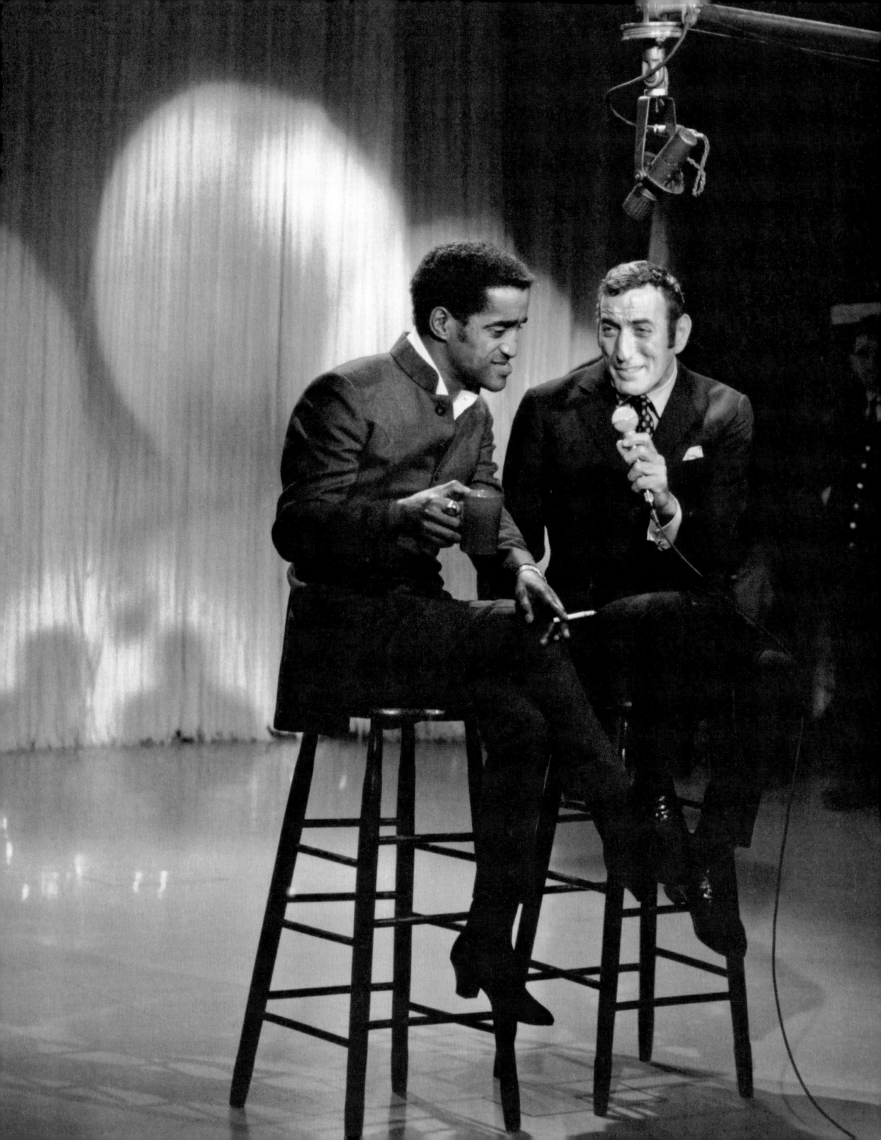

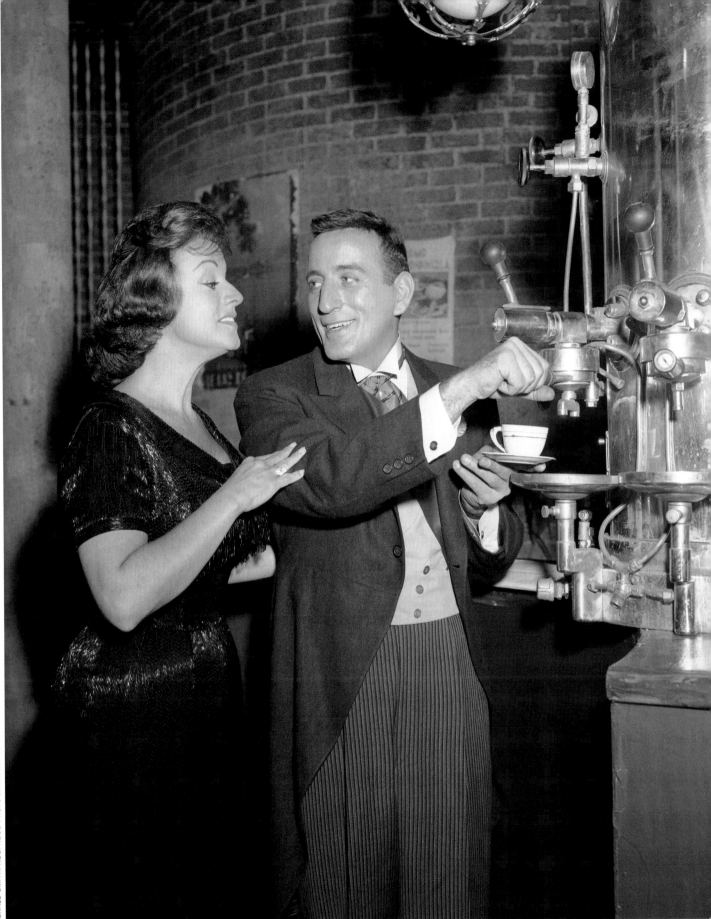

LIKE MANY AN ENTERTAINER, Tony branched out into different forms of entertainment. We'll get to the movie thing—the brief movie thing—a few pages on, but as for TV: He had a gig for a few weeks as host of a network television show, and at left he is back on the small screen circa 1960 with his friend Sammy Davis Jr. (He emphasizes to me at one point, though: "I wasn't in the Rat Pack. I was in New York; they were there. I had my singing and painting, and with the hours they kept—*whoa!*—it's just as well I wasn't in that scene.") Above: He is appearing on an episode of Dinah Shore's *Chevy Show,* pouring for Kay Starr.

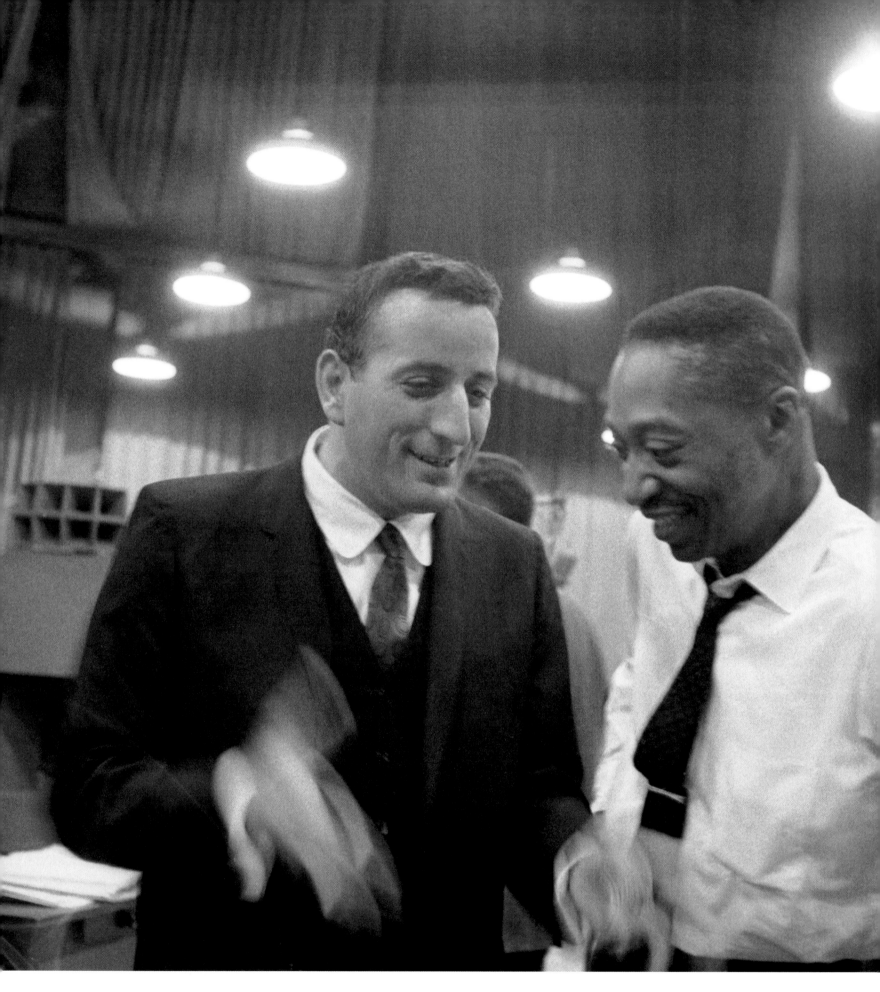

ON APRIL 5 AND 6 OF 1961, Tony enjoys wonderful sessions, seen in these two pictures (above, with drummer Art Blakey), that yield "Close Your Eyes," "Toot, Toot, Tootsie! (Good-bye)," "Dancing in the Dark" and "Stella by Starlight," among others. The first two numbers had "my favorite entertainer, Zoot Sims, on saxophone." The latter two were also included on the album *My Heart Sings.*

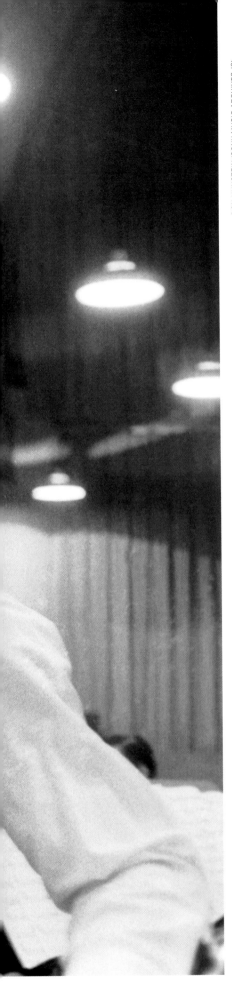

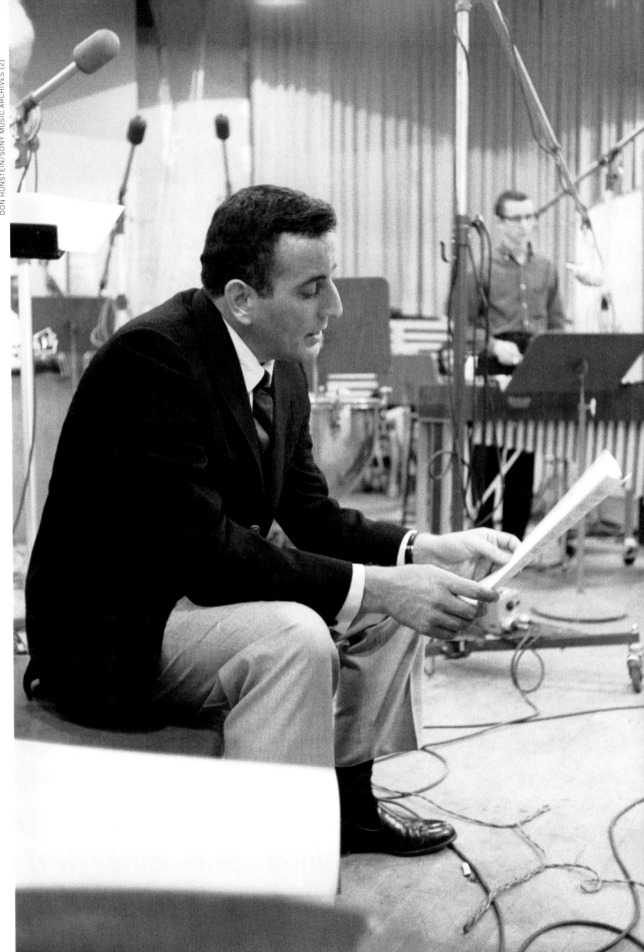

"There is an amusing anecdote about 'Dancing in the Dark,'" Tony recalls. "Arthur Schwartz [the late composer, and radio host Jonathan Schwartz's father; Howard Dietz wrote the lyrics] was in Britain once, at the BBC Radio 2, and the radio personality was playing his recording of the song. In the same booth was a rock 'n' roll artist, a very nice man, who said to Mr. Schwartz, 'Is that your song playing right now? It sounds wonderful. I wish you a lot of luck with it!'" Schwartz and a hundred different singers, including Tony Bennett on more than one recording, have had fine luck with the magnificent "Dancing in the Dark."

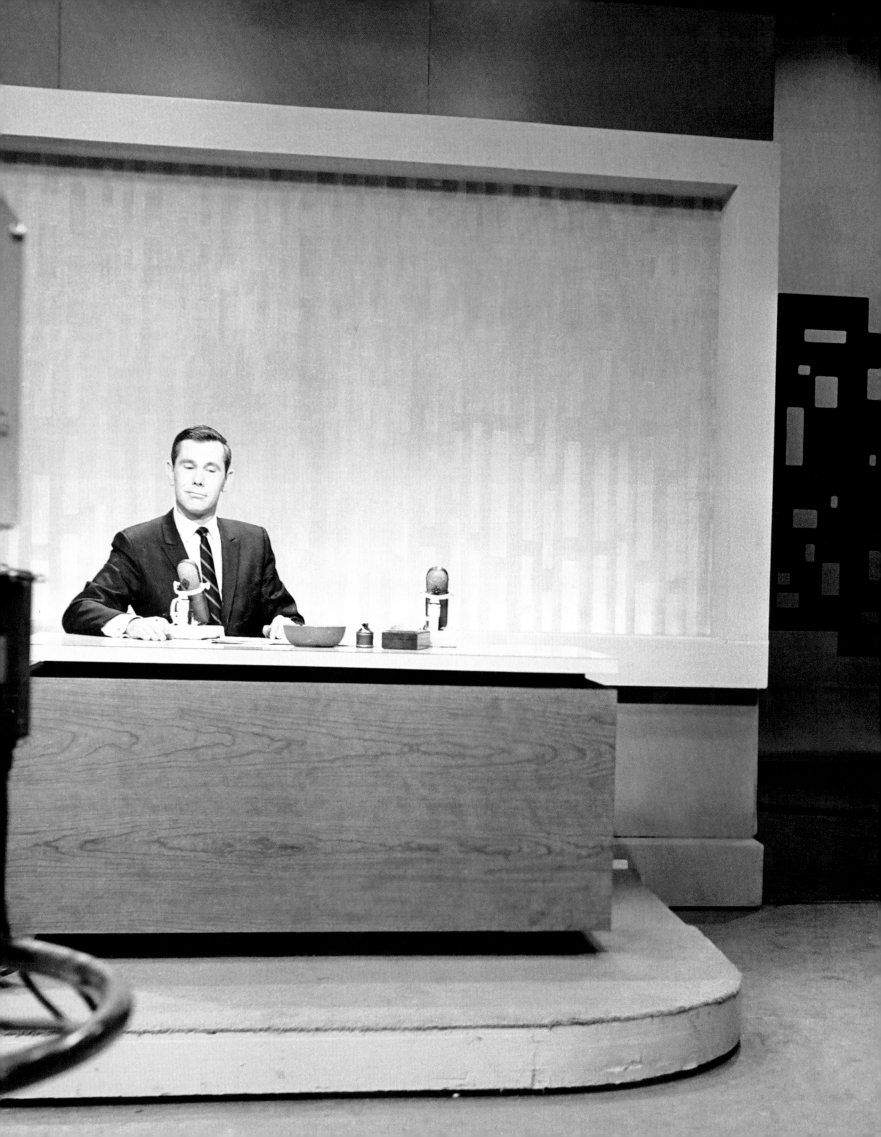

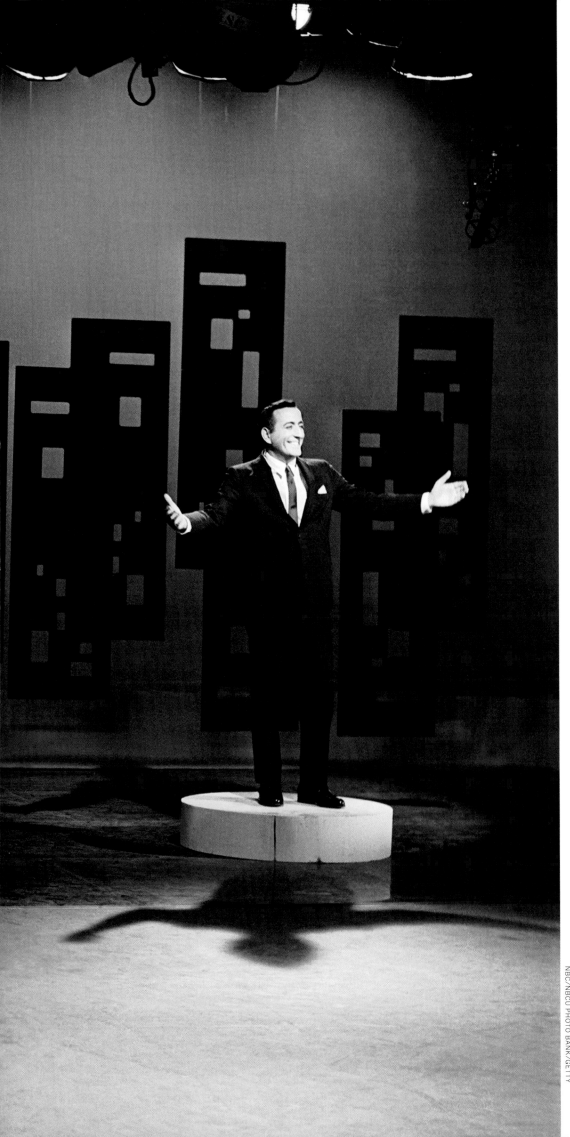

ON JANUARY 23, 1962, Tony recorded "I Left My Heart in San Francisco." It was just what a crooner's career needed as rock 'n' rollers were edging out the prior generation. The same-titled album, released in June, was a hit and the single climbed into the Top 20; it would sell more than 2 million copies, win Tony his first two Grammy awards and become his signature song. In June of '62, the tremendous live double disc, *Tony Bennett at Carnegie Hall*—still regarded as one of the finest live pop albums of all time—is recorded. Here, at left, on October 1 of the same year, Tony happily drinks in the applause during the very first episode of *The Tonight Show with Johnny Carson.* Tony tells the story behind the career-shaking song: In the early 1960s, he is still making great music, but is admittedly playing smaller venues—for instance, the Fairmont Hotel in San Francisco. In anticipation of a stint there in 1961, his arranger Ralph Sharon asks George Cory and Douglas Cross, two songwriting partners who had spent time in San Francisco in the '50s, whether they had anything that might strike a Bay Area chord. "Well, we've got this seven-year-old tune called 'I Left My Heart . . .'" Tony, who wears a constant half-smile when it's not a full-blown grin, beams as he talks about that song: "Thank God I like it. I don't think I've ever left it out of a show. I sing it every night."

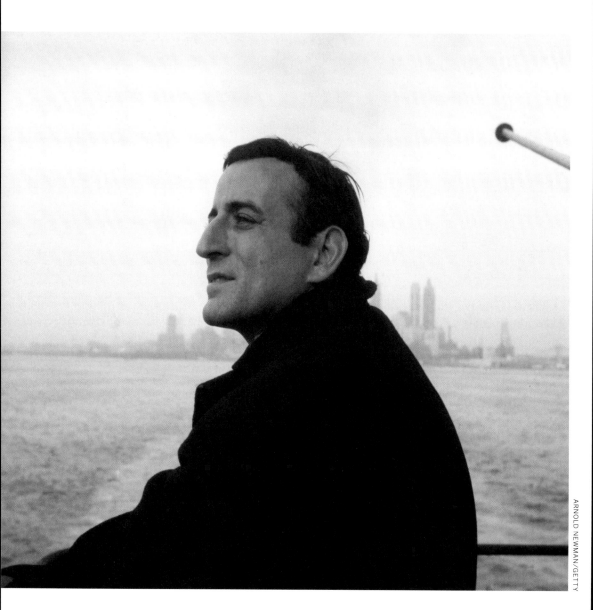

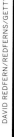

ARNOLD NEWMAN/GETTY

DAVID REDFERN/REDFERNS/GETTY

TONY IS ASSOCIATED with locales—New York City and (since 1962) San Francisco in particular—but he has for more than a half century been a global celebrity; his tours in 2013 took him to, among many other places, mainland China for the first time. "Remember last summer?" Susan asks Tony during that lunch we three share at the museum. "In Siena. We were at this museum, and all these American kids just mobbed you. It was like you were the Beatles." In these portraits he is pictured close to home (above, off Staten Island, New York) and in Britain, a place that he will later call home for a while—as we will learn.

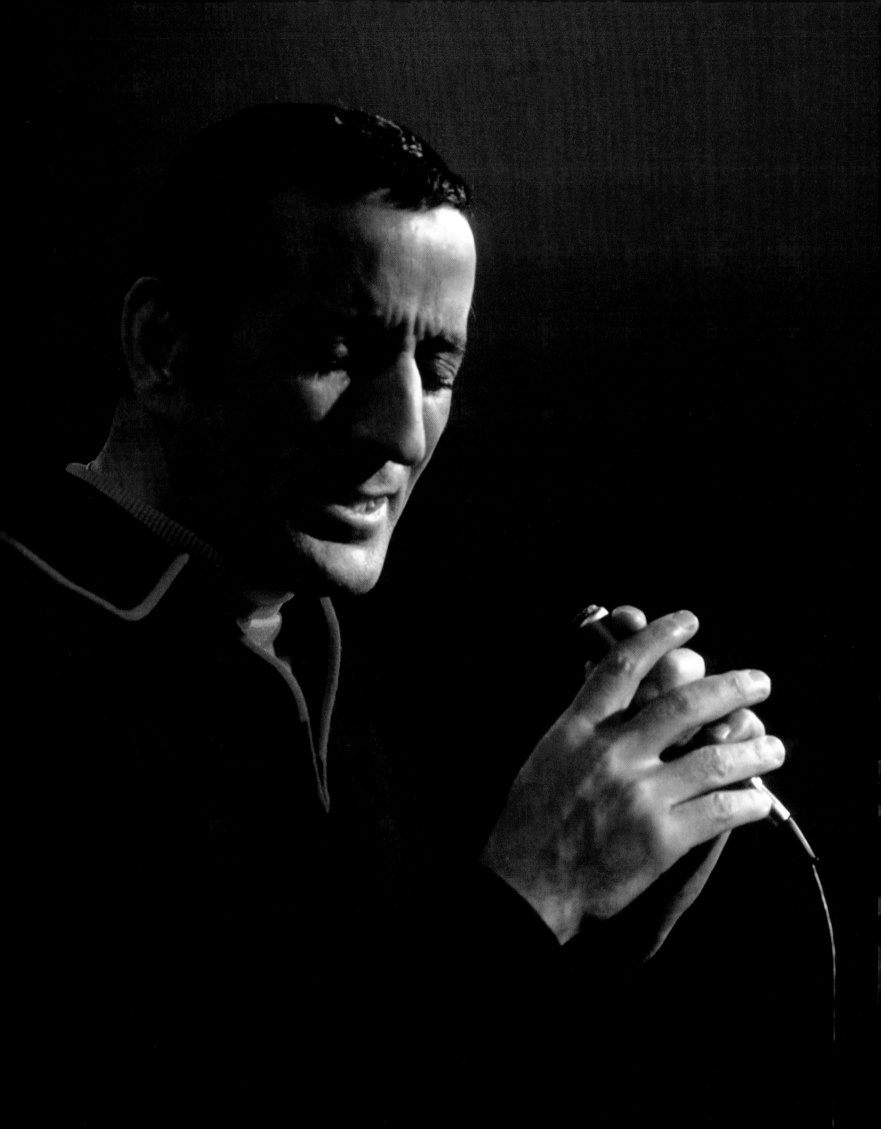

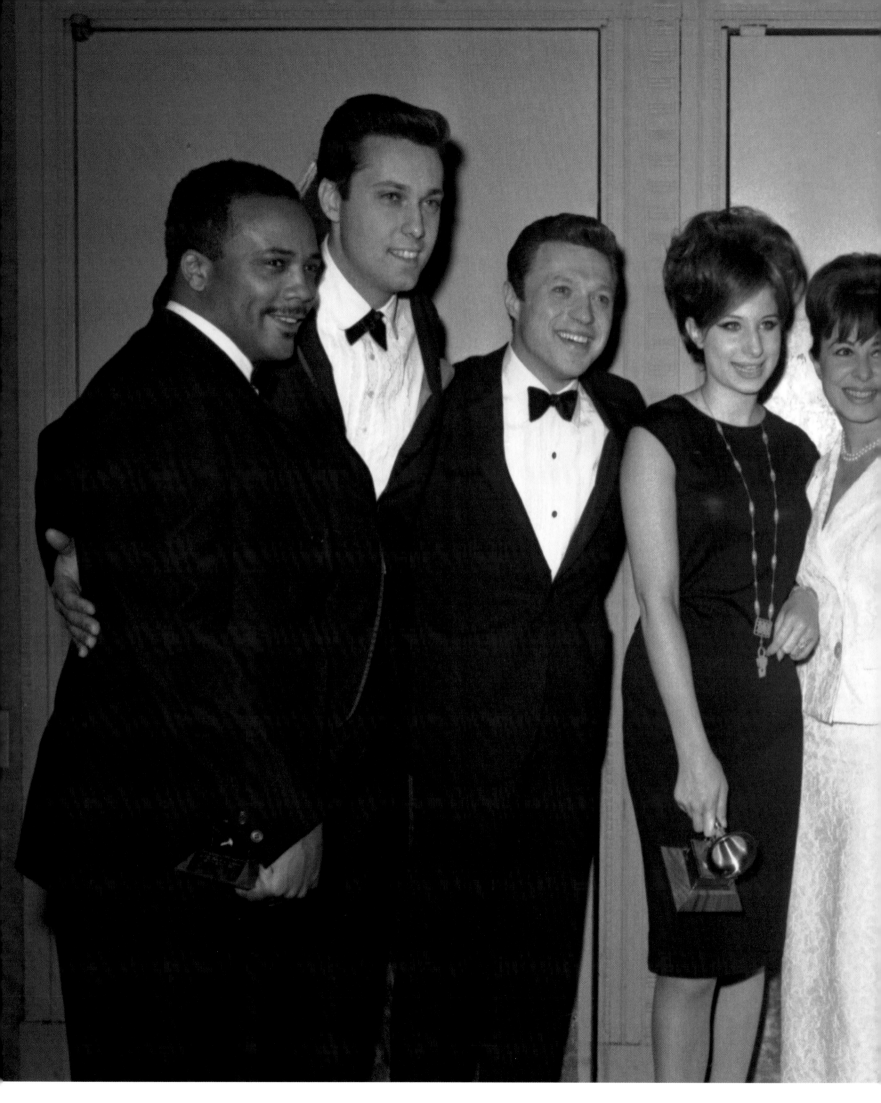

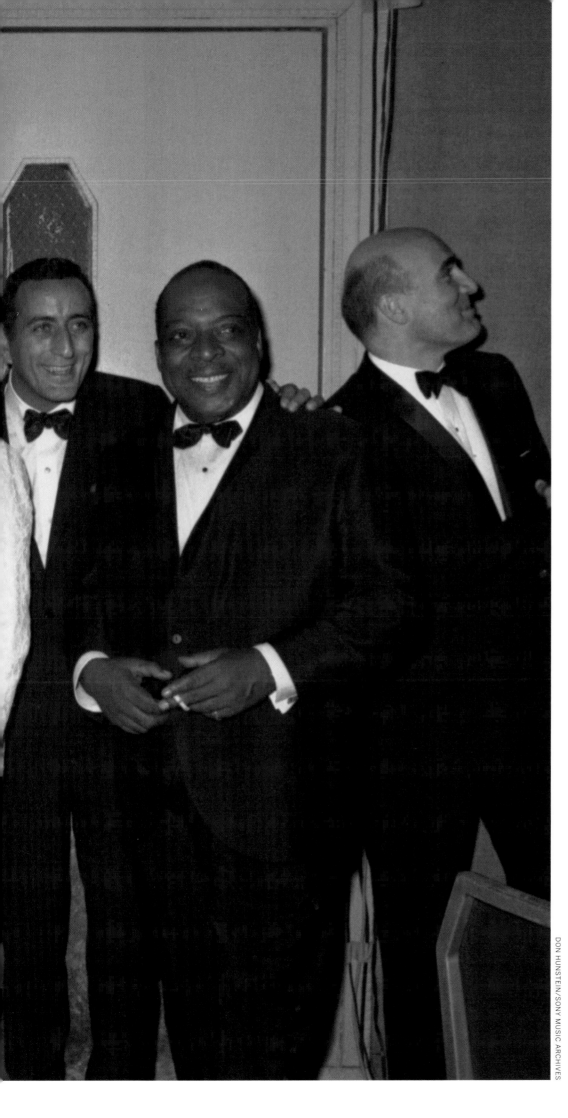

TONY, IN THE EARLY '60s, is now winning Grammys, and so is Barbra Streisand (with a trophy). From left, a firmament of stars: Quincy Jones, Jack Jones, Steve Lawrence, Babs, Eydie Gorme, Tony, Count Basie. All of these musicians and many others would get caught up, more or less, in the rock 'n' roll onslaught. "Those were such stupid days," Danny Bennett, who was a rocker himself before he became his father's manager, says now. "They were telling Streisand to sing Dylan songs. So stupid." Barbra would come back around in Tony's life and career many years later when she and a host of other warblers would take part in his very successful duets series, which continues with his recent, celebrated, full-album collaboration with Lady Gaga. Barbra, for her part, teamed up on a rendition for the ages of "Smile." Frank Sinatra in his duets projects often allowed the parallel vocal to be mailed in from afar, and then he would harmonize. By contrast, Tony and Danny wanted the partner in the studio, making the connection—and the song—happen in real time. One more sound musical decision by the Bennetts.

EVERYTHING ON THE next several pages is from 1962 and 1963. Sixty-two was the year of "San Francisco," Carnegie Hall and the first great comeback, which surged into '63 and even '64—before Beatlemania swept America. (Performing at Carnegie can be seen on pages 102 and 103; at right, Tony is well into a set in September of 1962.) A wonderful footnote to that wonderful year, '62: Tony sang for the Kennedy White House just 17 days after "I Left My Heart in San Francisco" debuted on the charts (where it would reside for nine months). He was paired with pianist and bandleader Dave Brubeck, and Tony announced when he took the bandstand that day, "We haven't rehearsed this, folks—so lots of luck." As Ted Gioia, author of *The Jazz Standards: A Guide to the Repertoire,* has written about the White House sessions, "At first glance, these two artists might seem to come from opposite ends of the spectrum. Brubeck, raised on a ranch in California, had learned his craft under the guidance of avant-garde classical composer Darius Milhaud and has earned a reputation as one of the most iconoclastic modern jazz musicians of his day. In contrast, Bennett, from Queens in New York, had . . ." And then Gioia went into the singing waiter and *Talent Scouts* stories. He finished with this: "The concert that day was held to honor college students who had come to Washington, D.C., to work for the summer—in fact, they had met earlier that day with President Kennedy. Historians often use the phrase 'the best and the brightest' to refer to the smart, idealistic people who gravitated to government service in those years, but I would apply those same words to the artists on stage that day."

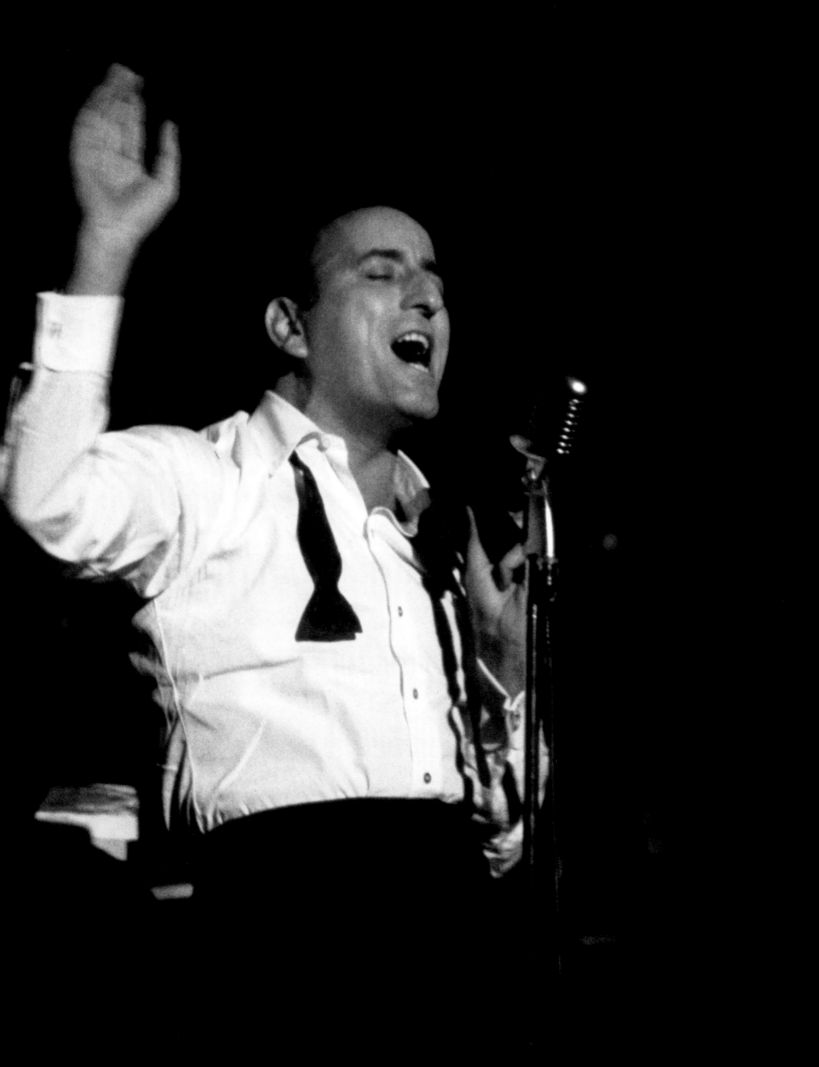

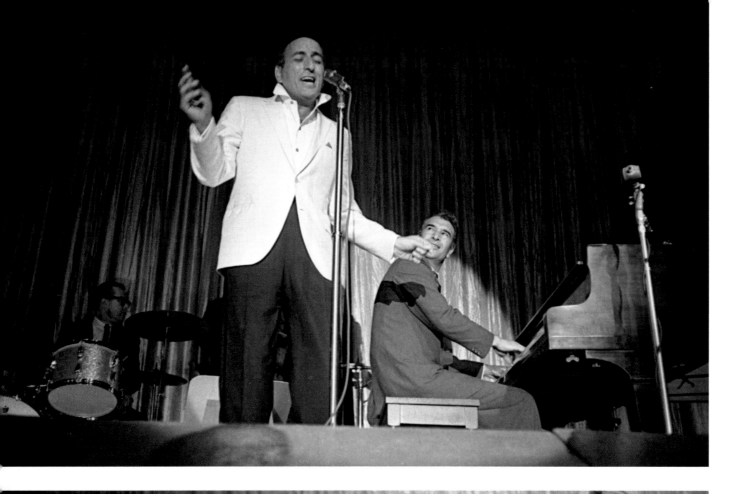

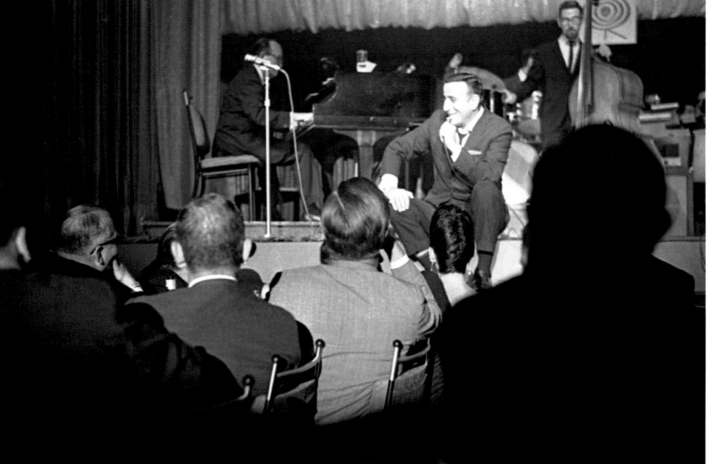

ONE DAY, at the White House. The next, at top, another terrific performance in September of 1962, also with Brubeck on piano—they were all terrific in this period. Above: At a Columbia sales convention in September of 1963. Photos such as this are among the many dozens of "finds" in the Sony archives, many taken by the wonderful photogapher Don Hunstein. Opposite: Tony's back at the Latin Casino in Philadelphia, a stopover as familiar as the Copacabana for an East Coast artist, in November 1963.

TWO SHOTS from the legendary June 1962 Carnegie Hall concert in New York City: Tony looking pensive (above) and talking the beat with the bongo and conga drummer Candido. Jazz pianist

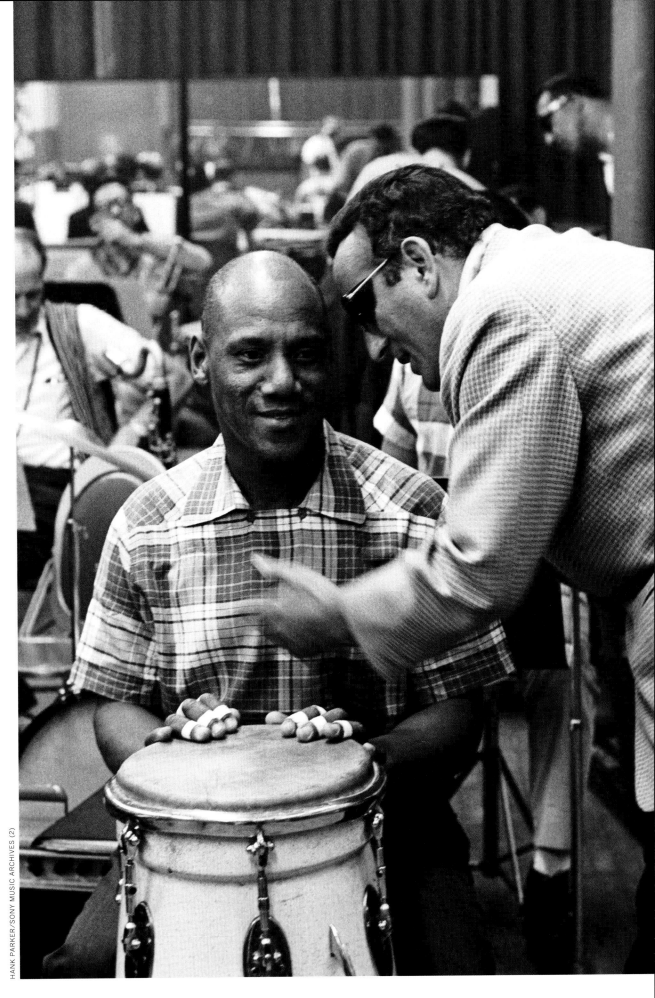

Ralph Sharon would later write of that night: "The orchestra members outdid themselves by giving just that little extra something that cannot be produced by merely playing the notes 'as written.'" Sharon singled out several musicians, including "Candido for his performance in 'Ol' Man River' and later in a spectacular display of solo virtuosity in the final tune, 'De Glory Road.'" As for the boss, and his confidence in booking this particular room: "Tony now had to justify the enthusiasm of his public by turning in the performance of his lifetime," Sharon said. He did—"he rose magnificently to the occasion"—and that, too, is part of 1962.

TONY VISITS WITH Peggy Lee
in her dressing room during a break in her
nightclub performance in April 1962.
Of the 1950s and early '60s in the business
of popular song, he remembers during
a casual chat in his apartment on Central
Park South: "The competition was intense
back then. It was a great era—you had
Jo Stafford, Dick Haymes, Nat King Cole,
Sarah Vaughn, Rosemary Clooney, Louis
Armstrong, Billy Eckstine, Lena Horne,
Judy Garland, Dinah Washington, Peggy
Lee, Margaret Whiting. All these great
singers. Fierce competition, but there was
camaraderie. Sinatra was the one who set
the tone." It is certain that when Tony reads
this he will slap his forehead and say, "I
left out Ella!"

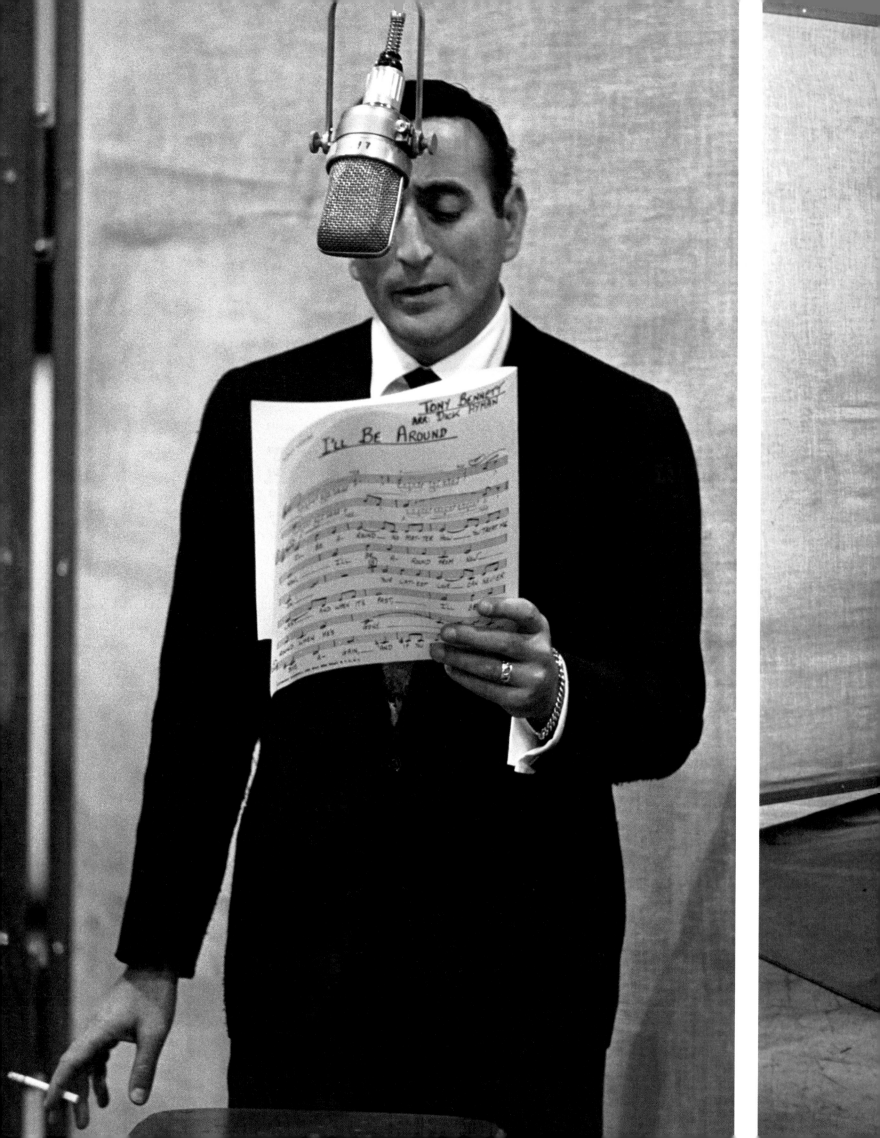

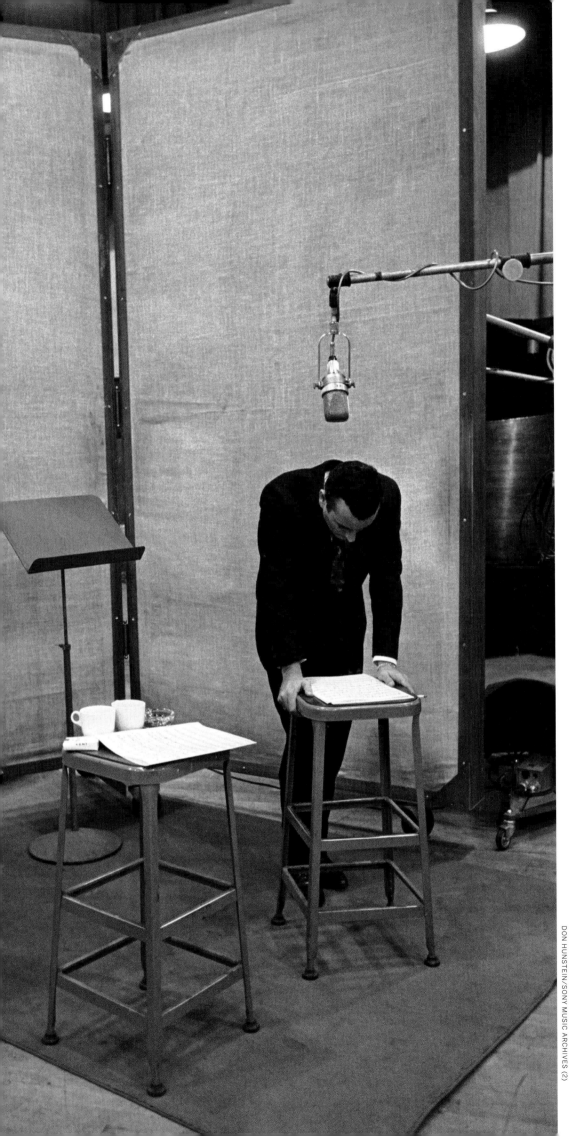

ON THESE TWO PAGES Tony is recording with Ralph Burns in 1963, and honor should be paid—to Burns and also to the seriousness of purpose Tony has always brought to recording. Burns not only arranged and conducted for Tony, but wrote songs for him and other artists; his collaborations with Ray Charles, including the recording of Hoagy Carmichael's "Georgia on my Mind," will live forever.

As for Tony in the studio: In 1998 I was privileged to attend, at a midtown Manhattan studio, one of the sessions for what would become the wonderful CD *Bennett Sings Ellington—Hot and Cool.* When I arrived, Tony, dressed in a lustrous blue suit, was in the control room chatting with Herman Leonard, the renowned photographer from New Orleans who had spent much of his lifetime chronicling the jazz world. I said hi to Tony and was introduced to Mr. Leonard, and the small talk continued. I remember Leonard making a little joke about how jazz photography just hadn't been the same since everyone stopped smoking. Tony laughed warmly. I thought for a second and realized Leonard wasn't all wrong: In those great old black-and-white images there was always smoke swirling. By contrast, here, beyond the glass panes in this clean, well-lighted and utterly haze-free studio, the members of a good-sized orchestra, who would play alongside the Ralph Sharon Quartet during today's session, milled about. And then, suddenly, their break was over and everyone returned to his place.

I'll continue this small story on the pages following, as we see Tony hunkering with Harold Arlen.

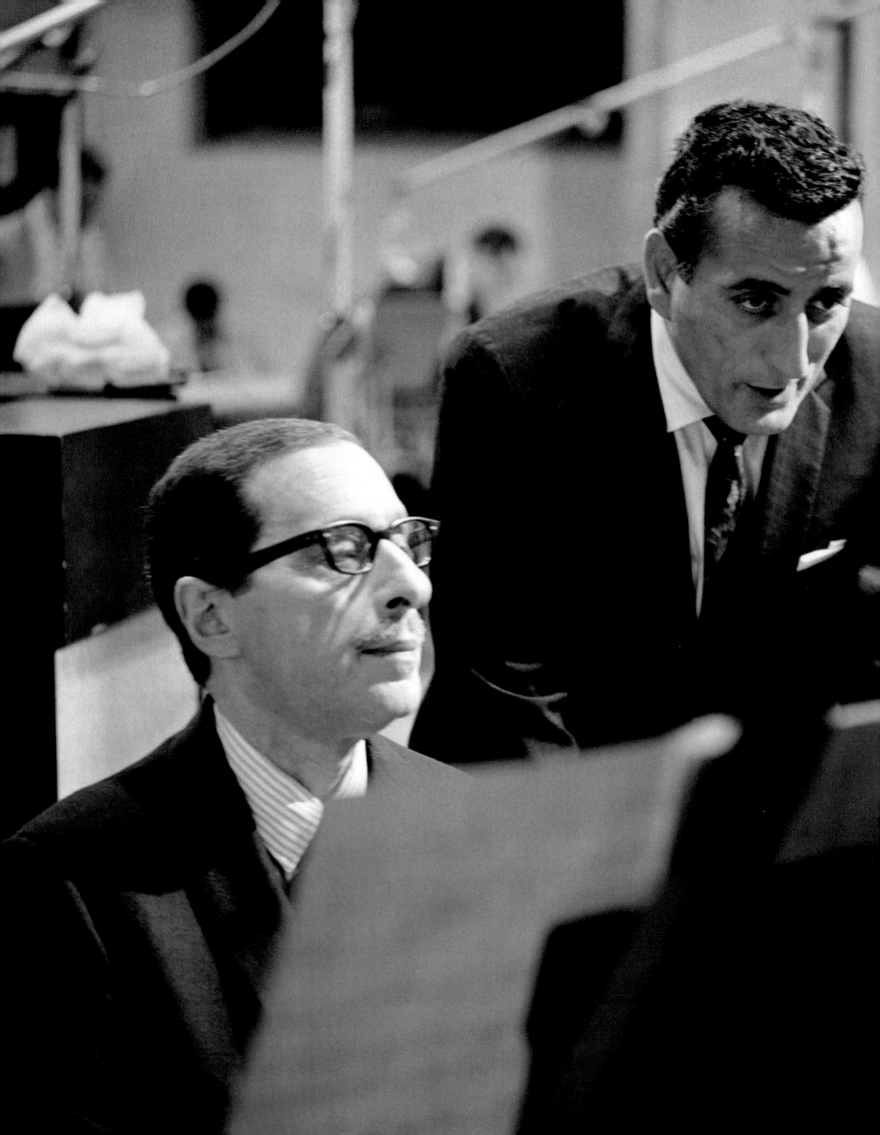

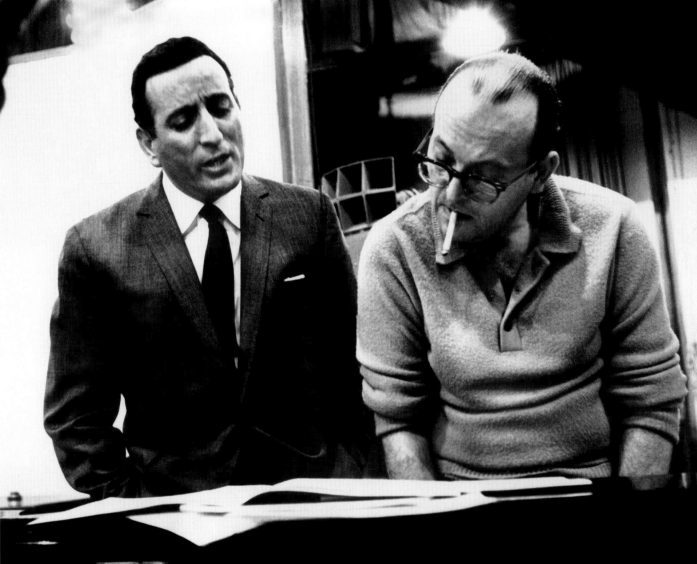

ON THAT DAY during the Ellington sessions, Tony was up front, behind a music stand, facing the band. It was fascinating to watch him work. Theretofore, I had seen him work only in a concert setting. As I watched on this day, I arrived at an obvious notion that a good part of what a performer needs to do is sell the song. So on stage there are lots of smiles, little dance steps, many gestures, ranging from a raised arm to help with a high note, to a hand over the heart to acknowledge applause. But here, in the studio, there was none of that.

Tony was all business. He was trying to get it right, and he wasn't fooling around. He studied the sheet music between takes: He was working, working hard. "I do get into a zone," he says. "The focus. In music and painting, it's nice when you can find that zone." At left, he is working with the legendary songwriter Harold Arlen and above with his kinsman Ralph Sharon. From the stage of Carnegie Hall before singing "What Good Does It Do": "Harold Arlen has a talent for making any performer feel he owns his songs."

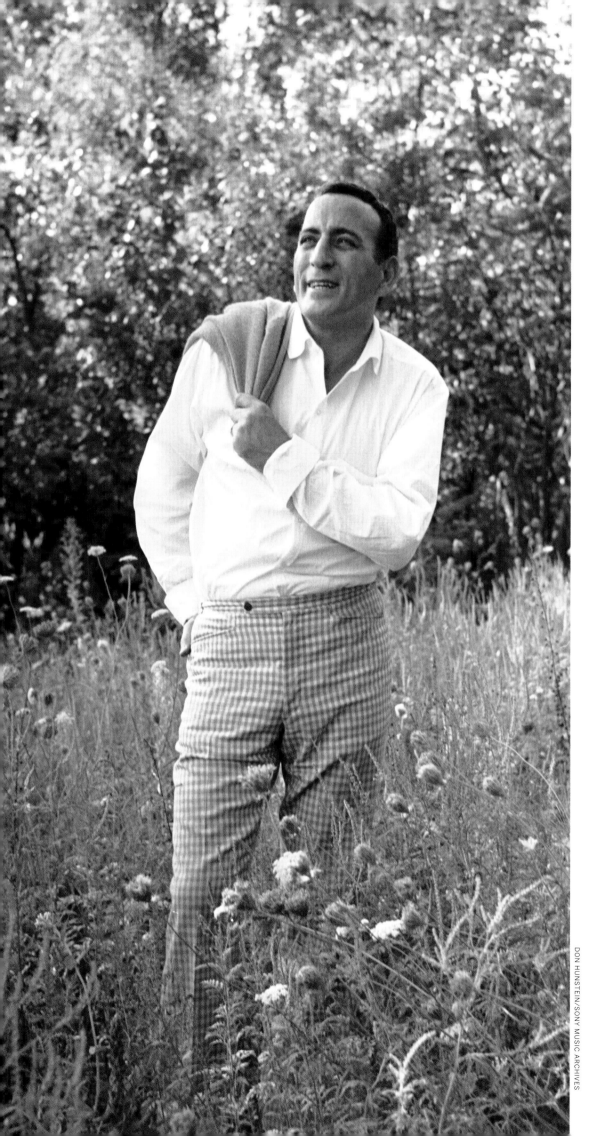

IN SEPTEMBER 1964, Tony is sporting some truly sporty trousers (left), and circa the same period he is with his mother at a movie premiere. Which brings us to another interesting period in the career: The Beatles have happened, the boost of "I Left My Heart in San Francisco" and the Carnegie Hall album are now months in the past—months seeming as years—and Tony is, if certainly not at sea, wondering where the future lies. He signs on to play a part in a movie, which will be *The Oscar,* of which the kindest thing said might be: It had a fine theme song sung by Tony Bennett. "It's gonna sound a little like I'm name-dropping here," Tony says with a smile, "but I'm not. I hope you realize that. This is about Cary Grant. Some of the best advice I ever got was from Cary Grant. As I said, I had done a little bit in the movies, and I was asking him what I should do in the future. Here he was, this handsome man—the handsomest man in the world. He said to me, 'Don't do films. It's so boring on a set. You love to sing and paint. Follow your passion; those are your passions. Go travel the world and become the best entertainer. You make people feel great—you're alive, they're alive! Sing! Paint!'"

That was an answer, and as Tony says, "And it's Cary Grant, right? So I thought I may as well listen."

But in late 1964, the crisp answer was not necessarily enough.

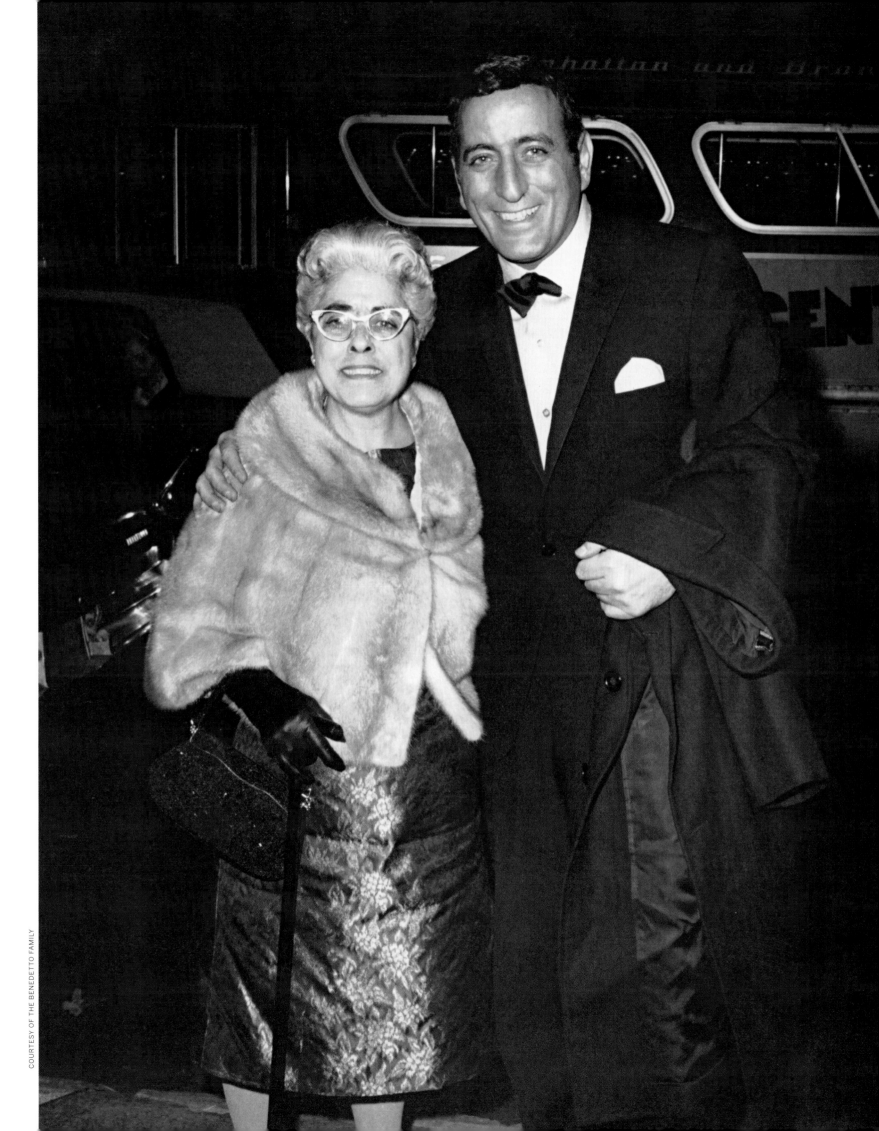

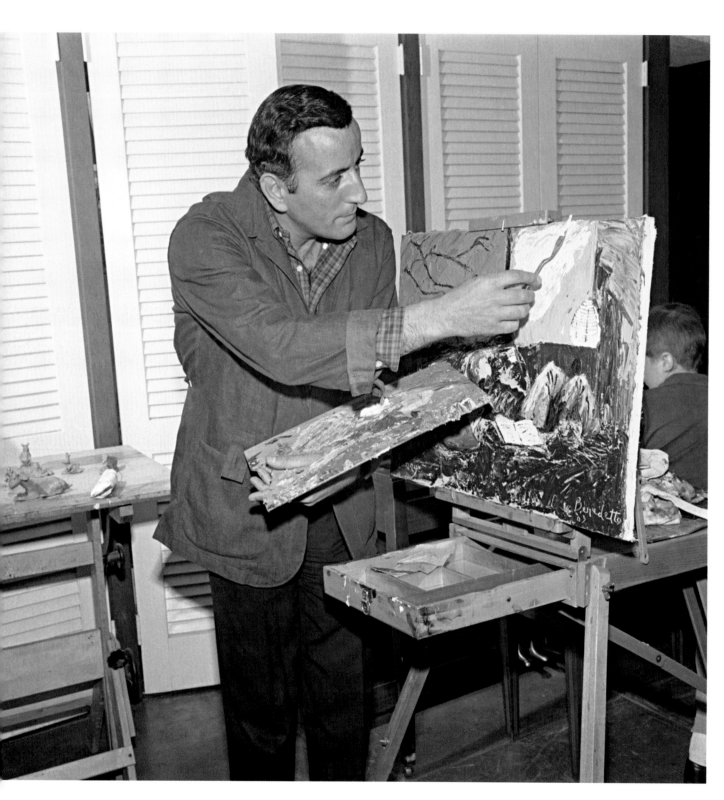

LIFE AT HOME, depicted as wonderful in these pictures of Tony painting and with Patricia, pet cats, and sons Danny and Dae—growing boys, now—was not happy on a daily basis. In fact, as we will learn on the pages immediately following, at this point the domestic life is ending, although divorce would not follow until 1971. Incidental to these photographs: It is unknown what Tony was working on in his home studio, but the book of artwork he and Patricia are perusing contains the work of Michelangelo. Are the boys and their cats listening to Dad or rock?

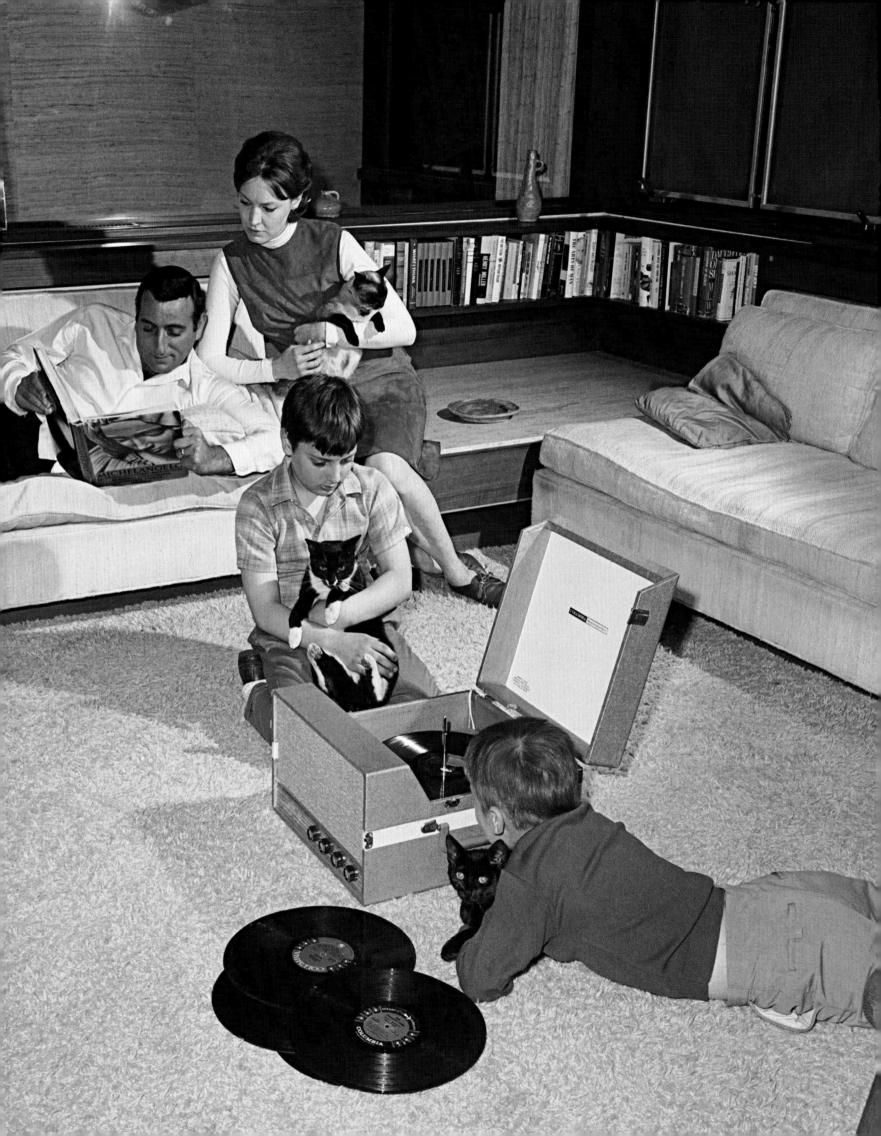

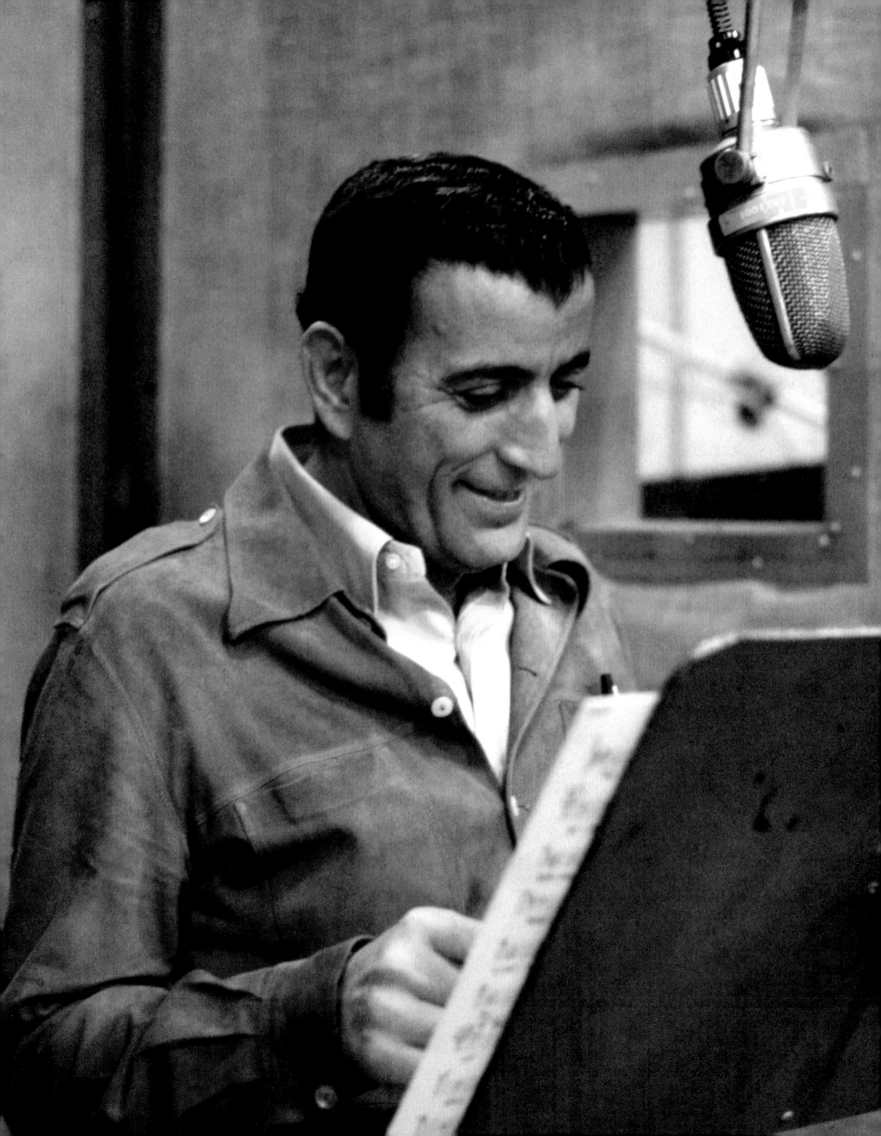

BETWEEN ROCK AND A HARD PLACE: 1965-1979

IT IS CHRISTMAS EVE 1965, and a depressed Tony Bennett is spending a long, lonely night by himself at the Gotham Hotel in New York City. In his life he has known thrilling highs and deep lows, but he has never been down like this before. His 13-year marriage is all but over; his wife and two boys are at the family home in New Jersey, enjoying the holiday as much as they can, and he is here, desolate. Careerwise, too, things are less than aces. While he can still get a gig whenever he wants, he senses that, with rock growing

ever more dominant, his music is slipping out of style. To Tony, at 39, the future looks bleak.

He doesn't have to be here, alone in his room. He could have been out, he could have been enjoying some music. Tony's close friend Duke Ellington, whose orchestra has backed Tony on many an occasion, is conducting the Sacred Concert only a few blocks away. That would be one way to capture some spirit on this cold Christmas Eve. But Tony just can't pull himself from the hotel.

He tries to sleep, but it is a fitful effort. Suddenly, he hears a noise. Figuring he's left the television on, he gets up to turn the switch. The noise continues; it's coming from the hall. Tony opens the door, and there stands the chorus from the Sacred Concert singing "On a Clear Day You Can See Forever." Ellington, knowing that his friend is in the dumps, has dispatched the singers for a private serenade.

"Wonderful gesture," Tony remembers during a quiet moment at the table. "But that night was as bad as it gets."

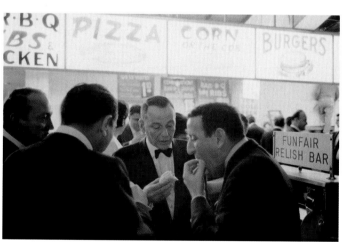

TO CONTINUE THE STORY from the previous pages—yes, it was a wonderful gesture by the Duke and also a point in Tony's life that was as bad as it gets. But another episode occurring at roughly that time would return, again and again, to point the way back to the heights. In a 1965 article in LIFE, Frank Sinatra said the following: "For my money, Tony Bennett is the best singer in the business . . . He excites me when I watch him. He moves me. He's the singer who gets across what the composer has in mind, and probably a little more." Says Tony of Sinatra's words today: "That quote would change my life.

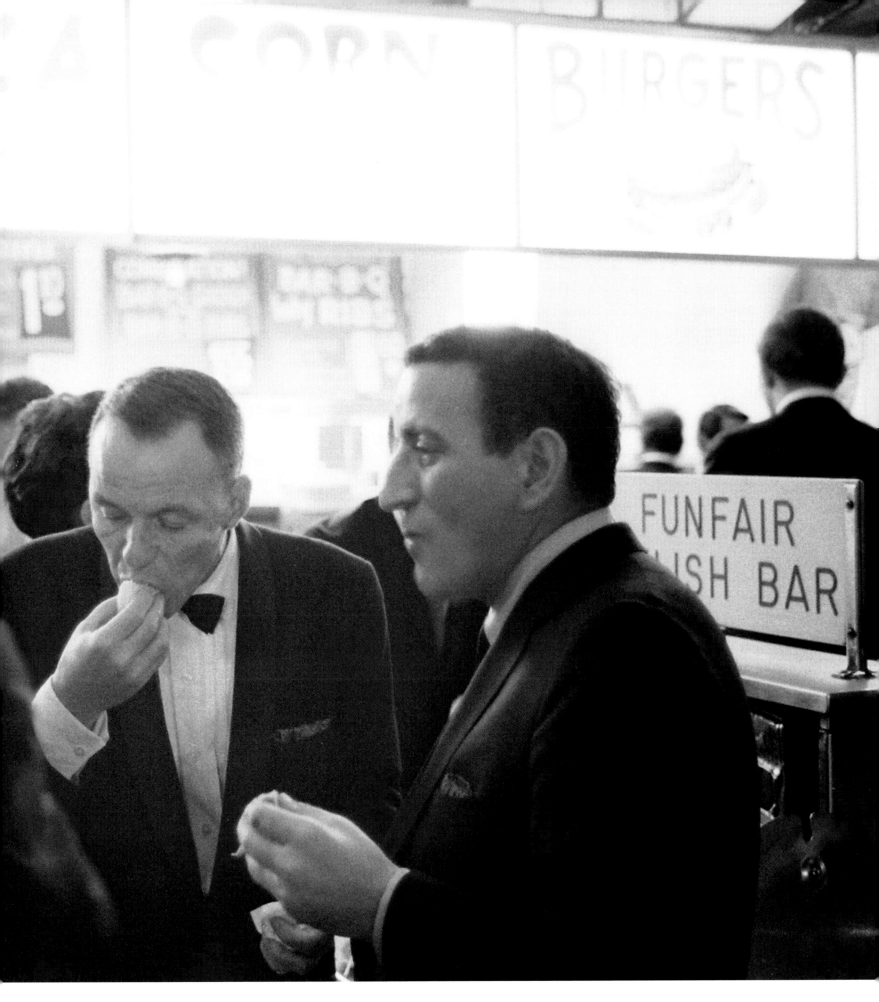

Frank was always such a generous man."
On the opposite page are four never-
before-seen outtakes from John Dominis's
10,000-image epic on Frank Sinatra at the
age of 50, shot for LIFE in 1965, and above

are Frank and Tony enjoying frankfurters
together after Frank's show in Miami;
the man with his back to the camera is
the comedian Joe E. Lewis, a forever
favorite of Frank's.

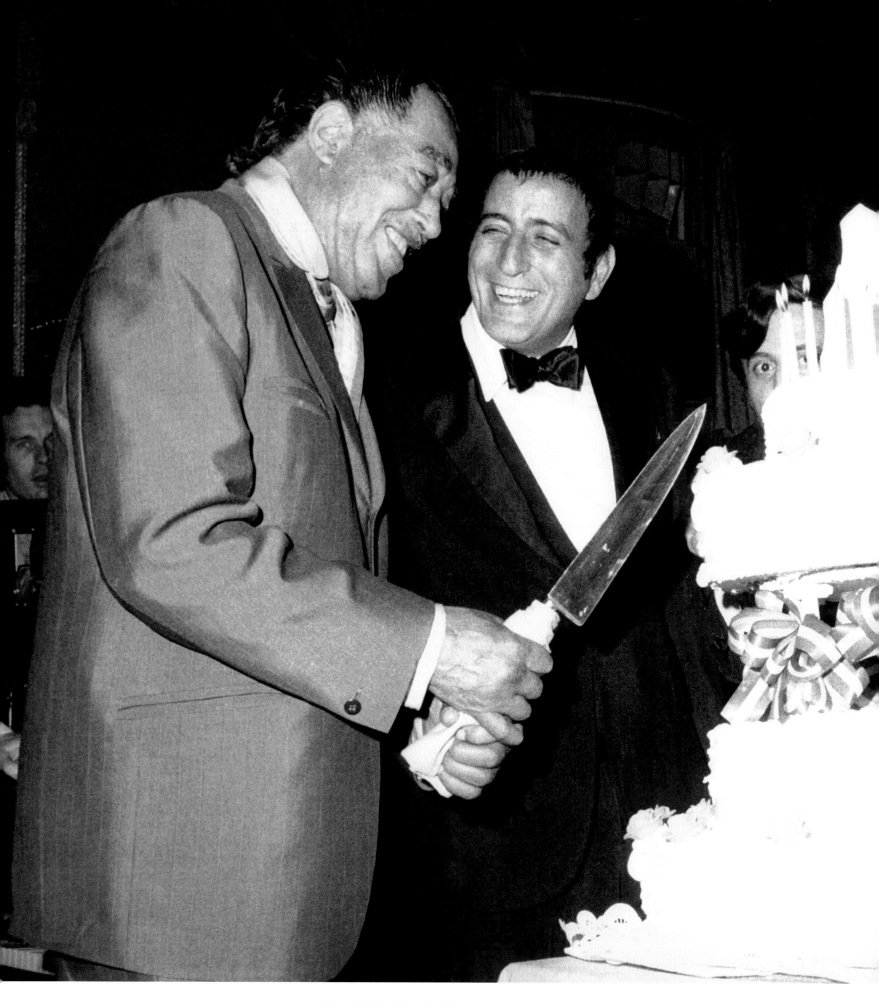

TO RETURN TO THE DUKE: Here he is with Tony cutting the birthday cake circa 1965 and (opposite) at the eighth annual Grammy Awards, at which Ellington is a jazz winner. A short time earlier but still in this period, Tony, whose thoughts on race we have touched on, wanted to hang out with his friend Nat Cole after a performance. Tony had to visit him backstage after the show rather than in the café, where Nat

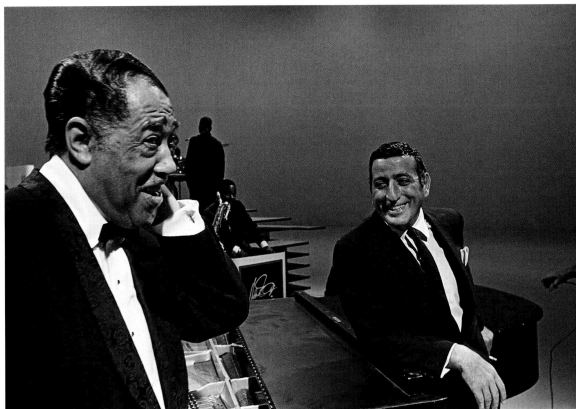

was not welcome. He's had to watch as, after a performance, the orchestra of his friend Duke leaves the grand hotel in Miami where they have just played sensationally in order to bunk off-site at a crummy motel.

"These things went beyond politics," Tony says. "Nat and Duke were geniuses, brilliant human beings who gave the world some of the most beautiful music it's ever heard, and yet they were treated like second-class

citizens. The whole situation enraged me." And so: "When Harry Belafonte called me up and asked me to join Martin Luther King's civil rights march in Selma, Alabama, in 1965, I accepted."

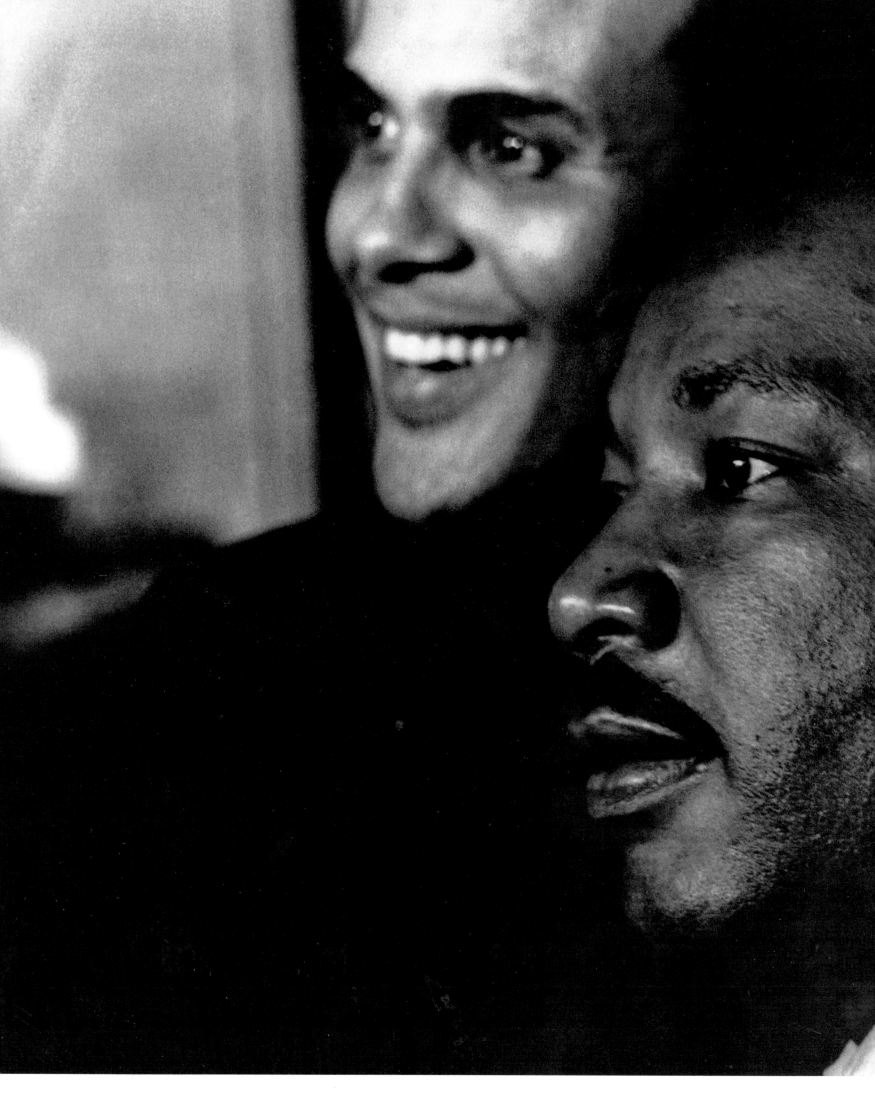

HERE ARE Harry Belafonte, Martin Luther King Jr. and Tony. King was trying to attract attention, certainly, and so the presence of celebrities such as Tony, Sammy Davis Jr., Shelley Winters and Leonard Bernstein only helped. "I remember on the march, I noticed Jilly Rizzo, Sinatra's right-hand man, marching right next to me," Tony recalls during a lunch at an Italian eatery on the East Side, when the subject is exclusively Sinatra. "I said, 'Jilly, what are you guys doing here?' I looked at him and I see he's got these brass knuckles on. He's wearing them! And he looks at me and says, 'Just in case any of these guys want trouble.' And I say, 'Jilly, this is supposed to be a peace march!'"

Despite the humor of that recollection—and as Jilly's precautionary measures suggest—it was hardly fun and games on the march. The threat of violence was constant, the mood ever ominous. When Tony and the others performed for the protesters that night, they did so on a makeshift stage built of coffins.

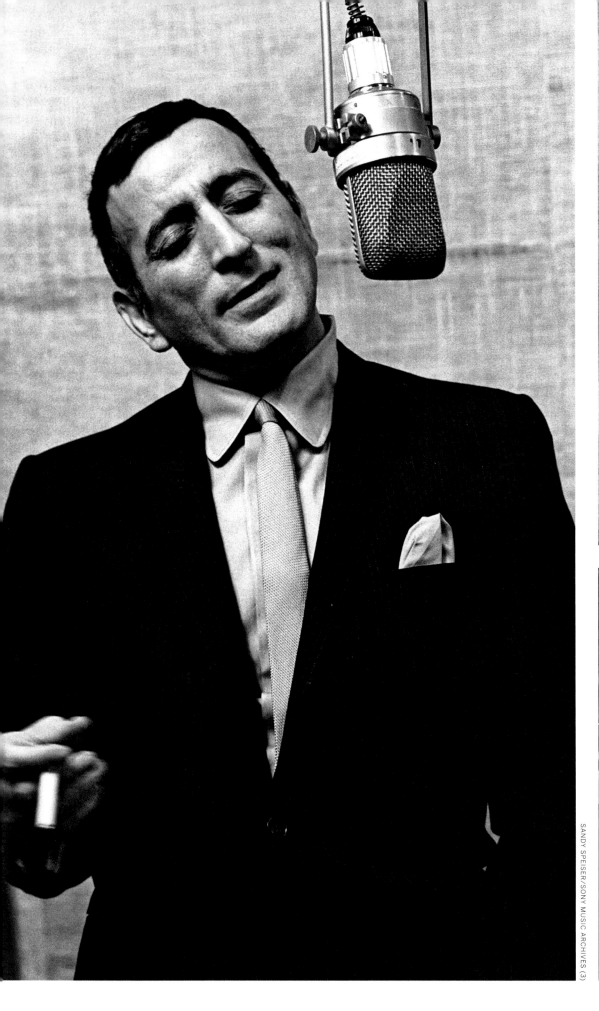
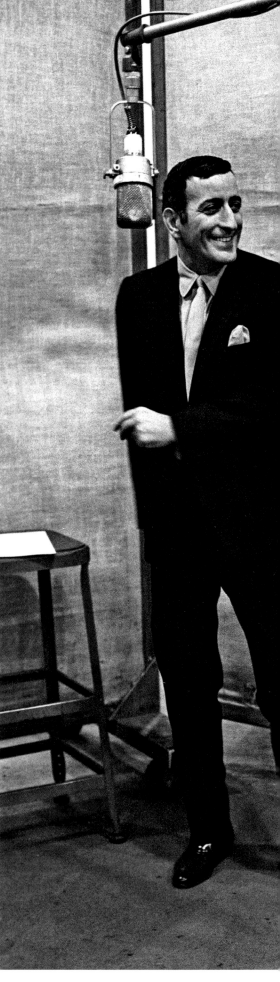

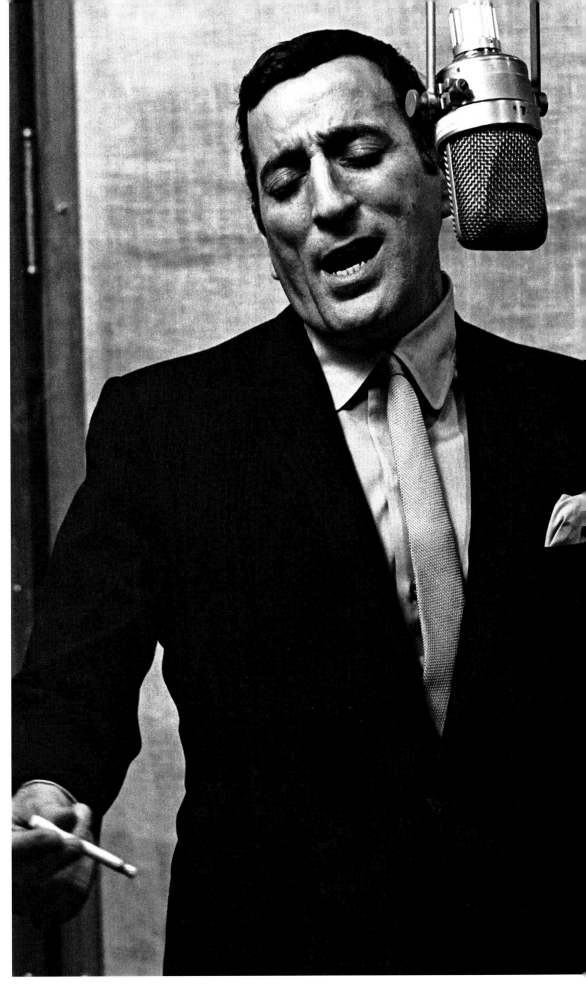

SOME OF US get a golden watch after 25 years on the job, some of us after 50. From the postwar years until the present day, 67 years, if you include that minor record label in New Jersey, and already 62, if you date it from the beginning of the Columbia years, Tony has not gone a season without standing before a microphone. He may retire one day, and if he does he says that he's content to paint—express himself that way. He does vocal exercises every morning as he gets ready for the day before the bathroom mirror. "If I start to wobble, I'll quit," he says. Here: At a session in 1967.

THIS IS, believe it or not, a very rare photograph, and not just because it shows Tony holding the score from Woody Allen's *Play It Again, Sam* in 1969, but because it shows him holding any score at all. In a conversation with the writer James Isaacs at Boston's Hotel Lafayette on June 24, 1986, when Tony is playing a weeklong engagement in the area, the singer is asked what Mitch Miller, back in the early days, had taught him, if anything (Tony's musical tastes and Mitch's had never jibed). He answered: "Being up for the job, being well-rehearsed, being very professional. Don't just read it off the sheet music, come in memorized. He was a good classical musician [Miller was an oboist] and he knew about discipline. When you're a young kid, you think you can do everything, but you don't know discipline, and as you get older you realize that it becomes your greatest friend." In these years, Tony leaned on that learned friend—discipline—in the studio, even as it occasionally eluded him in his personal life.

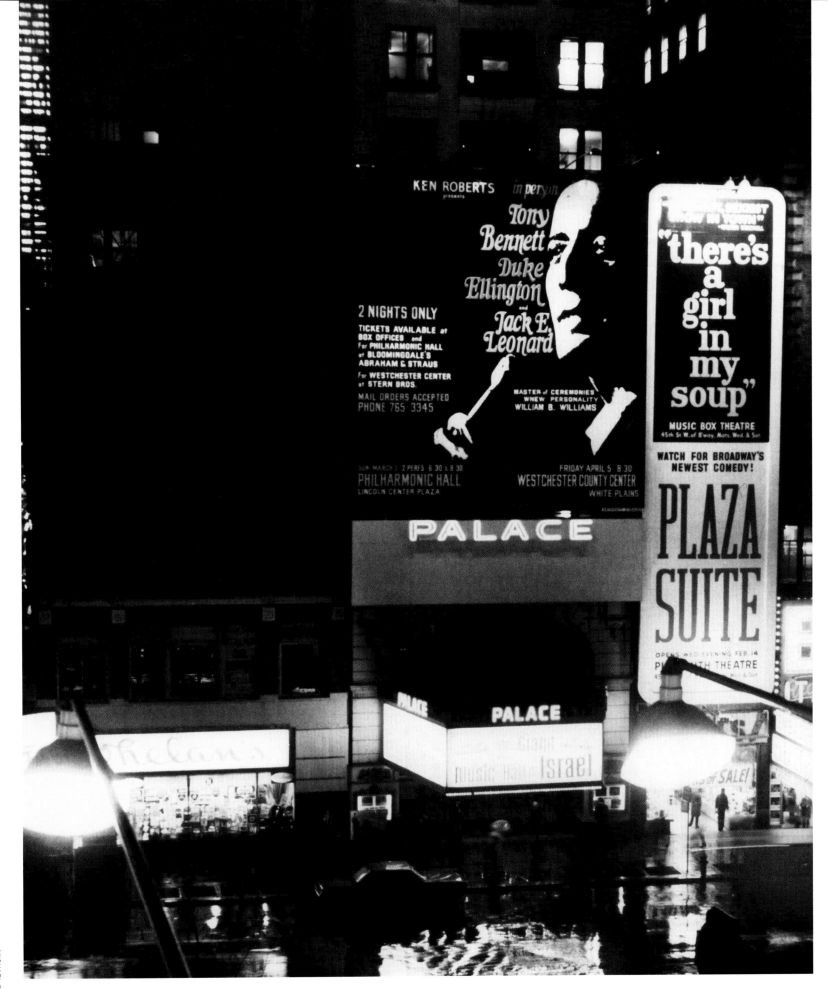

BENNETT'S LIFE circa the late 1960s: introspective, as is perhaps reflected in the portrait opposite, but also still in the game, as indicated by this billboard in New York City's Times Square. His divorce from Patricia is just about final, Columbia is starting to pressure him to *get with it,* to become a more rockish singer. That's not who he is, it's not what he does. As Danny Bennett says: "stupid days."

THIS IS A PHOTOGRAPH of Tony and American actress Sandra Grant in London in 1968; she and that city would figure largely in the next years of his life. Let's pick up the story circa 1970: Tony, who had been drained by the constant battles with the then-new Columbia president, Clive Davis, over Davis's insistence that his traditional pop artists cover contemporary chart-toppers (don't ask Tony about the album *Tony Sings the Great Hits of Today!*), finally walks away from the label. "I left Columbia for one reason: They were forcing me to sing contemporary songs, and I just couldn't stand it," he says one afternoon at the apartment, the sun shining in through the windows. "I actually regurgitated when I made that awful album—I got physically sick. You see, show business is a game. Everybody plays a certain game. My game—what I gravitated to intuitively—was to try to do definitive versions of popular songs. I just love a well-made popular song. If I really adore a song, I just get into the creative zone and try to get the definitive version of the song that would make the composer feel magnificent. Where he would say, 'That's what I was trying to convey.' And Columbia wasn't letting me do that anymore." So he left the label, with one exec saying as Tony shut the door, no one leaves this place and continues in this business.

Meanwhile, the personal life. Tony and Patricia were splitting, Tony and Sandra uniting. They wed in 1971. Tony was also entering what he calls "my English period." This would last from late 1971 into 1974, with occasional stints back in the States. Tony had a new manager, a new record label, a new young family—he and Sandra welcomed two daughters during their relationship, Johanna and Antonia—and all the impetus in the world to jump-start a new phase. And so he did. He harkened to advice he'd once been given by the bandleader Ted Lewis—"Do yourself a favor. Play England every year. The fans are unlike anywhere else in the world. They're loyal. They never forget you"—and he relocated with Sandy and Johanna, the older girl, to London. Lewis was proved right: In 1972, Tony sold out concerts all over Great Britain, starred in a musical television series, and selected and recorded his own music for discs that would be put out on MGM/Verve. "I worked hard while I was in England," Tony says in his autobiography, "but I also took some time for my personal life, something I hadn't done in years. Sandra, Johanna and I took in the lovely English sights and got to spend some good times together. I'd been painting whenever I could, but it was during this year in London that I really started to get serious about it." He took up tennis, developing yet another passion that would remain with him the rest of his life. Free of Columbia Records, free of expectations, he felt liberated to experiment and grow. Back in America, too few heard or saw the fruits of this period in Tony Bennett's life.

BOB DEAR/AP

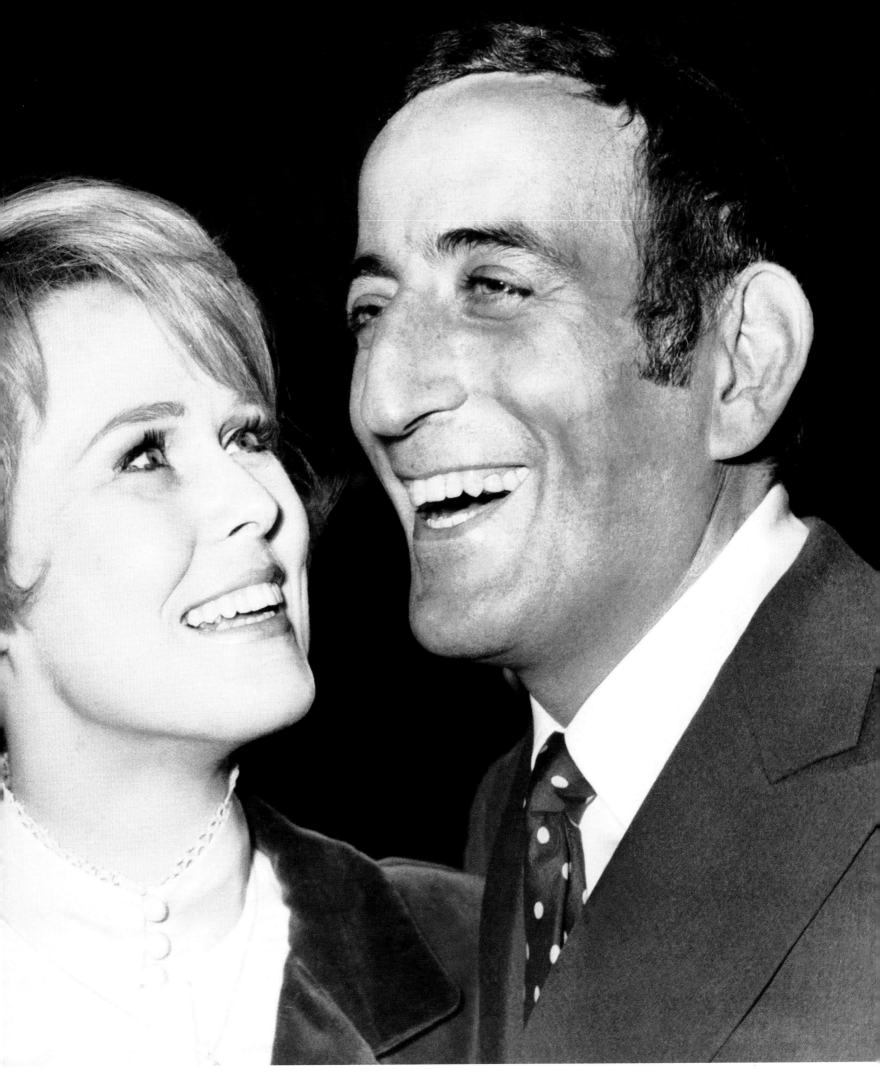

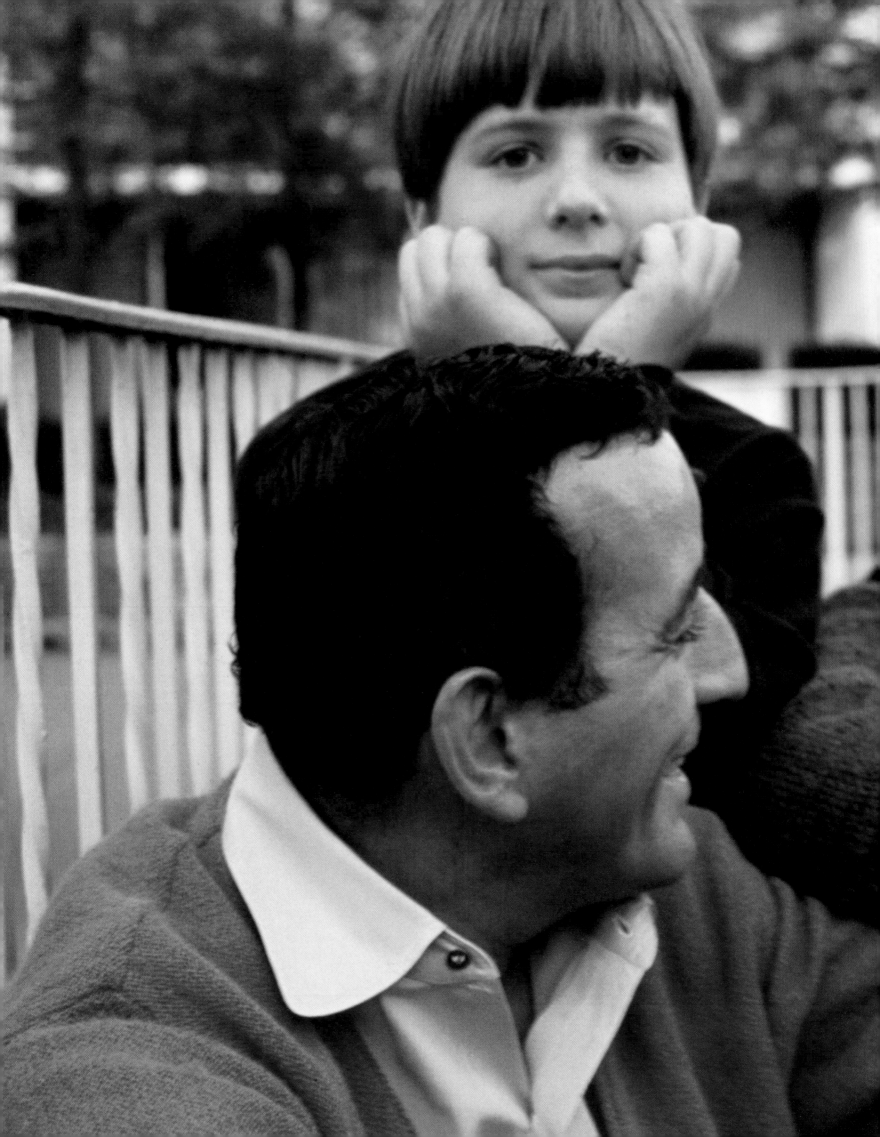

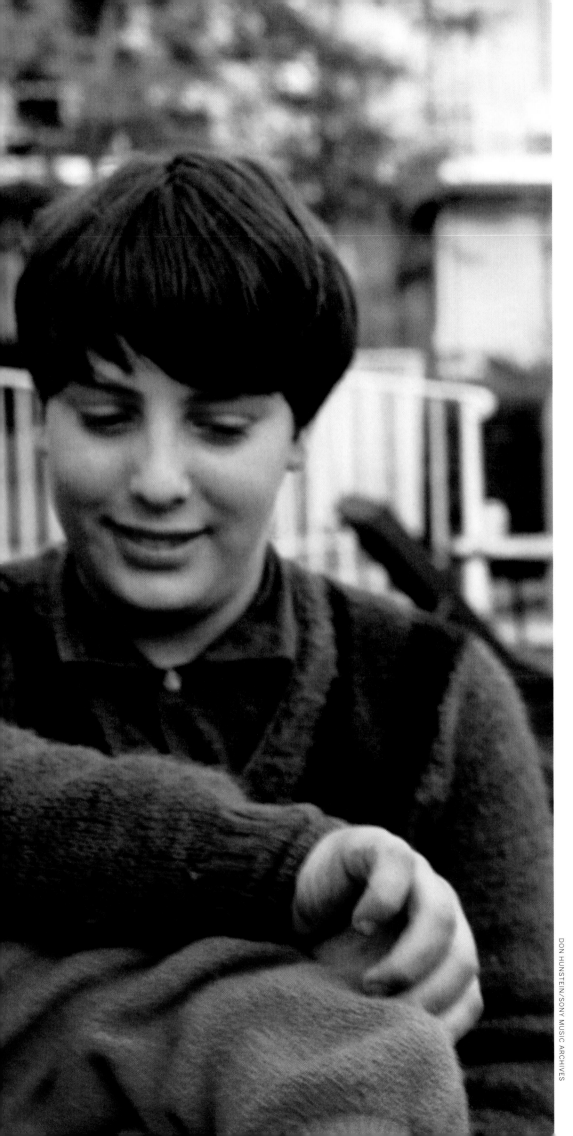

EVEN AS TONY MOVES to another personal journey, he is careful to maintain ties with his boys, Dae (left) and Danny. The funny thing is, as relatively forgotten as the early 1970s is in the Bennett canon, it was an exhilarating time creatively. He found a painting teacher he revered, John Barnicoat, and worked with the storied English music producer Robert Farnon; the Christmas album the two collaborated on remains a classic. The thought does occur: Would Tony be where he is today if that guy in the suit at Columbia Records had been right, the one who muttered, as Bennett was exiting, "Nobody leaves this label and is heard from again"? It does seem remarkable, in retrospect, that Tony Bennett did not disappear for good as the door closed. But if the man has been two things throughout, they are these: He's been a belter, and a plugger. "No way he could've stopped then," says Danny. "It's not about making money, it's about making music. I'm his son, but about one thing I can be objective—he is one of those people who has to do what they do. He will die singing."

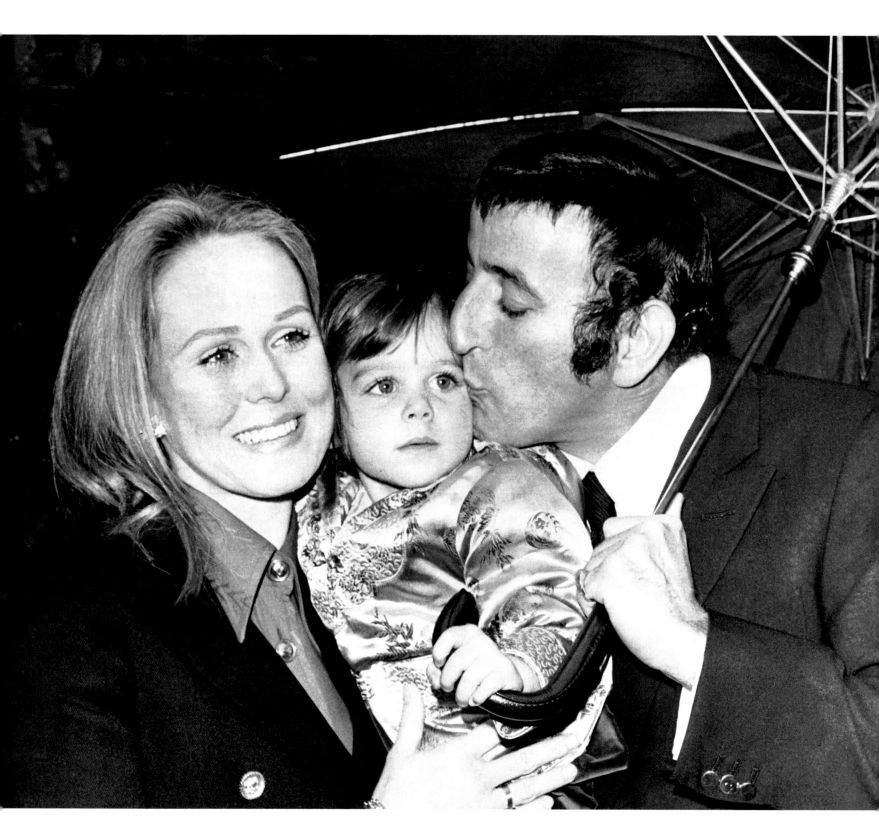

ABOVE ARE TONY AND SANDRA with Johanna on January 3, 1972, and opposite they're at the London Zoo in Regent's Park later that month, on the 25th. On the pages immediately following, he strolls through Berkeley Square that May, during the time he is filming his British television series. Tony resists the notion that he has had comebacks—"I was always working"—but he admits that he has had ups and downs, periods of being in and out of style (at least, the mainstream youth style). He also admits that he never could have predicted what was ahead and marvels at his later-in-life ascent back to the pinnacle.

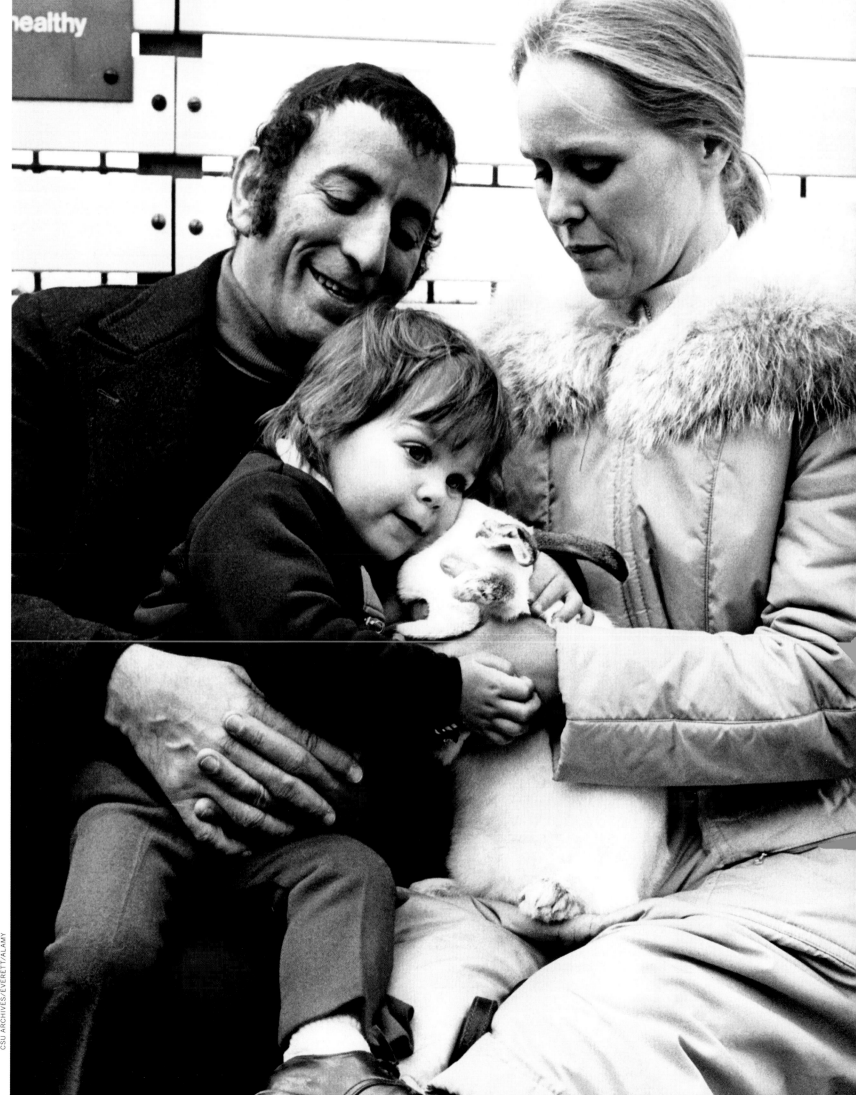

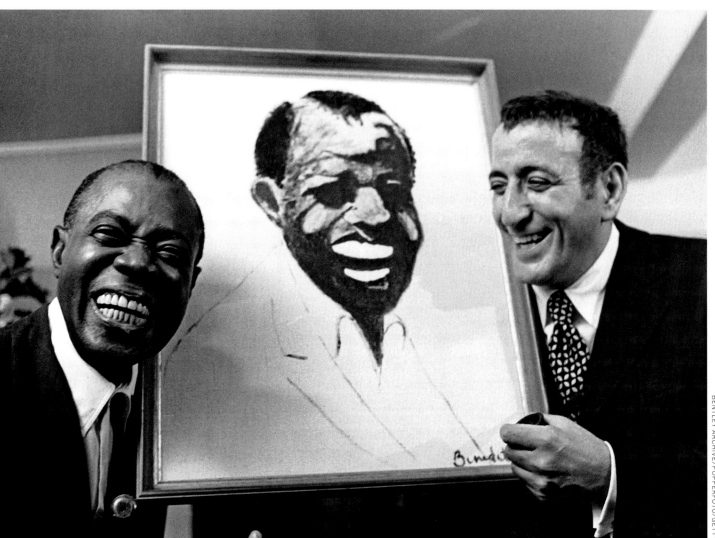

BENTLEY ARCHIVE/POPPERFOTO/GETTY

BOB WANDS/AP

IN ENGLAND, none other than Louis Armstrong drops in on Tony and gets a portrait done (above). Right: The artist at his easel. "I found a wonderful professor of art" in London, the aforementioned John Barnicoat. "I was staying in a flat next to the American embassy in Grosvenor Square, and he'd come over to my place and give me some lessons on technique. I became more serious about painting than I'd ever been, and I've never looked back. I was determined to become a skilled painter, no matter how hard I had to work at it." As for his friend Louis—whom he is firm was

never called and should never be called Louie—he shares another reflection while musing in his apartment: "I love books. Here I have books and books. I haven't read them all yet, but I'm working on it. I love the classics. Sometimes I'll read something, and it will move me to sing, or to paint—to express myself. As much as I love to read and admire great writing, I've never been able to write myself. A guy like Louis Armstrong wrote his own life story and it was magnificent. He was able to be himself. He had a gift with words. I don't have that gift, which in one way I regret."

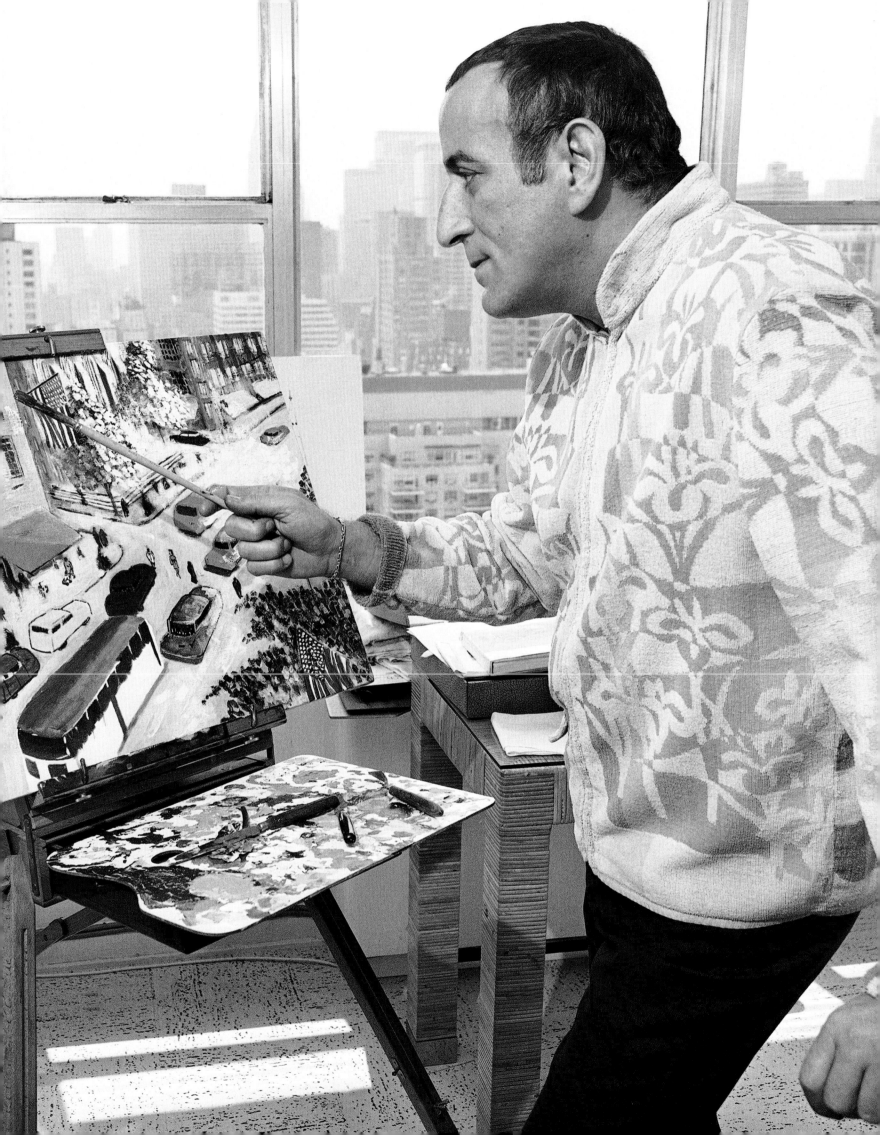

A PAINFUL PICTURE, this one, and a picture on which to hang a story of a painful time in Tony's life. The pianist is the jazz genius Bill Evans, who would collaborate on two brilliant piano-and-voice recordings with Tony in the 1970s—both for labels other than Columbia, both treasured recordings today.

In 1975, Tony realized a longtime dream when he and a partner formed their own independent record label, Improv. His work with Evans on the first album was a magical summit meeting, and the music they produced, accompanied in the studio only by an engineer, is sublime. This is remarkable considering that Evans was in the death grip of his addiction to heroin, which would claim him by overdose in 1976.

Shortly before his death but after he and Tony had finished their work on the albums, Evans tracked Tony down in a small Texas town where he was staying while on the road. "Bill, what are you calling me here for?" Tony said.

In a desperate tone, Evans said, "I wanted to tell you one thing: Just think truth and beauty. Forget about everything else. Just concentrate on truth and beauty, that's all." The phrase became something of a mantra for Tony even after it took on a shadow of tragedy with Evans's death. That event, says Tony, "made me think hard about my own drug use. I knew that somehow, something had to be done." It would take a few more years yet for Tony to leave the speed and cocaine behind, and he would do so only with the help of his children, but the thinking had begun: *I want to survive. I want to be around.*

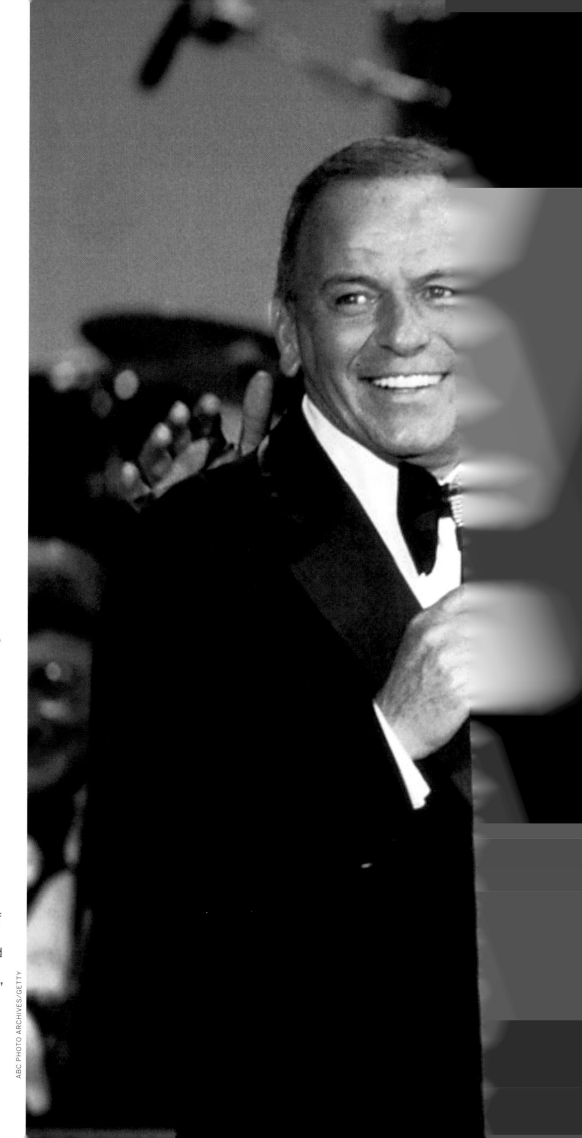

ON APRIL 21, 1977, Tony is a preeminent guest on the TV special *Sinatra and Friends.* Here's another story from that lunch I enjoyed at the Italian restaurant on the East Side, when Tony was reminiscing about Frank. It so entertainingly expresses his appraisal of his dear friend: "I was reading *The Autobiography of Benvenuto Cellini.* Benvenuto was a sculptor in Renaissance Italy whose works were pure magic. Kings and popes from Italy and France demanded his works. Now, Benvenuto's father demanded true justice from everyone he encountered, and he passed this philosophy down to his son. Benvenuto would draw his sword and battle every hypocrite and phony who stood in the way of truth. It reminded me so much of Sinatra's plight that I once sent a copy of the book to him for his birthday. I inscribed it, 'If Shirley MacLaine's philosophy is right, you *must* have been this cat in another life.'"

When Tony founded a high school in his birth borough of Queens in 2001, he resisted suggestions that he name it for himself and instead called it the Frank Sinatra School of the Arts.

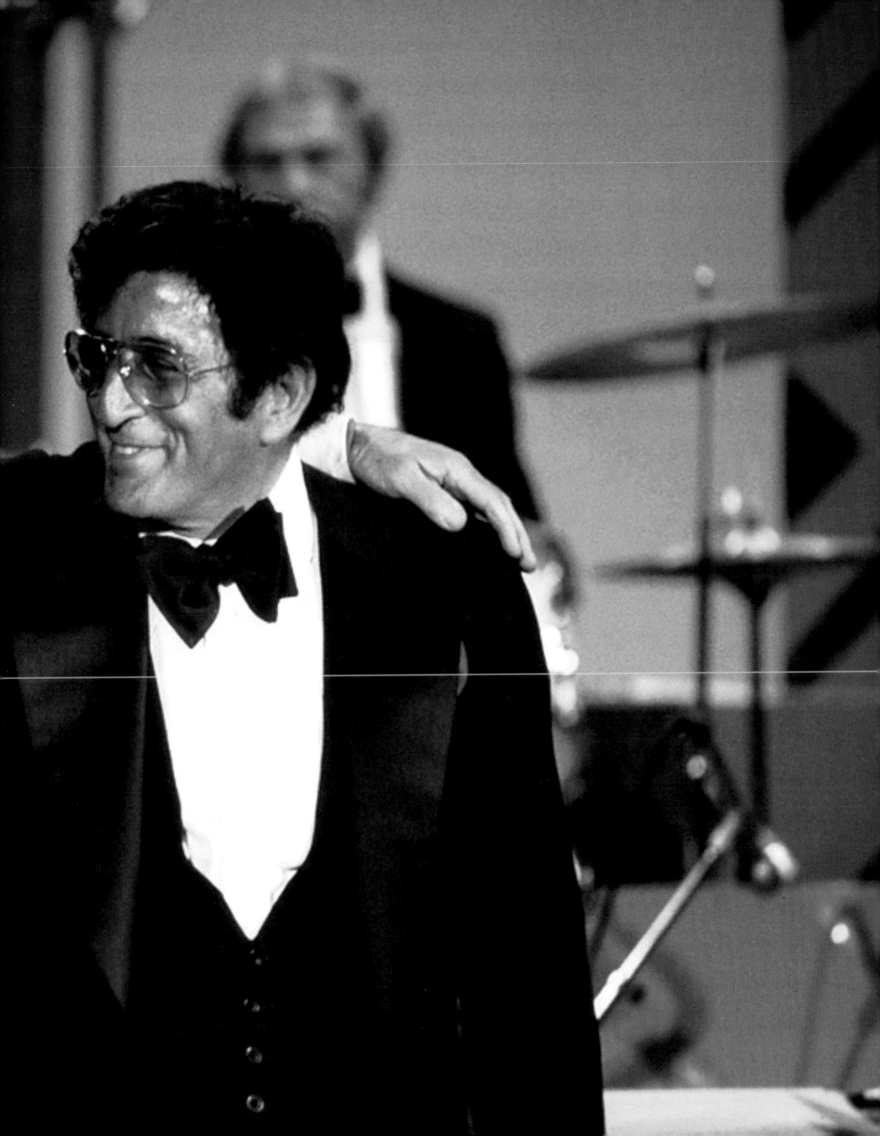

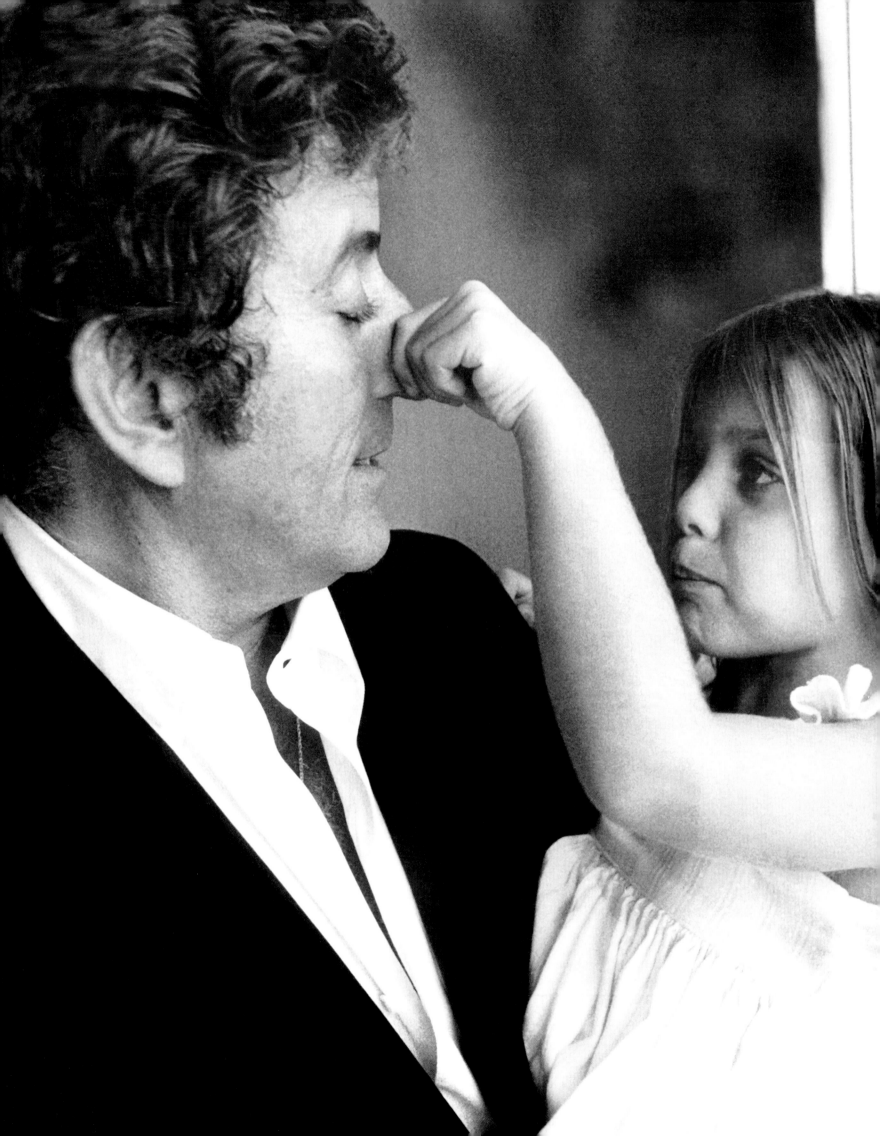

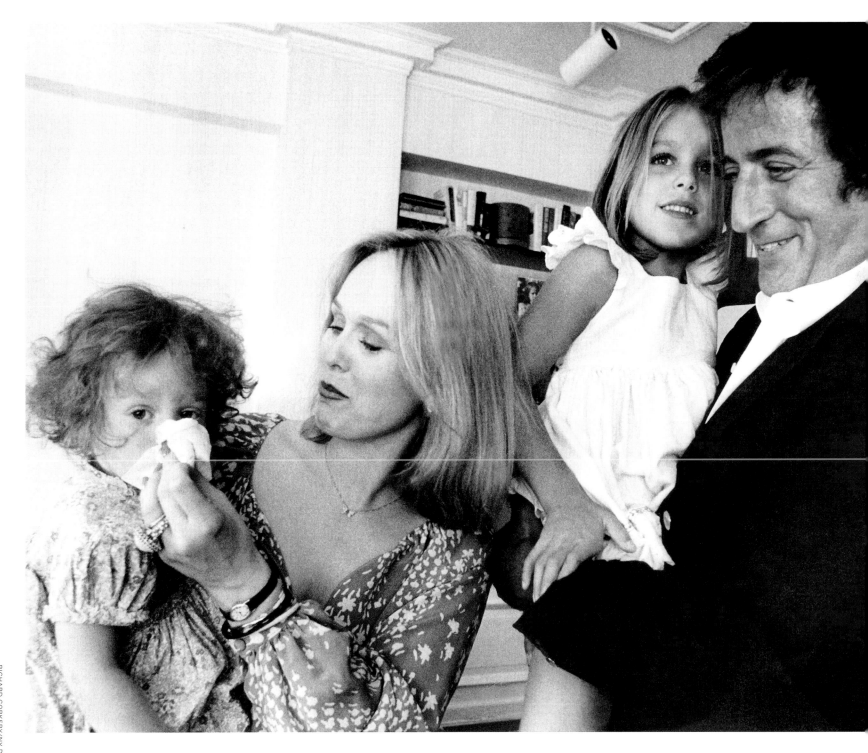

RICHARD CORKERY/NY DAILY NEWS ARCHIVES/GETTY (2)

TONY AND SANDRA'S second daughter, Antonia, was born in the spring of 1974. (Antonia is an accomplished singer today, and throughout 2014 was joining her dad at regular occasions on tour.) Not long after her birth, the family relocated to Los Angeles, but that didn't last very long, as the lifestyle was problematic—a point we will explore a little more fully on the pages immediately following. By 1977, when these pictures were made, the family is back in New York, on Central Park South. Opposite: Dad and six-year-old daughter Johanna. Above, the family coping with Antonia's sniffles.

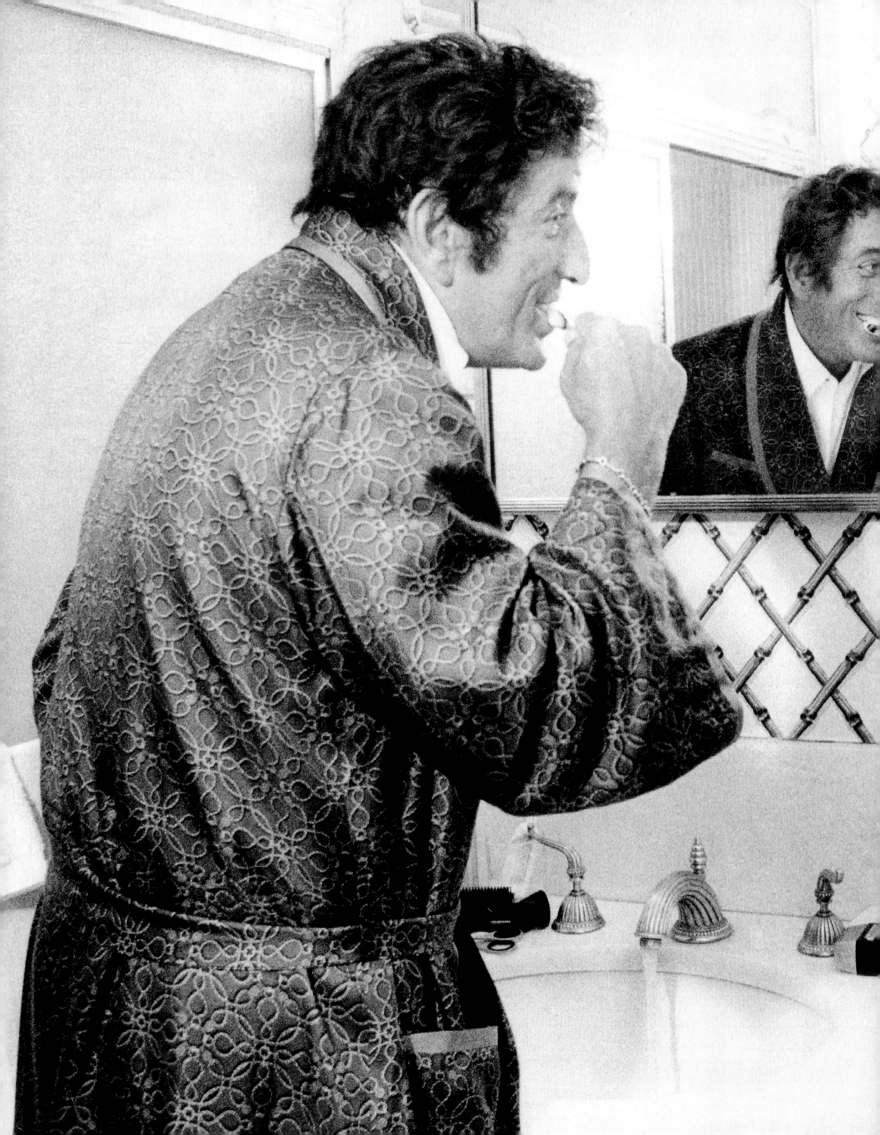

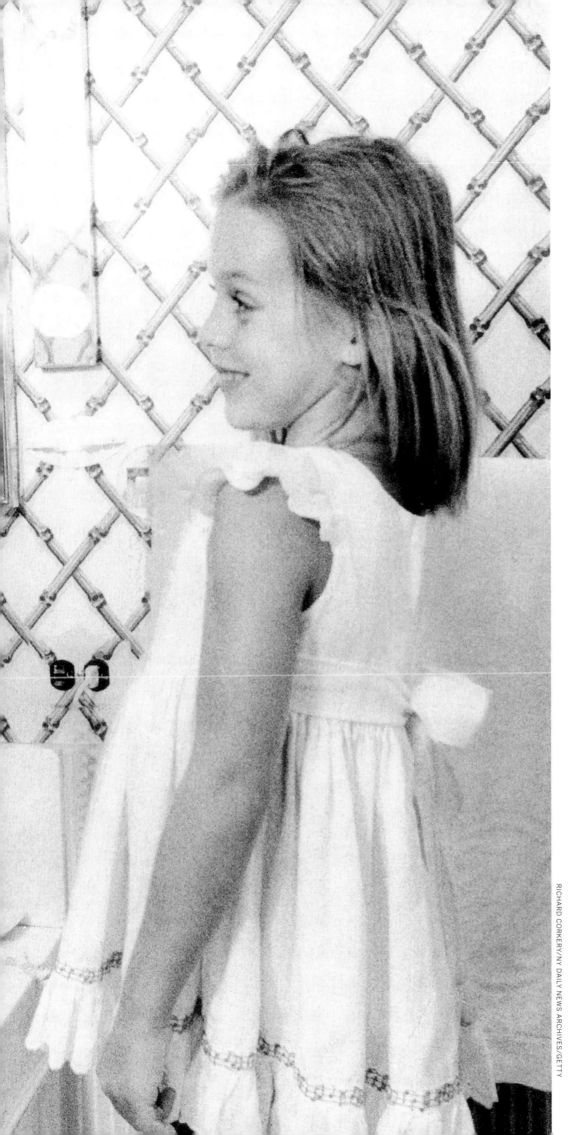

HERE ARE TONY AND JOHANNA
in the New York apartment in June 1977. As
for the brief stint in La-La Land: That was
in a large house in Beverly Hills. A mistake?
That really can't be said of any particular
events or decisions in a life as full and
successful as Tony's—who can possibly
know what might have led to what?—but as
he freely admits in his memoir, he was soon
experiencing all that Southern California's
showbiz society had to offer, "the good and
the bad." The good included deep friendships
with Fred Astaire, Cary Grant, Ella Fitzgerald
and others. Johnny Carson, who had
featured Tony on his very first *Tonight Show,*
was a pal, and asked Tony to perform on
several occasions. Carson was happy to have
Tony bring along new paintings, too, to
show the folks, and thus was Tony introduced
to his fans as a visual artist.

The bad included drugs and an
increasingly unstable marriage. His record
company hadn't worked out financially—
"One thing I'm not is a businessman."
He once told *Good Housekeeping* magazine
of a vivid moment when, after a postconcert
party in Las Vegas, he looked down from the
balcony of his hotel and saw a solitary man
walking the streets: "It was like a light bulb
went off in my head. Very quickly I came to
realize all I needed to make me happy was a
drumroll, a band and some people who want
me to sing. Looking back, I know I grew up
only when I was already in my forties."

"I WANNA BE AROUND": 1980-1990

"I GOT TOO MUCH TOO SOON," Tony once told London's *Daily Mail,* while reflecting in that thoughtful way of his. "It takes a long time to learn to live with the helium in the brain and you just kind of float away. You need lead weights to hold you down." He felt, at the dawn of the '80s, that he needed his sons to help him—and he told them so. This was the birth of the solid family team that would nurture the remarkable twilight renaissance of Tony Bennett—one of the greatest and most sustained late-season rises in the history of American entertainment.

Tony shook his drug habit. Danny took a look at the books and realized Tony and Sandy were living in a deficit situation. He proposed a budget, and a new professional direction that included less Vegas and a strong push for a younger audience. Tony was fine with it—delighted with it—but his relationship with Sandy was already on the wane, and the stripped-down lifestyle was the last straw. Tony's second marriage was headed for the rocks.

Sad news, certainly. But still: Gears had shifted.

Tony went forth into a new tomorrow.

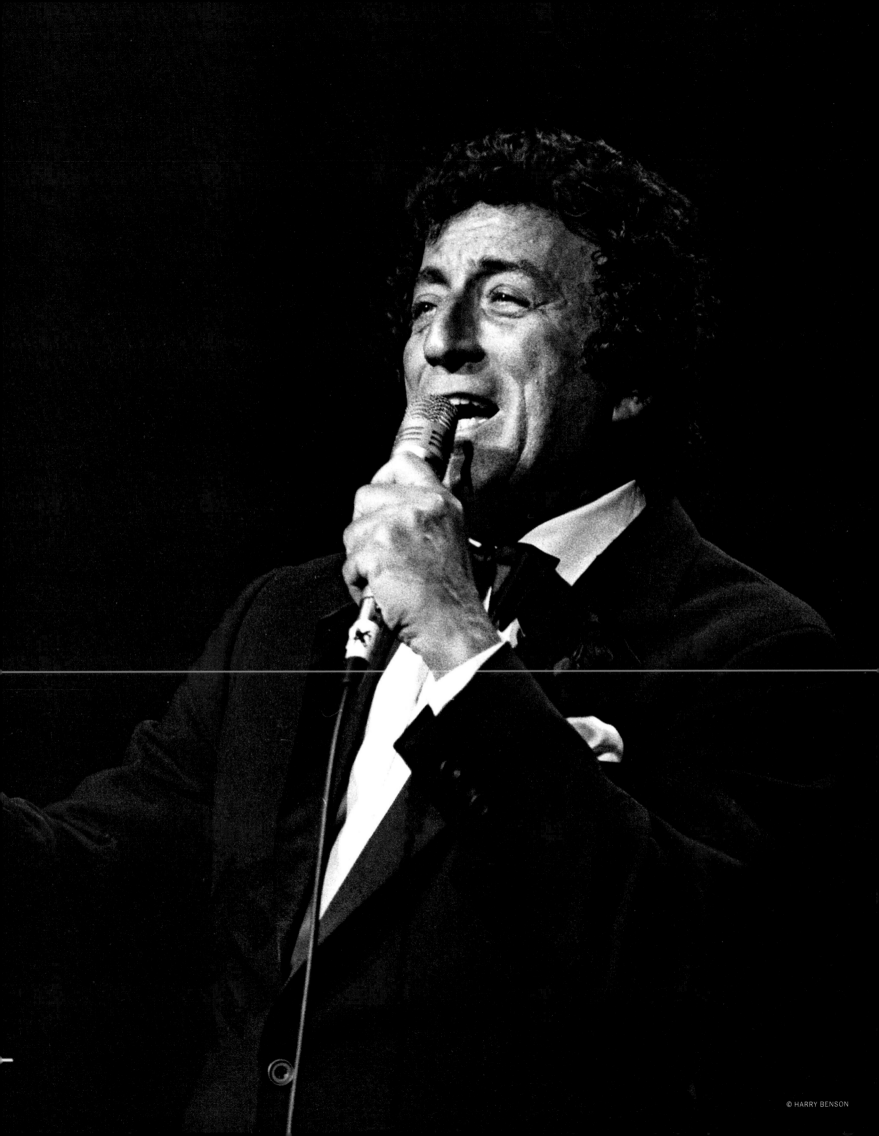

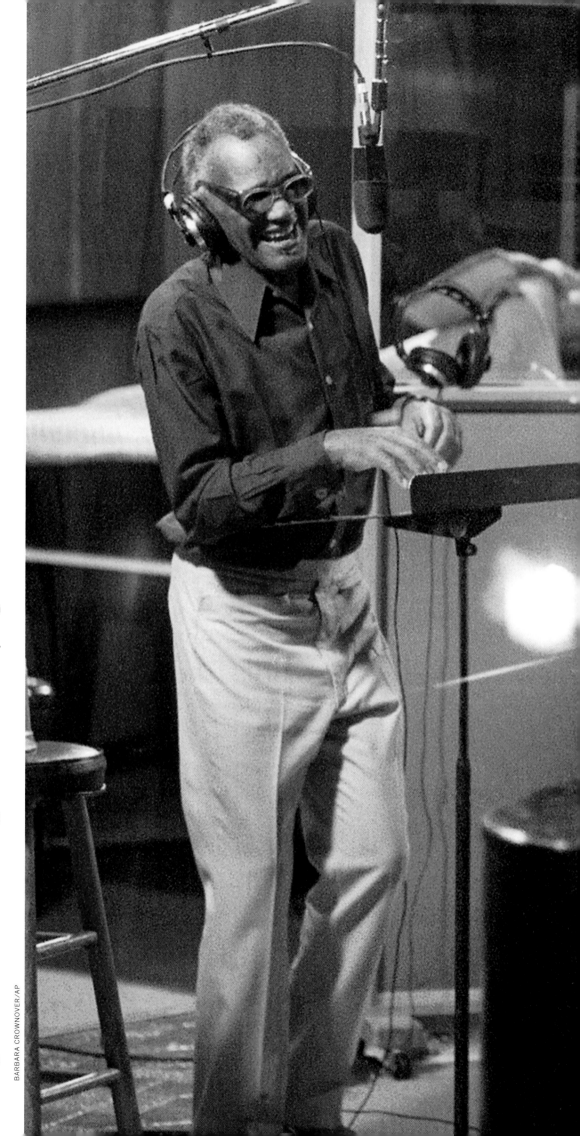

EVEN AS HE COURTED a new
audience, he never departed from what he
saw as "quality," and here he records
with the great Ray Charles at Larrabee
Studios in Los Angeles on January 4, 1986.
Somehow, all the trials, and the fact that
he was coming out at the far end of them
with a plan for the future, strengthened
him. He had the perspective of a man who
had tasted much that life can both offer
and inflict. In this period, he gave an
interview to *The Boston Globe* before a gig in
Cohasset, Massachusetts. He said at one
point, "I used to take pills. Uppies. Downies.
Sleepies. But no more. I'm in touch with
myself. I'm healthier now than I have ever
been. And I've become unbuggable."

Unbuggable. What a fine Tony Bennett
word.

One thing he had never left behind and
could summon again, as here in L.A., was
the singing. When I first wrote about Tony
Bennett in 1995, Abby Mann, the writer of
Judgment at Nuremburg and Tony's lifelong
friend and confessor, was still alive, and
told me the most vivid story regarding this
compulsion to sing, even when any other
person might feel not at all like singing: "He
was terribly depressed, at loose ends—his
second marriage was breaking up and
he was trying to find himself. I was in a
divorce at the same time, and we were
helping one another get through. We were
in Rio, I remember, in a club. This singer
started singing in Portuguese. Tony started
humming, then it just poured out of him.
He was scat-singing away! Everyone was
electrified. He wasn't drunk or anything. He
was a very unhappy man, and still he sang."

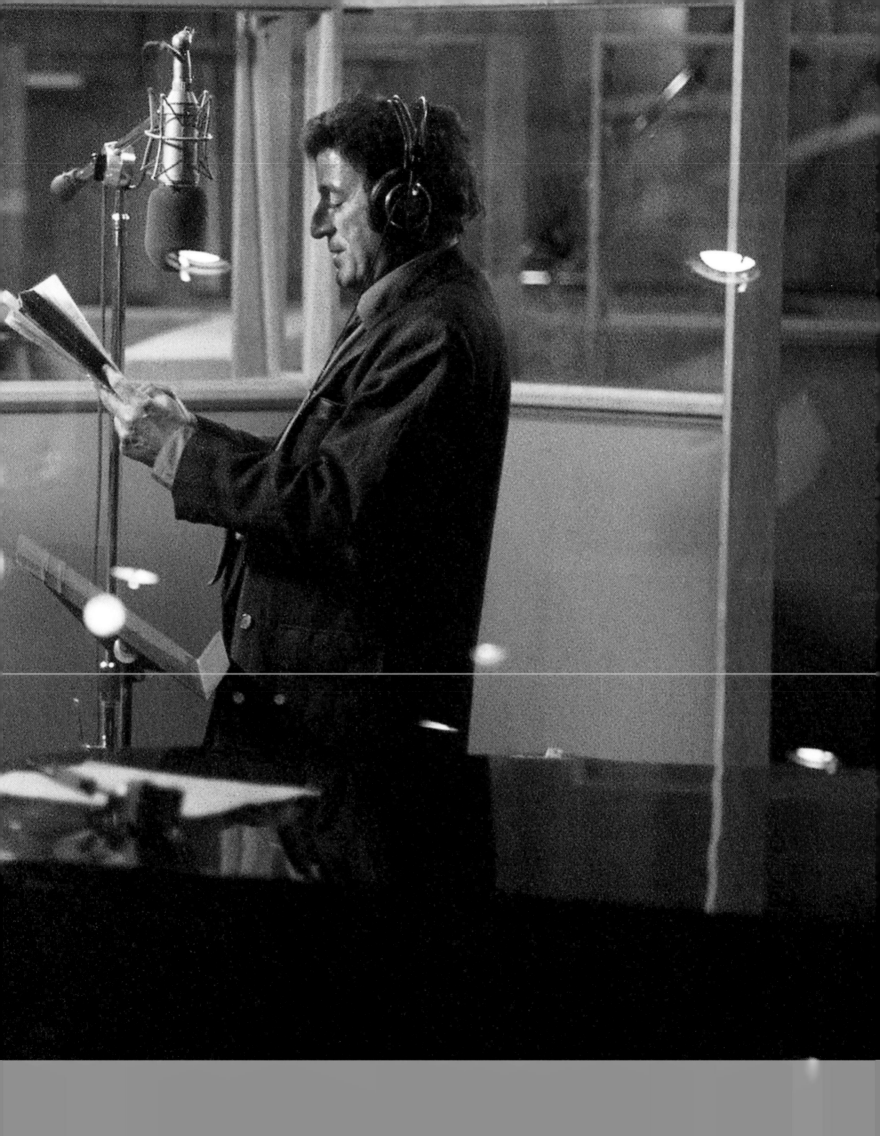

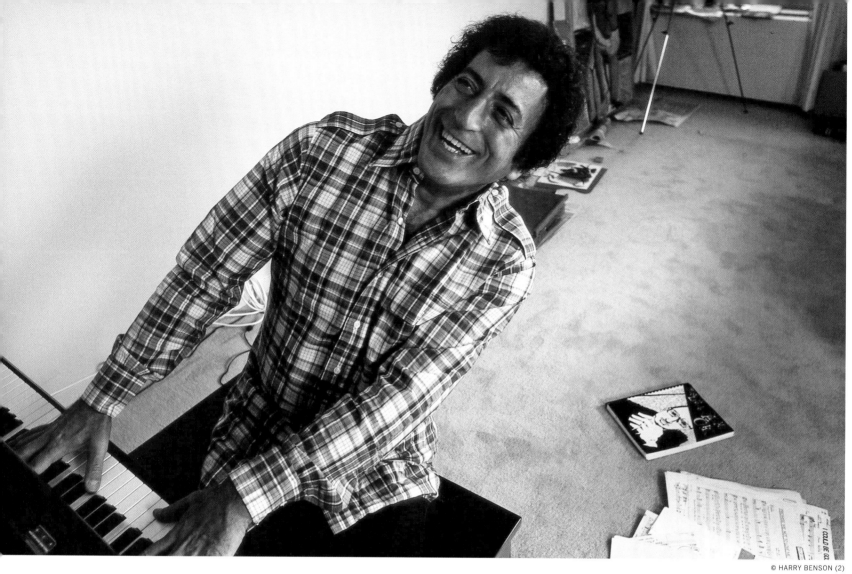

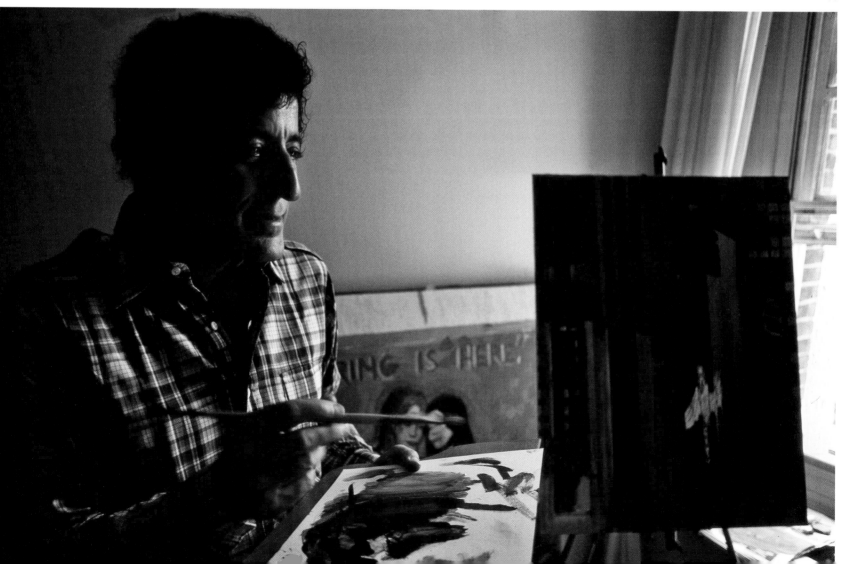

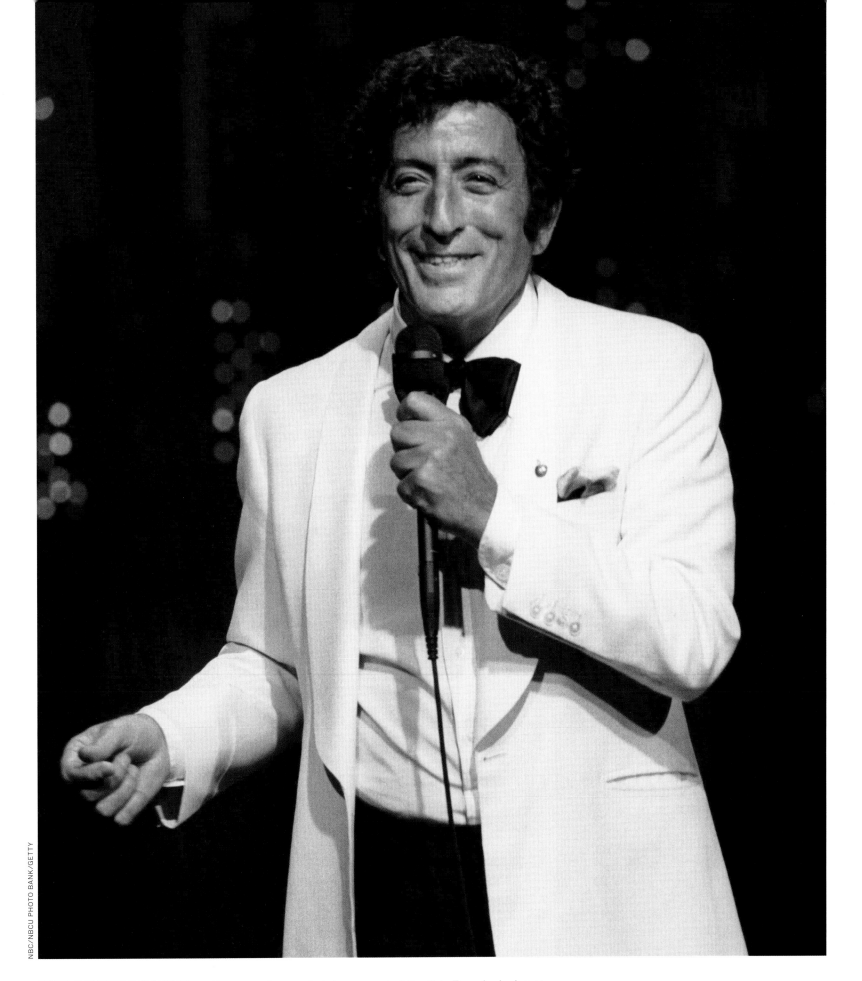

THE PHOTOGRAPHS on the opposite page, as well as the one that leads this chapter, were taken in New York City by Harry Benson and therein lies a small irony: As a young man, Benson shot the famous Beatles photographs of a pillow fight in a Paris hotel room and of the Fab Four deplaning at New York's Idlewild Airport to initiate their conquest of America—the very moments the Beatles were shunting aside popular singers such as Tony Bennett. Above is Bennett climbing back to the top of the heap in 1987.

HERE AND on the pages immediately
following are two more photographs by
Harry Benson, a great friend of LIFE's since
the 1960s. He took these in 1986. What
was Tony thinking, as he looked out on the
New York sidewalk? Perhaps about the
journey, about having become unbuggable.
And perhaps: He is ready to succeed at
this last chance at the big time. He is strong
and will get stronger.

When we sit in the Trustees Dining Room
at the Metropolitan Museum, he watches
streetlights coming on in Central Park—the
precise same attitude he displays in this
Benson photo—and remembers his old friend
Abby Mann's advice: "He always told me to
do it by yourself—keep going forward, and be
loyal to yourself." As if to reward Bennett's
tenacity, and his return to sound principles,
Las Vegas's Desert Inn has given him
$1.8 million for 16 weeks as the '80s dawn.

There is a leitmotif running through
Tony's testimony: "Somebody told me." He
never says, "I say this . . . I say that." He's
careful not to sound egotistical, although
given his seniority, that might be excusable.
He ascribes the standards he lives by to
minds that, he fancies, are wiser than his
own. Bob Hope knows show business. Abby
Mann knows psychology. Sinatra knows
what an audience wants. He seems to be
saying that "Tony Bennett" is a synthesis.
But he isn't. He's a guy with sand in
his voice and an ability to communicate his
passion, who has, by paying attention and by
going the extra airplane mile when it looked
like the game was up, become an original.

Another interesting thing about this
leitmotif is the history of American culture it
traces. In a single afternoon at the museum,
Bennett recounts that he was given advice
by George Burns and Jack Benny during
the waning years of vaudeville, by Sinatra
and Crosby and Ella and Nat during the
glory years of popular singing, by Duke and
the Count and Louis Armstrong on jazz,
by Martin Luther King Jr. on the value of
pacifism—King's counsel helped Bennett
overcome a pugnaciousness that had landed
him in more than a couple of fights—by
Judy Garland about the perils of stardom, by
Rosemary Clooney about perseverance,
by Allen Ginsberg (Allen Ginsberg!) on book-
buying in New York and by Elvis Costello

about the kids these days.

One of Bennett's big hits was "I Wanna
Be Around," and he has been. His mature
interpretations of the Great American
Songbook have an insight that is breathtaking.

"You know what he's doing?" asks Dick
Golden, a radio personality who has known
Bennett since the 1960s. "Given this last
chance to record, he's doing definitives. He's
nailing some of these songs to the wall.

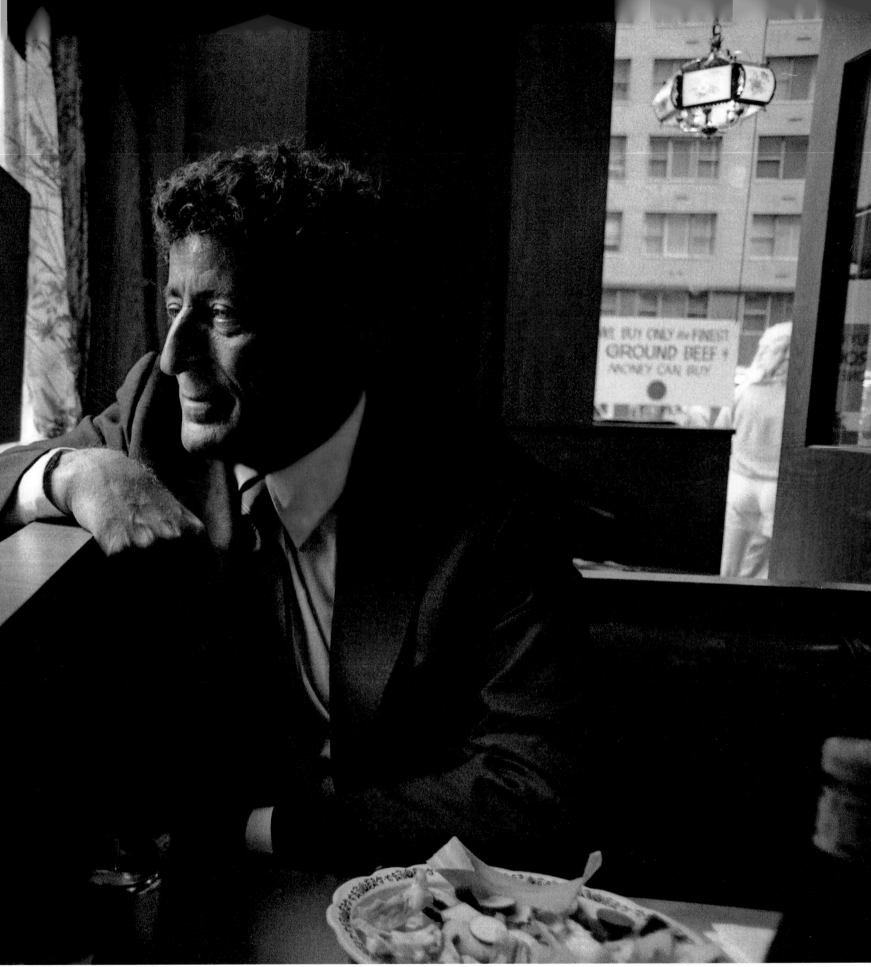

When Sinatra recorded 'Night and Day,' that was it, right? Well, listen to Tony's 'Dancing in the Dark.' Listen to how he refound 'Steppin' Out' with that rhythm. Listen to what he does with Weill's 'Speak Low.' I mean, it's just unbelievable."

Dear reader: Please indulge me with a recounting of the Allen Ginsberg story, and why it may matter or not matter at all, on the pages immediately following.

LET'S AGREE: Tony Bennett always has been hipper than thou, vital and eclectic. Perhaps because of that, his world has never fit into a circumscribed sphere, a Rat Pack or, today, any kind of oldies mode.

He and Allen Ginsberg, the late Beat poet, were born 88 years ago. These two boys grew up on the other sides of rivers, gazing at bridges, dreaming Manhattan dreams. One was from Astoria, Queens, as we know, and the other from Paterson, New Jersey.

Each crossed his river, going to school in town, finding a first rush of excitement and a first blush of success on the never-sleeping streets of postwar Manhattan. Then, like so many young men, they went west. In the Bay Area, that well-watered garden of hipness, they seized greater notoriety—in fact, became branded by the town, as the seminal works they created there became, for their millions of followers, anthems. The 1950s became the '60s, and their arts and minds expanded. Both got into drugs.

The 1960s belonged to a younger generation, yet these two men were still standing. One embraced Buddhism well before it entered the zeitgeist; the other went south and marched with Martin Luther King Jr.

In 1994, I was to write two profiles, the Tony Bennett piece for LIFE and another on Ginsberg. I was interested in both men, who were obviously as different as day and night. My tastes in music had aged to a point where I owned several Tony CDs, but my world view was still informed by lots of Kerouac, Ferlinghetti and Ginsberg. Miss Cusick, a cool English teacher, introduced me to blank verse. I and colleagues on the school paper took her to Caesar's Monticello nightclub in Framingham, Massachusetts, in 1971. She chose Caesar's because Tony Bennett was performing.

A couple years later, I saw Allen Ginsberg and his partner Peter Orlovsky perform, and a few years after that I saw Ginsberg play tambourine, or some odder instrument of percussion, when Dylan's Rolling Thunder Revue rolled through Lowell. Anyway, I had these deadlines for comeback-kid pieces on these guys I had seen long ago.

I met Tony and Susan in midtown and we rode in the stretch limo up Madison Avenue, then across to the Metropolitan Museum of Art: This was that first lunch. Tony was

impeccable and upbeat. He had a "Hiya" and a hand clasp for any museum worker or adoring fan who approached with a smile. We sat and talked in the Trustees Dining Room near a large window overlooking the park. It was winter, and the four o'clock slant of light flared, then faded as streetlights came up.

Tony played the gallant host throughout the session. But even as winning a conversationalist as he cannot carry the ball forever, and there came a lull. Searching to fill dead air, I offered irrelevantly, "Tomorrow I'm seeing Allen Ginsberg."

"Allen Ginsberg, Allen Ginsberg," Tony said, in that soft rasp of his. "Very interesting cat, Allen. I like him very much. Met him long ago at a party in the Village for [the artist] Franz Kline. We hit it off. I had been looking for this art book and Allen told me where to find it, a dealer named Bill . . ." Tony remembered the name, but I don't. "I called the guy up and got the book. Allen was into Blake. We talked about Blake. I was trying to put some Blake poems to music, and so was Allen.

"Tell Allen I said hi. Interesting cat, Allen."

We left the museum, and as the limo drove south through Central Park, Tony was humming a tune.

Next day, it was bitter cold as I walked to the Lower East Side building where Ginsberg lived. The front door was broken and open; I made my way up several flights of stairs. Steps needed fixing and walls needed paint; the place did not feel safe.

Ginsberg's door was open. I knocked gently and heard him mumble something. The poet was seated at his kitchen table eating a bowl of soup. Dishes were piled in the sink; the place was thoroughly cluttered. But it was interesting: Books were everywhere. On one wall was a framed copy of Blake's "The Tyger"; on another, a Buddhist prayer wheel.

"Sit down," Ginsberg ordered. I knew that he considered the interview an art form, a duel, and we had begun. He ate, declaiming while he did so about one outrage or another—the CIA and Nixon came up.

I realized that of all the world's interview subjects there were few less vulnerable to being softened up by small talk than Allen Ginsberg, yet I had an assignment.

"Tony Bennett says hi."

"Tony Bennett," said Ginsberg in that

acute staccato of his. "Tony Bennett. Tony Bennett. I met him at a party for Franz Kline." *Remarkable,* I thought. "He was very much into Blake. Do you know Blake visited me in a vision in 1948? In Harlem? He did.

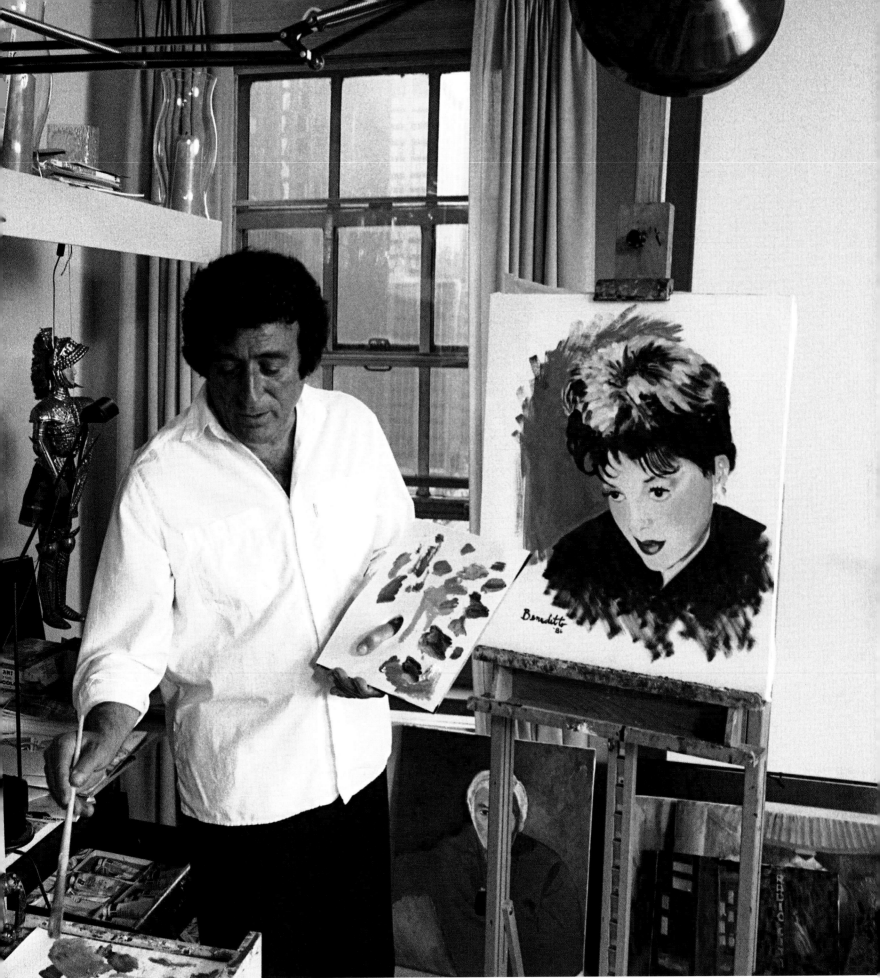

"Tony Bennett said he was putting Blake to music and I told him there was no need— I'd already done it myself." I suppressed a smile as I mused that Ginsberg's chanting might not fill the void for Tony's fans.

I said: "Tony said thanks for the book. He found the book through your friend . . ."

"Bill . . ." Ginsberg remembered the name, but I don't. "Well, I like Tony Bennett. Very interesting man, Tony Bennett."

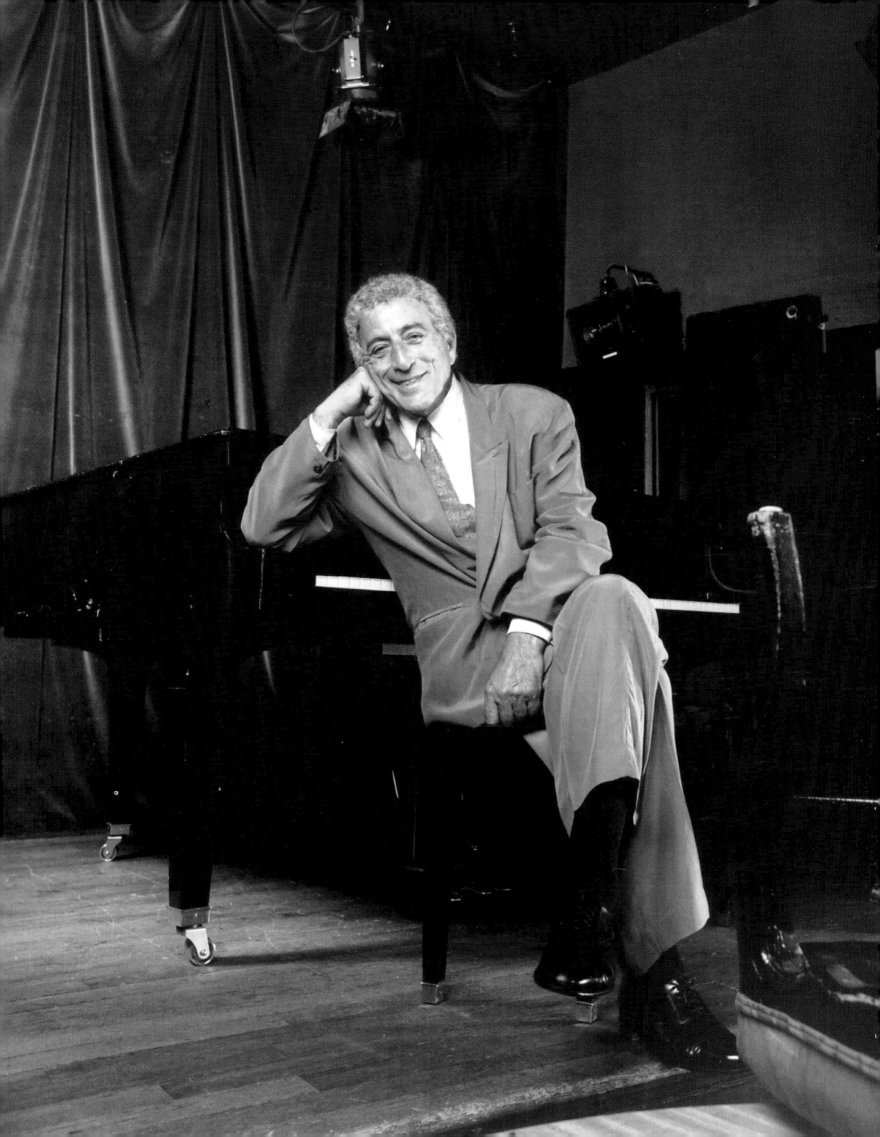

THE YEAR IS 1992 when he poses for a publicity photo, left. He is well and truly poised for this entirely unpredictable and day-by-day thrilling next chapter.

There's a well-worn joke about "the band Paul McCartney was in before Wings." But this wasn't a case of a later lesser band, this was the same guy. Kids who got to know Tony in the 1990s had no idea what "Rags to Riches" sounded like. Their grandmothers who wept when he married at St. Patrick's Cathedral had no idea who the Simpsons were. We will not invoke the Grateful Dead and that "long strange trip" business, but only because Tony never sang with them.

Or did he? You never know with this guy.

"THE BEST IN THE BUSINESS": 1991-2014

HE WOULD NEVER PLAY anything but the topmost rooms again, and here he is acknowledging the applause at Radio City Music Hall in Manhattan—just down the street from his apartment—on October 17, 1998. Radio City is nine blocks south, Carnegie Hall is three blocks away, and these would be his locals. On television, too, he only plays the best rooms, like that of his friend Johnny Carson (on the following pages, in 1992). Has any entertainer ever arrived at such a rarefied status?

Has any other entertainer ever so progressed and improved into his 89th year that he leaves audiences night after night not only marveling that he was still able to stand and deliver but thrilling at the wonderfulness of the performance?

As we have mentioned earlier, it was Frank Sinatra, admittedly a friend of Tony's but, still, a man whom many consider the best singer ever in the business, who called Tony, in the pages of LIFE, the best in the business. If Sinatra's estimation was right, we are all privileged that the best in the business is still on the job, night after night, blessing us with his talent, with the product of his lifelong hard work and with his singular aura. These things brought him back to the top, where he remains and reigns.

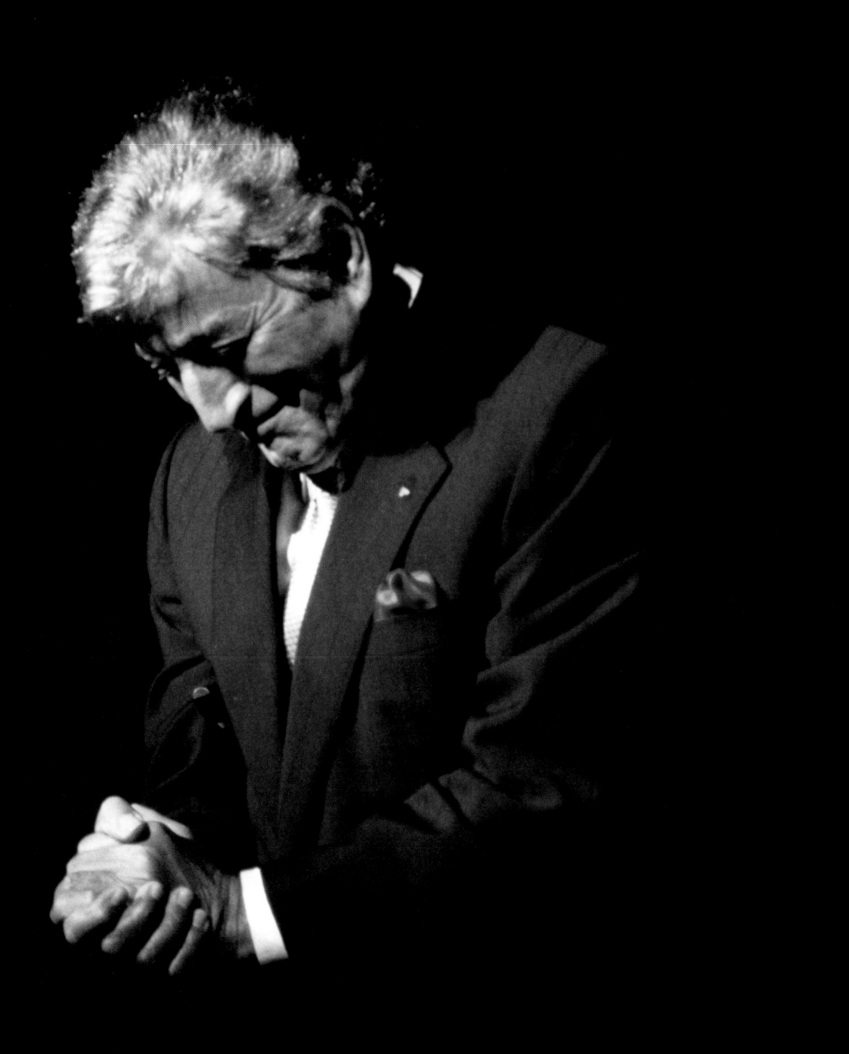

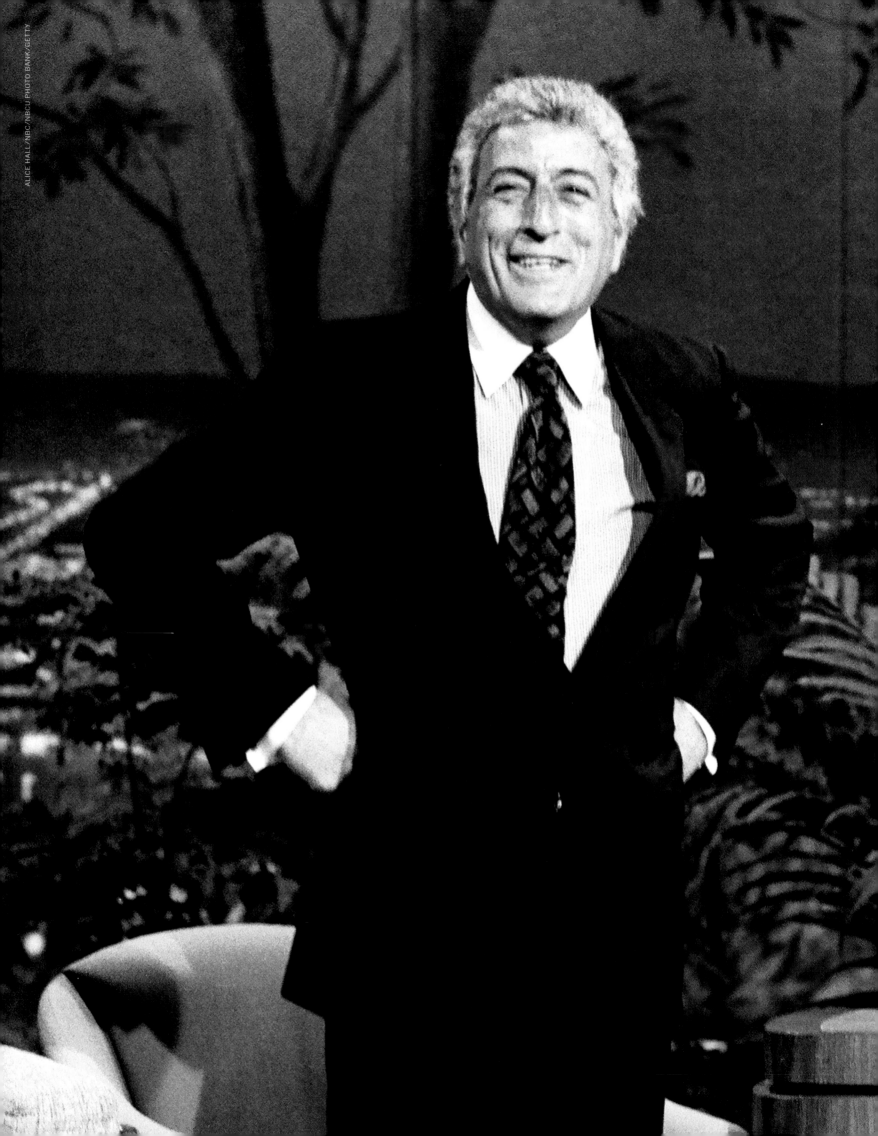

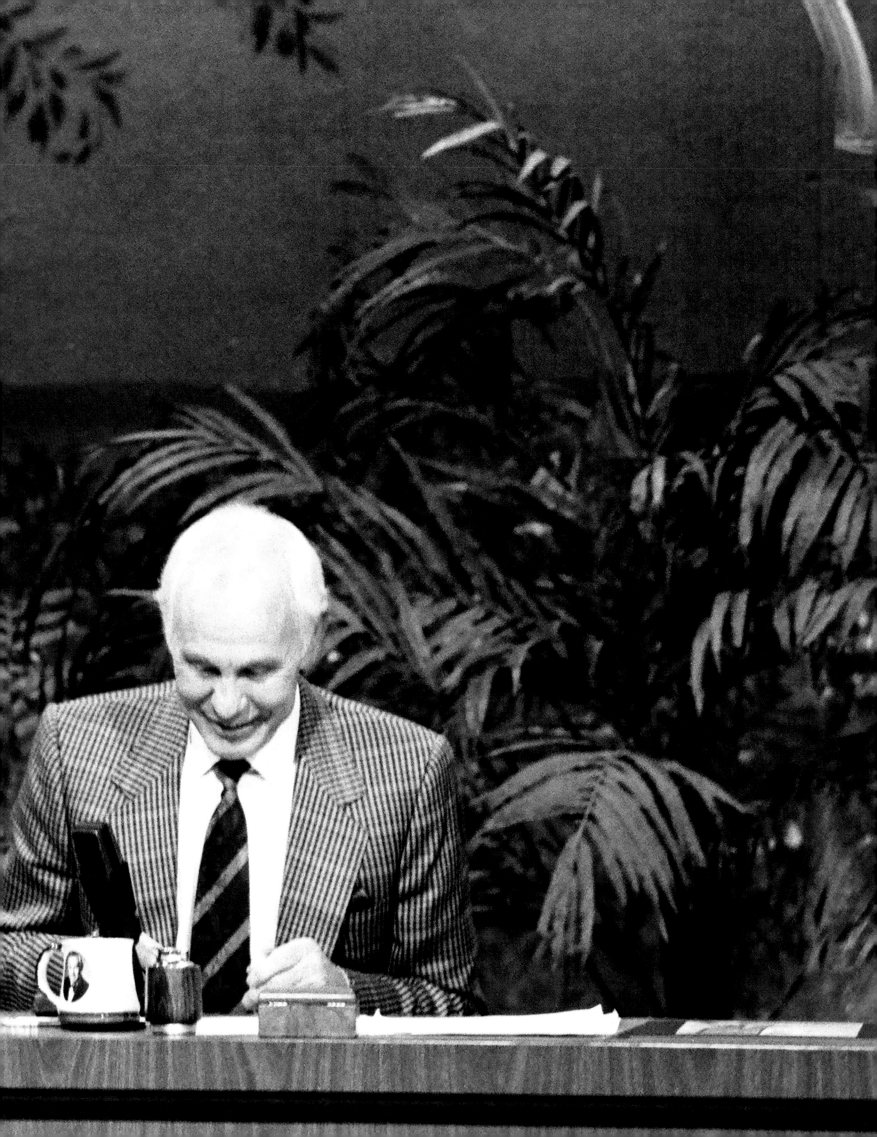

WHAT STRANGE TRAIL brings a man from the lows of the Gotham Hotel, alone at Christmas in 1965, to such a peculiar summit in later life? Tony is asked this question, in so many words, as he rides through Central Park early that afternoon of the lunch at the Met. "I'm not sure," he says, "It's been crazy, this whole thing with the kids. My son Danny did all that. He said, 'Just trust me, Dad.' He got me on *The Simpsons,* and then MTV. I said, 'Hey, what's going on? I'm not used to this.' He said, 'Trust me.' All of a sudden, kids!

"Strange," says Tony. He has this habit of delivering a final phrase in an airy, detached way; it's as if he is talking to himself—trying to figure things out for himself—as much as to his listeners.

The limousine pulls up before the museum. On the Met's endless series of steps, Tony is greeted by several fans. He handles each with an instinctive grace that creates a lasting memory. At the museum's entrance, he is met by an escort. Tony is given a star's table by the window, a huge window with a vantage that just might be the most sublime image in this warehouse of sublime images. Central Park cyclists and strollers are fleetingly seen through bare trees; on this winter afternoon the sky is already gray. "I love that park," Tony says in a soft voice. "I always dreamed of having a place that would catch the afternoon light, so I could paint the park over and over." Talking to himself again? Tony is well aware the dream has come true.

Sinatra, Carnegie, Carson . . . now *The Simpsons,* Elmo? "My life has been like a cheap novel," says Tony. "Interesting people, adventures, strange twists." It's the story of a roller-coaster ride: way up or way down, or headed in the other direction aboard a speeding train. Wrecked marriages, drugs, career dead-ends, depression and hours on the psychiatrist's couch now lie behind, and sitting here sipping juice is a tanned, impeccably tailored model of contentment. As he talks into the evening, it becomes clear that the factors behind his survival—and, indeed, his revival—include good fortune and also a kind of fortitude that is way beyond the norm, reflected in what Danny cited earlier: an absolute inability to stop singing, even when stopping would have been expected.

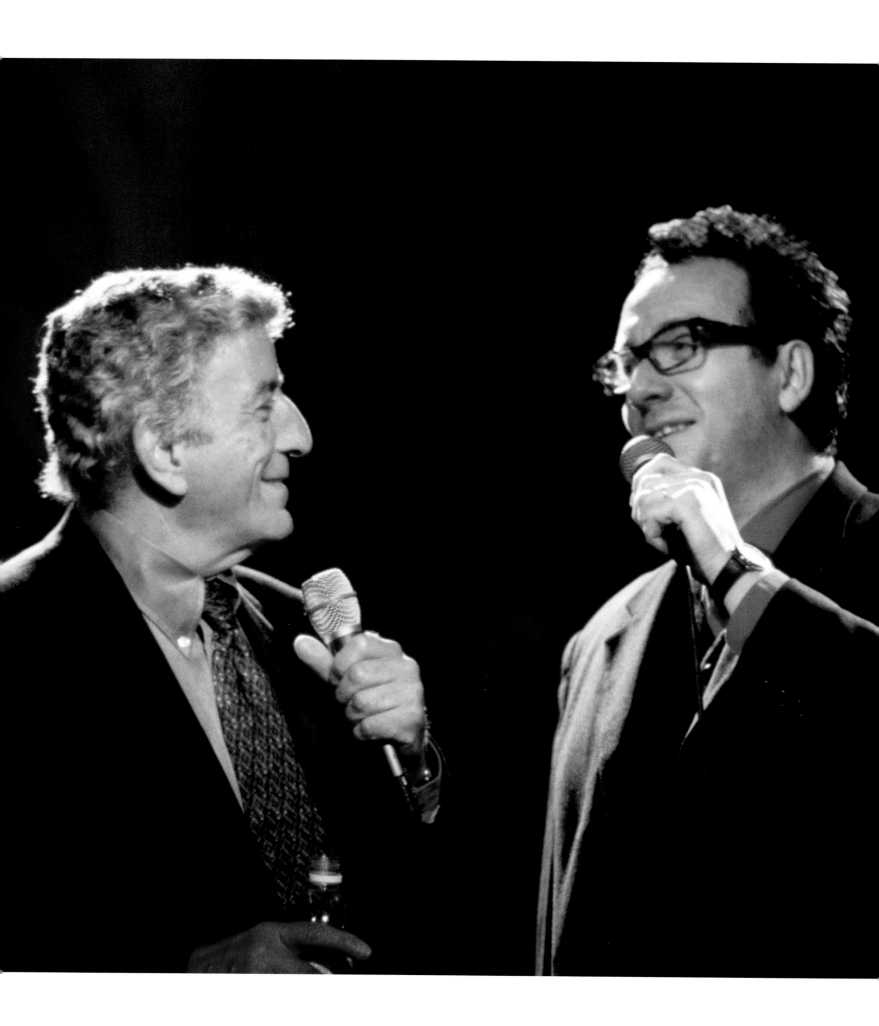

TONY WAS THE FIRST publicly famous person to portray himself in an episode of *The Simpsons,* in 1990. Danny's brilliance. Overnight, he was hip again with a young generation. Next came MTV;

opposite, Tony is seen with Elvis Costello, who would become a friend and future collaborator, and above, with K.D. Lang, who would become a friend and a larger future collaborator, even unto an entire duets disc.

Duets projects, which yielded sensational albums, were relatively easy to arrange in the new millennium as Tony was back at the fore, and who would *not* want to sing with him? No one would not want to.

SOMETIMES DURING the duets projects, the collaborators came to New York or New Jersey and sang alongside Tony. Sometimes Tony happened to be traveling, and serendipity prevailed: Above, in 2011, Tony and Andrea Bocelli record "Stranger in Paradise" in Bocelli's home outside of Pisa, Italy. Sometimes, too, as especially with the current Lady Gaga splash, duets turned into star turns, as when Paul McCartney and Tony, who recorded "The Very Thought of You" for the first duets disc, harmonized at the Shoreline Amphitheatre in Mountain View, California, in 2004 (right). The Beatles had once dethroned Tony and his ilk, and now this. On the pages immediately following: It is needless to say that Tony is in the highest realm of the world's celebrity in the present day, and that's George Clooney giving him a gentle squeeze in Beverly Hills.

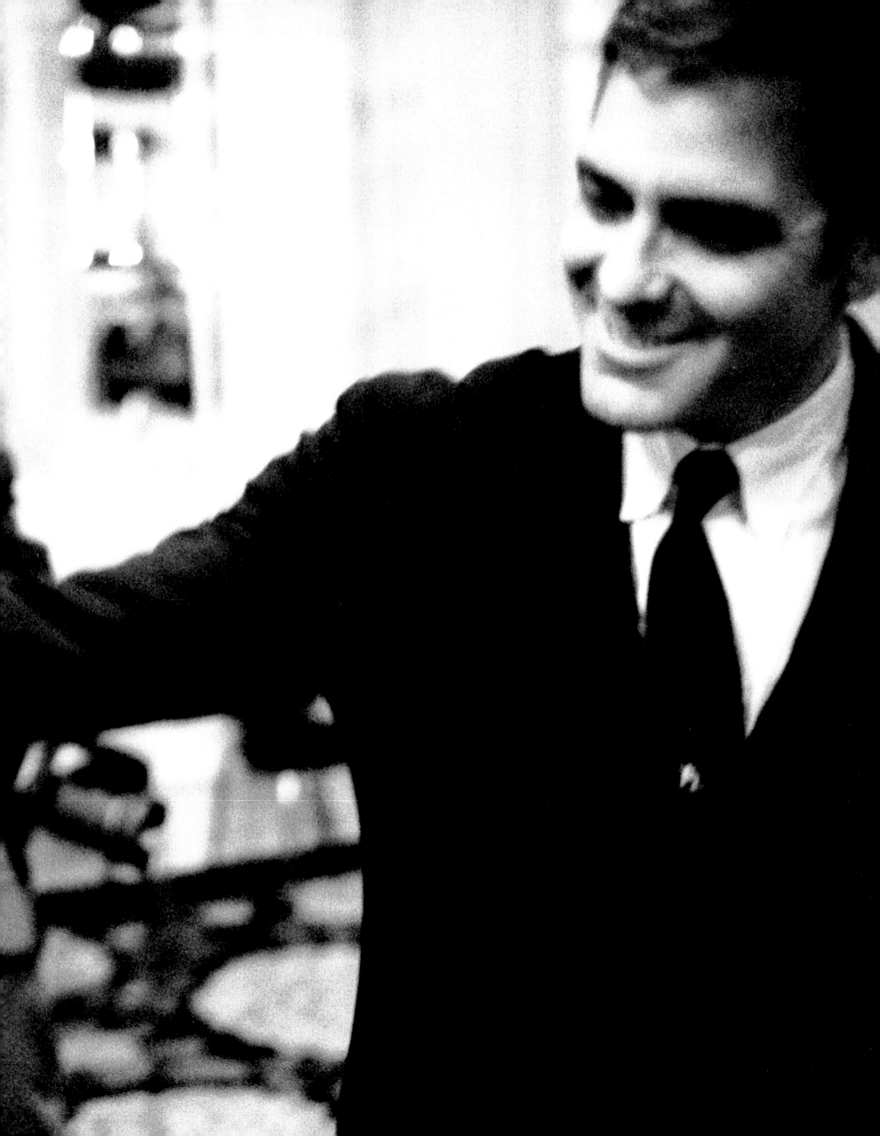

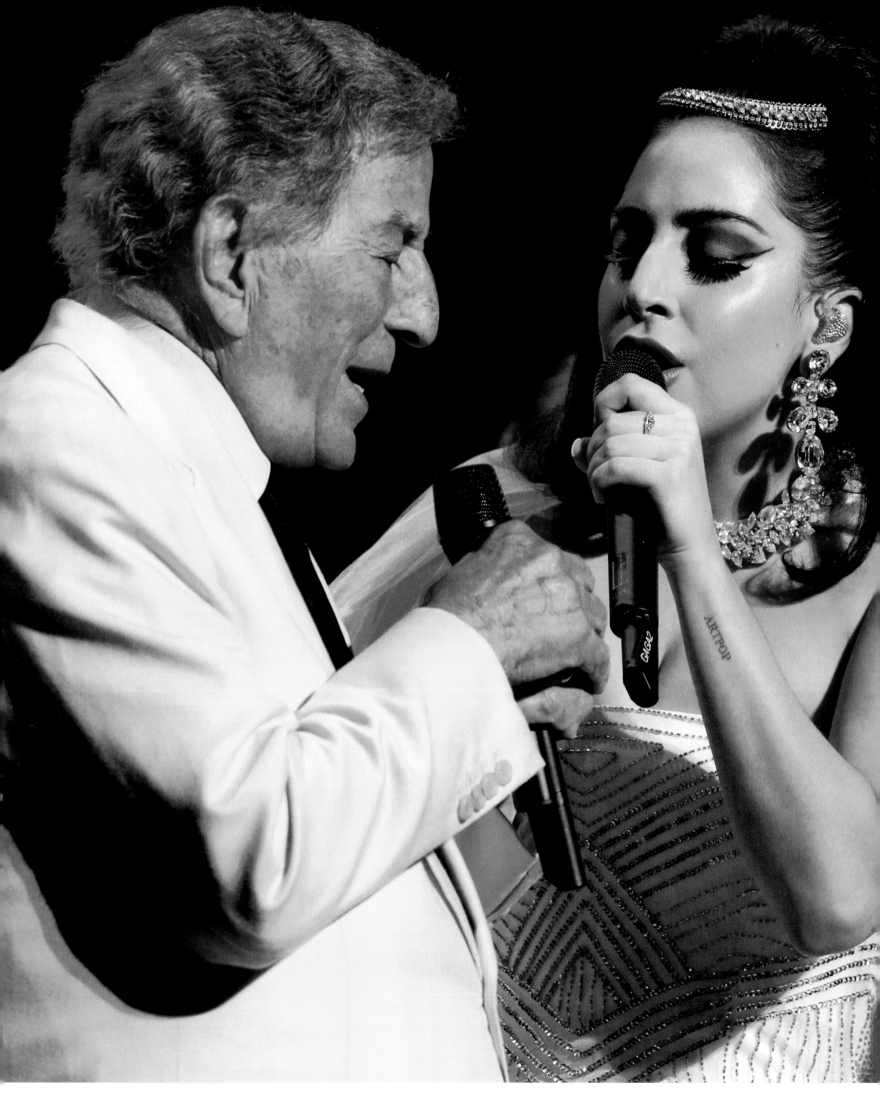

ABOVE: In 2011, Tony and Norah Jones hang out in a studio in L.A. where they record "Speak Low" for Tony's *Duets II.* A single from that album is "The Lady Is a Tramp," Tony's first collaborative effort with Lady Gaga—but not his last. "Turns out she loves jazz," says Tony during a recent chat. "She's a jazz singer, a very, very good jazz singer. She can bring this music to her fans. After *Cheek to Cheek* comes out, we're going to do some concerts. My thing with Lady Gaga, the reason I did this with her: I know her fans are going to come out and hear this music

and fall in love with it. She's a friend now, For my 88th birthday, I couldn't believe it, I was at the Fairmont hotel in San Francisco, in the Diplomat Suite—you can look out and see the sky. And I get these flowers, 'Happy Birthday, Tony—love, Lady Gaga.' And then this handsome boy, handsome like Cary Grant, shows up and he plays 'I Left My Heart in San Francisco' on the trumpet." The Tony-Gaga recording he speaks of came out September 23, and went right to the top of the jazz charts, only weeks after its first single, "Anything Goes," had done the same.

AT RIGHT IS TONY at the easel and above is a New York cityscape featuring yellow taxis next to an open window revealing the subject matter. Tony's taxis and his flags are, he freely admits, influenced by—even an homage to—Childe Hassam's New York City paintings. He enjoys riffing on the masters, and just trying new things.

I'm in his studio, a few floors down from his and Susan's apartment in the same building, and he says, "Right now, I'm studying values, so that colors all match one another. It's like a musician finding chords that all relate to one another. It's all connected. I like impressionism still, but I'm interested in all kinds of painting. I'm

very interested in aborigine painting. It's very similar to music, the way that aborigine paintings look. It's the only type of painting that looks like music. Here, I'll show you." He picks up, first, a calendar that features 12 pictures made by Australian aboriginal artists. "You look at these paintings, see, they look like music. See? It's a musical look, the swirls and dots. There's nothing else like it. And, so, look at this . . ." He picks up a small oil portrait of the late trumpeter Dizzy Gillespie. "Many years ago I did this thing of Dizzy. And now I'm applying this aborigine-type background to it. I'm combining the aboriginal influence with musicians. Just one thing I'm doing just now. I'm enjoying it."

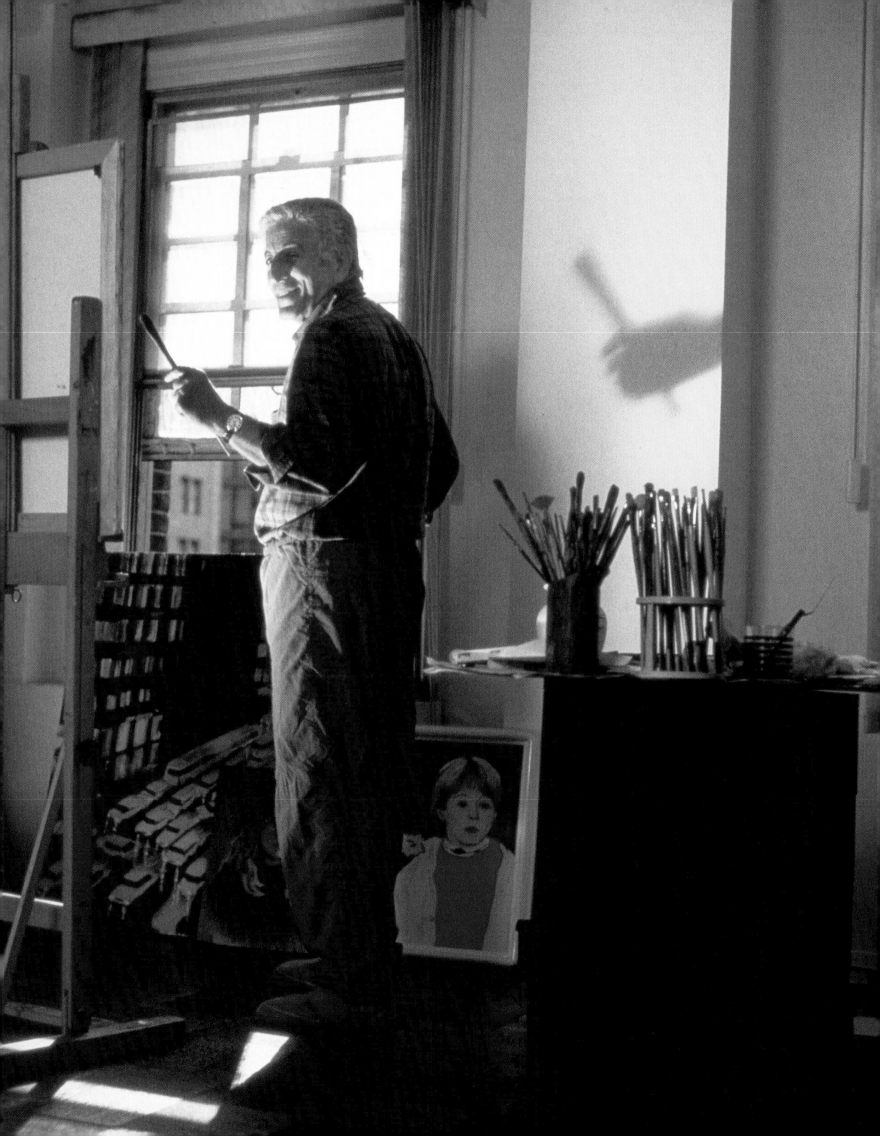

HERE AND on several of the other pages in this part of our book are a few wonderful portraits made by Joe McNally for the 1995 LIFE feature on Tony—some of these pictures have never been published. They show him in two locales—New York City, including the old Astoria neighborhood in Queens, and San Francisco. They don't attempt to sketch all the details of a good, full life, but describe where a boy came from and where the man has arrived.

Tony, in his seniority, still loves to travel, still loves to entertain his fans. When home he likes to enjoy a calm life with Susan and their dog, Happy. The dog we see on page 189 is Boo, who enjoyed many years of quality time and lots of love at the apartment on Central Park South. Boo is gone, but Happy looks quite like Boo, and behaves approximately the same. In the photograph here, Tony is reading the newspaper, a daily habit, on the New York subway. He stays engaged with cultural doings and especially politics. If he needed a term, he would call himself a Roosevelt Democrat, which has its own charm, considering that even such appellations as Reagan Republican or Kennedy Democrat are, these days, quite a reach back.

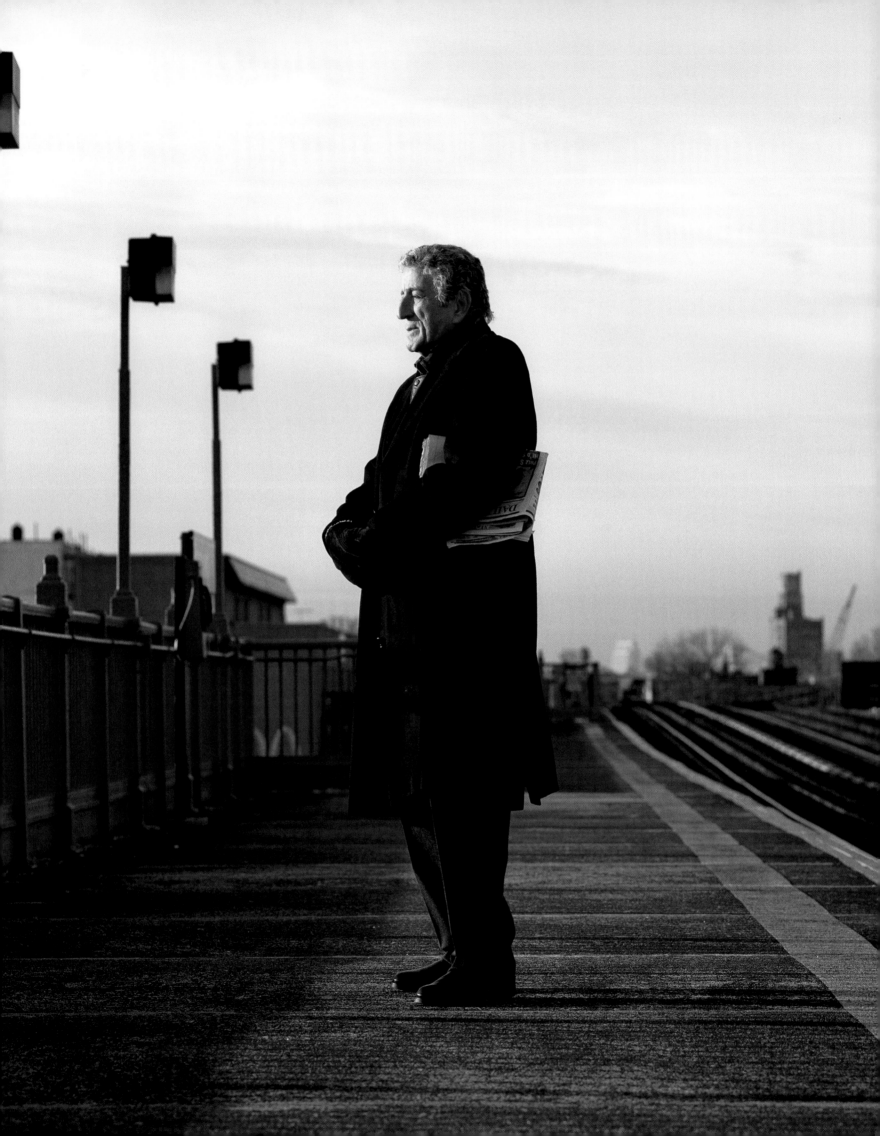

TONY IS WAITING for the next train in Queens. In that borough is his past—and a piece of his future and legacy. The Frank Sinatra School of the Arts in Astoria will open its doors in 2001, with Sinatra having nothing to do with it beyond inspiration. Tony and Susan found this institution within the New York City public education system, and today it offers six arts majors (fine arts, dance, vocal music, instrumental music, drama, film and media arts) and has nearly 800 students and one of the highest graduation rates (98 percent) and college enrollment rates (also 98 percent) in the city. Community service is a watchword at Sinatra—some 20,000 hours a year—and so is the quest for college scholarships, since many of the students are in need of them (more than $14 million in scholarship money this year). Tony is duly proud of the school and its brethren: "We now have 17 schools—three in L.A., 14 in New York in all five boroughs. We want to have a public school in every state if we can. We're gonna stay on that for my whole existence."

At the Astoria school, there have been regular surprise assemblies for the kids. Gaga and Tony came one day to talk and sing a little. Earlier, Tony was there with Paul McCartney, who performed a set and entertained questions. Remembers Melina McGaw, a fine artist and sophomore at the time: "Paul McCartney is one of my idols. My dad always played me Beatles music, so I knew that before I could speak. His new music is great too. I sat three seats away from Tony Bennett that day. We always have one surprise guest each year, but this year, after Paul McCartney, we also had Lady Gaga. Everyone got really excited. Her music isn't really to my taste, but seeing her sing this old, beautiful music—she's so talented, it was just great."

Melina says Tony and Susan do visit the school, and even though teenagers swim in a different sea culturally, "All the kids do know who he is, definitely." She adds: "People really do love him. They might disagree with some teachers or administrators, but everyone loves *him*."

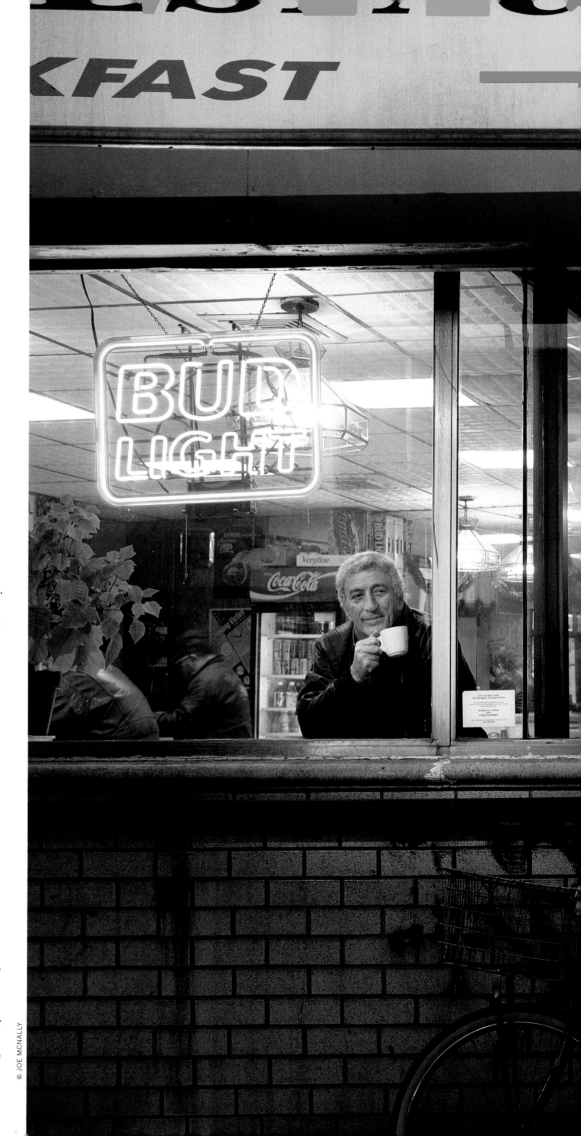

YES, IT LOOKS LIKE the Edward Hopper painting, which was surely photographer Joe McNally's intent—and it is equally certain that Tony appreciates this. "Someone said something very nice about my painting when I had my birthday." That was his 88th, celebrated this August, and what Louis Zona, executive director of the Butler Institute of American Art, said was, "Tony is an inspiration, an artistic genius whose art and music have transformed our culture." That's platitudinous, to be sure, but actually it's not far from the truth in this case. I was recently talking with Dick Golden, who has known Tony since the 1960s and has talked about (and with) him on the radio ever since, and he pointed me to a *New York Times* appreciation of the 65-year Complete Collection box set. *The Times* said, "We aren't likely to see a recording career like this again." Imagine that? Imagine putting a category of American music to bed with your achievement. Golden, as expert as any, targets his friend Tony's specific achievement in song: "Whereas Bing Crosby and Frank Sinatra were crooners and Ella Fitzgerald and Mel Tormé were pure jazz singers, Tony is recognized as the one singer that truly bridged pop and jazz and this remains his major contribution to the history of music." Plus: It all sounds so good.

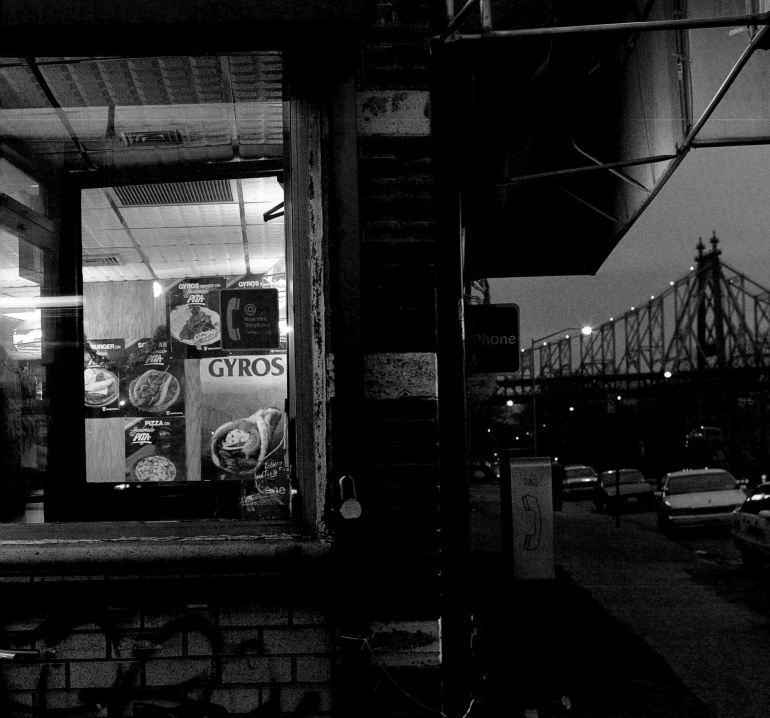

DANNY BENNETT and his dad sit on the stoop of Tony's boyhood home; on nearby sidewalks, young Tony used to draw elaborate murals with chalks that his mother had given him. Danny is rightly credited, by his dad, and many others, with being a partner in the recent success of his father. MTV, Tony playing himself on *The Simpsons,* the retro hipness of Tony Bennett, Danny's contributions to the production of the records . . . But I think it would be a large mistake to think that Tony's renaissance could be constructed if Tony wasn't right and ready to give it—and his fans—his best. It could not have lasted this long; people would not be coming away thrilled night after night. Danny, more than anyone, appreciates this. He recently told Dick Golden: "Tony Bennett doesn't think in terms of time, and that timelessness is a transcendent quality of what his artistry is all about. As a result, the millions of fans all around the world who listen to his music and see him in concert are transported and experience this transcendence . . . They become arrested in the moment . . . This is the essence of all great art." Danny is biased, of course. But it's nice when a kid would say such a thing about his dad. We can all agree on that.

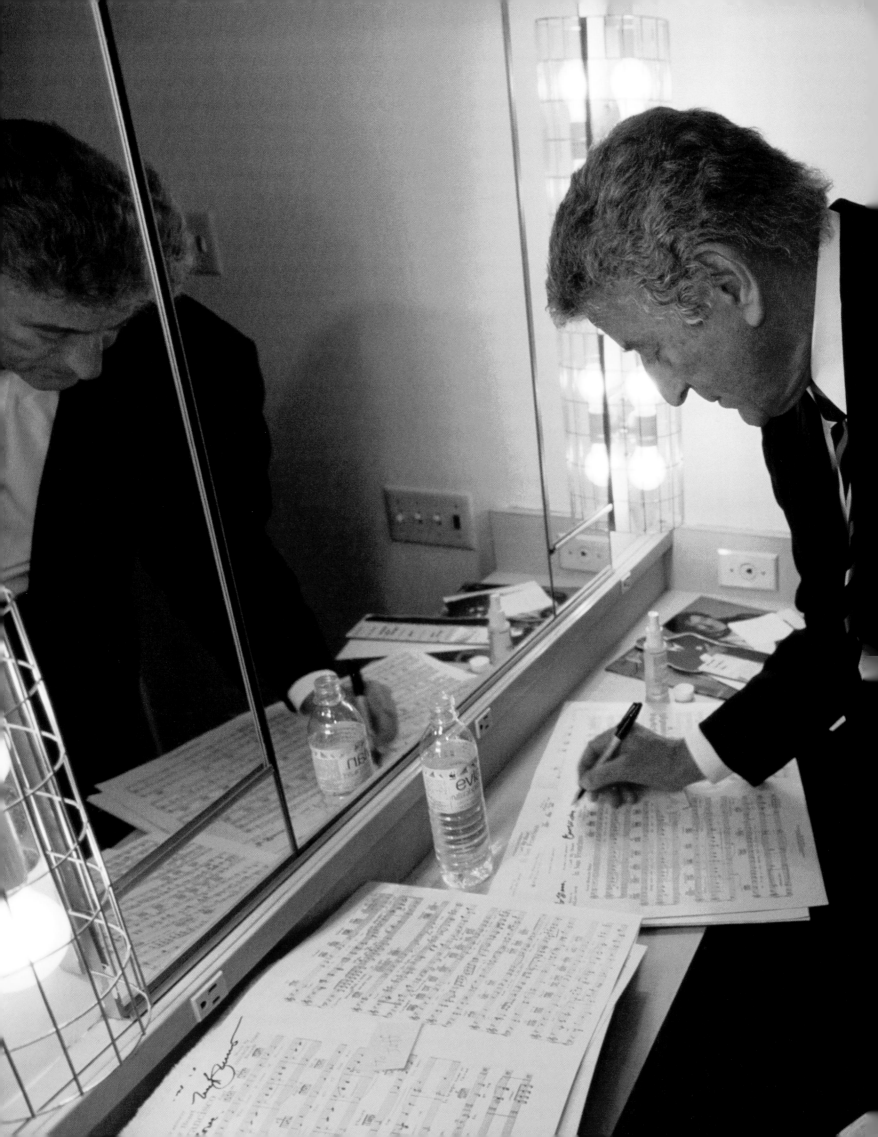

JUST REDUCING this discussion to the true giants: Dylan is on his never-ending tour, Willie's bus is ever-rolling, McCartney, rich as Croesus, simply can't stop. Tony Bennett, here in his dressing room before a performance, keeps going; he loves it. And he sings the Great American Songbook, night after night. When things weren't going so well, "I asked Count Basie what I should do," he says on that day at the museum. "Some of my friends were trying to sing rock, and I didn't know what to do. Basie told me in that sly, wise way of his, 'Why change an apple?'"

As just mentioned, the music he speaks of is what's usually known as the Great American Songbook: the scores of classic popular songs—"standards"—composed by Porter, Berlin, Gershwin and others, popularized by Frank, Tony, Ella, Rosie and others. Tony is not only a purveyor of but a proselytizer for the Songbook, and in fact had a hand in coining the encompassing title. He, the *New Yorker* jazz writer Whitney Balliett, and composer and writer Alec Wilder had all been thinking independently about this semi-codified body of essential work—America's classic music—"and we wound up on a radio show together down South many years ago, talking about this," remembers Tony in a recent conversation. "We were talking about the importance of recognizing this music. And on that show, we came up with the phrase the Great American Songbook." *There's* a little music history for you; more than a little, actually. Tony says today, "I was on the road for two and a half years with Lena Horne. She told me, 'When you come up with a great idea, everyone's going to steal it.' Boy, was she right."

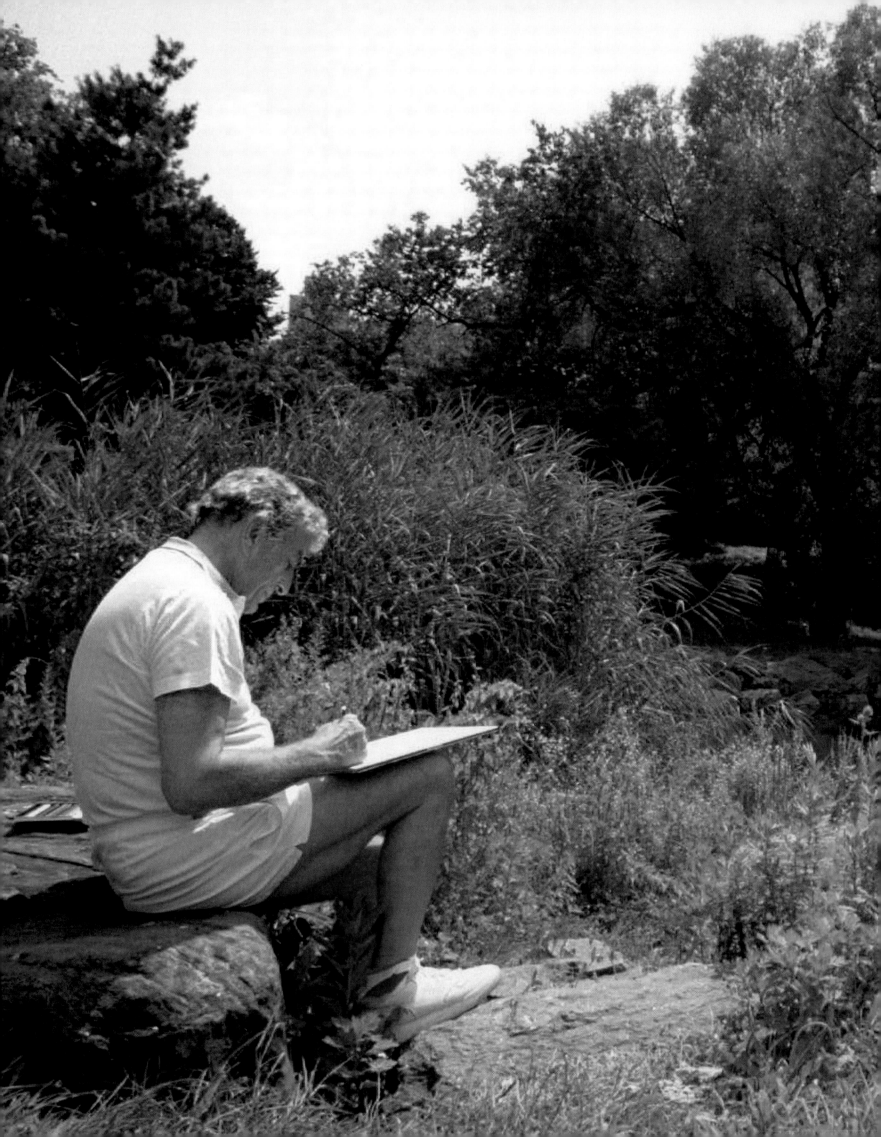

ON AN AUGUST DAY, Tony is in his element: He's in Central Park, and he's sketching (in this case, the Gapstow Bridge). He loves to sketch as well as paint, and I attended, at one point, a gallery show on the Upper East Side where his drawings were being exhibited. From his sketch pad, which he carries with him constantly, and also from a collection of drawings made on any available scrap—saloon napkins, hotel stationary—came these black-and-white portraits that struck me as amazing in a couple of ways. First, obviously, they chronicled an extraordinary life. Tony had been here, there, everywhere. He had been in that jazz club, this far from Ella, on that particular night. But of course he had! That was his scene, for all those many decades. The second thought—and this took a moment to sink in—was that the work was complicated and expert in an artistic sense and was the product of a man compelled, constantly, to express himself. He could have been enjoying his wine or chatting between songs, but instead he was drawing: transforming the feeling of the moment into art. There was not only Ella in that sketch but the song she was singing as the artist was hearing it and interpreting it for us. I imagined it to be "Mood Indigo," but Tony has no idea, so I'll never know.

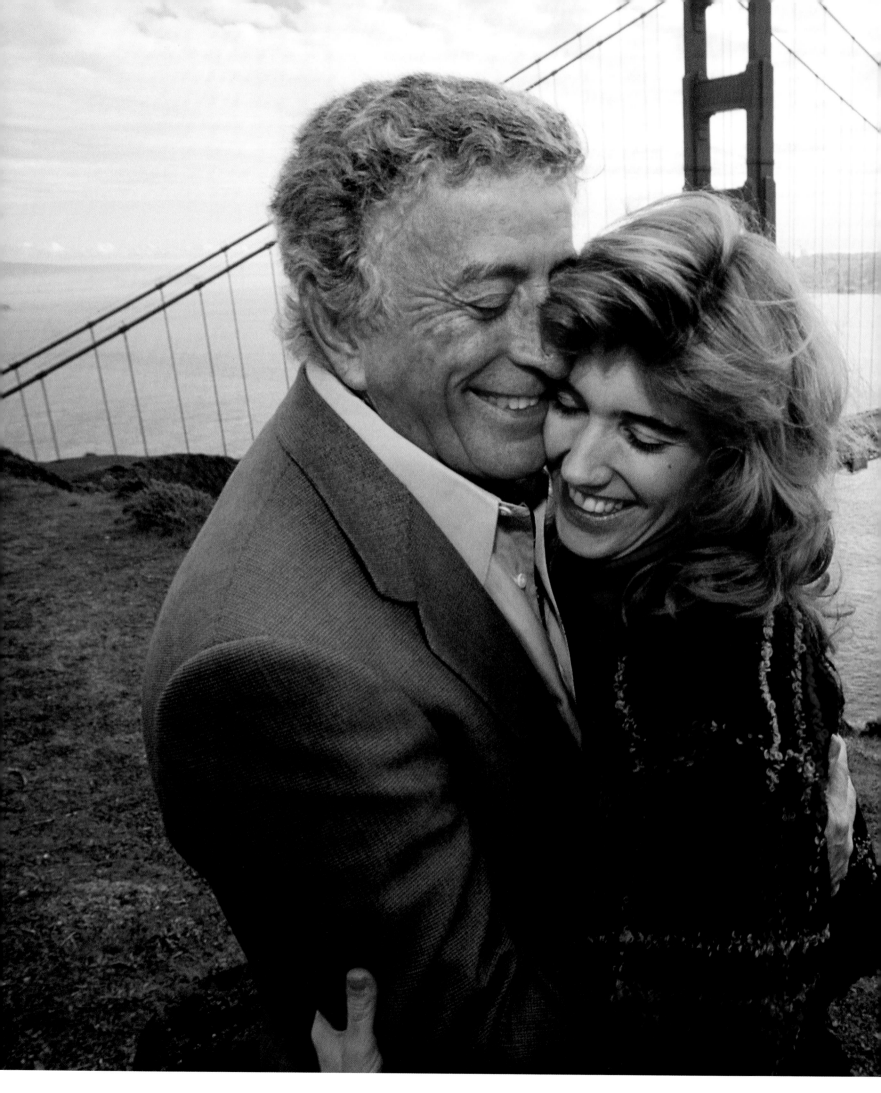

WE ARE AT THAT LUNCH, now technically turning into early dinner, as Central Park is bejeweled beyond the window with lights against the darkness, at the Metropolitan Museum of Art in 1994, and Susan Crow, Tony's companion, has excused herself to make a phone call. "She's wonderful," Tony says softly, talking to himself. "I really love her so much." They had met in the late '80s at a concert. Crow, in her early twenties at the time, was a fan of the music well before others of her generation bought into it, and she was in the habit of going to Tony Bennett shows. They were introduced, and have been inseparable since. At that time in '94, when I am researching the LIFE article, many of Tony's close friends tell me they have never seen Tony in a more stable relationship, or happier. Tony says before Susan returns from the telephone (remember telephones?): "I relax best at Susan's parents' ranch north of San Francisco. We escape, and I paint."

Here they are, in a Joe McNally photo, overlooking the City by the Bay. Susan and Tony wed in 2007. Susan, a former educator, has been instrumental in establishing and building the Frank Sinatra school and its many offshoots. Wrote Tony in his memoir: "It was a lucky day for me when I became acquainted with a beautiful lady, Susan Crow. She's happy, thoughtful, truthful, intelligent and she comes from a terrific family. She's helped me balance my life, think straight, and become a healthy person. She has a special way about her that I've never found in anyone else."

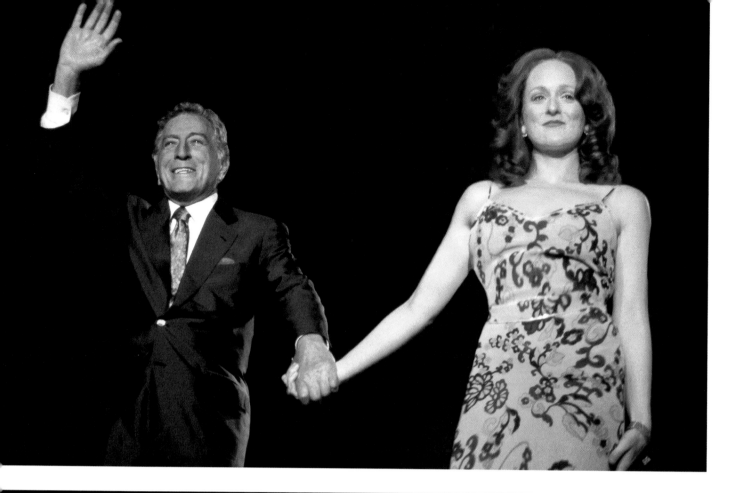

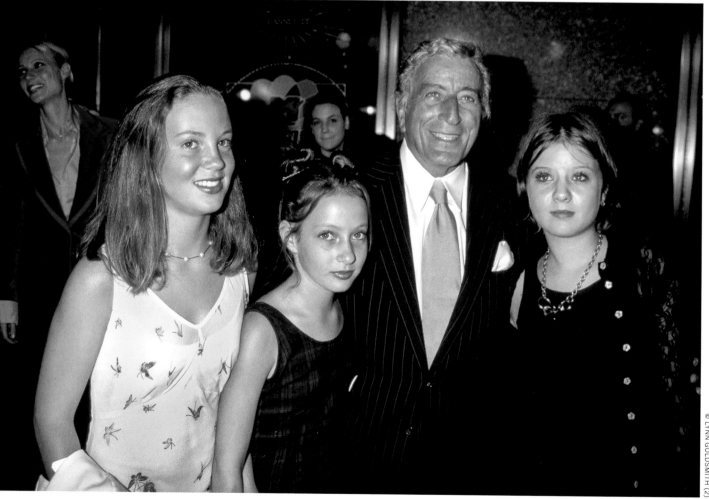

IT'S ALL ABOUT FAMILY once again, just as when it began. At top, Tony and daughter Antonia, a wonderful singer in her own right, take a bow; she is part of many of his appearances as a special guest in 2014. Above: Tony with granddaughters in 2003; they're a good bit older today. Opposite: Tony at home with his and Susan's dog, Boo.

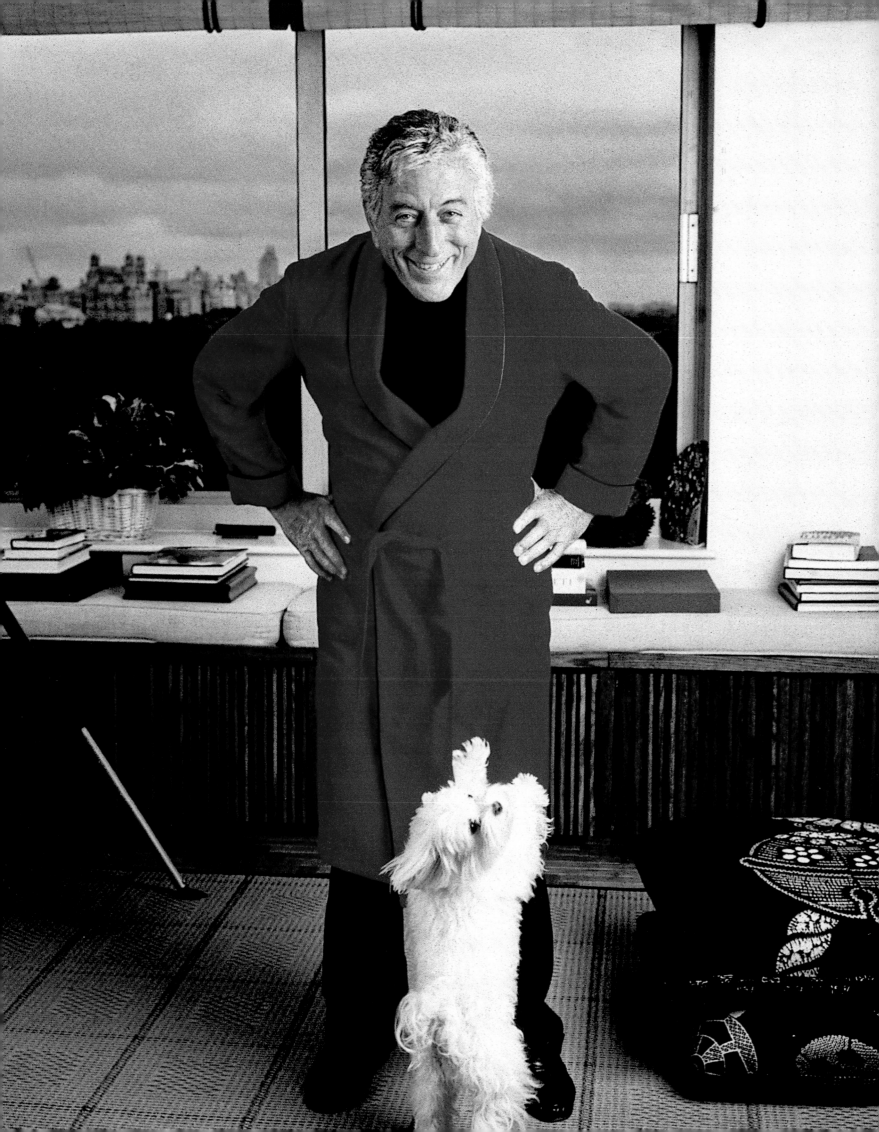

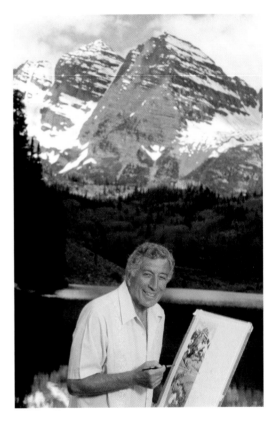

IN THESE TWO PHOTOGRAPHS,
Tony is in Aspen, Colorado, in July 2003,
engaged in painting a watercolor at Maroon
Bells. "Painting is a vacation for me at
all times," he says. "If Susan says to me, we
should go on vacation somewhere, I don't
feel like doing that. I'm on vacation all the
time. As I travel, I'm on vacation—sketching
and singing. These are the things I love to
do. There are three quotes about painting
that I love. One is by Hokusai, the Japanese
painter, who said, 'When I'm a hundred, I'll
get better. When I'm a hundred and five,
I'll still have to study more. But when I'm a
hundred and ten, I'll have it.' Isn't that great?
He called himself the Mad Old Painter. And
the same with da Vinci. Leonardo, on his
deathbed, said, 'Has anyone ever finished
anything?' And Michelangelo, when he
finished the Sistine Chapel, said, 'I'm still
learning.' So that is the whole premise of
what I do—the search. I'm looking to grow.
To learn."

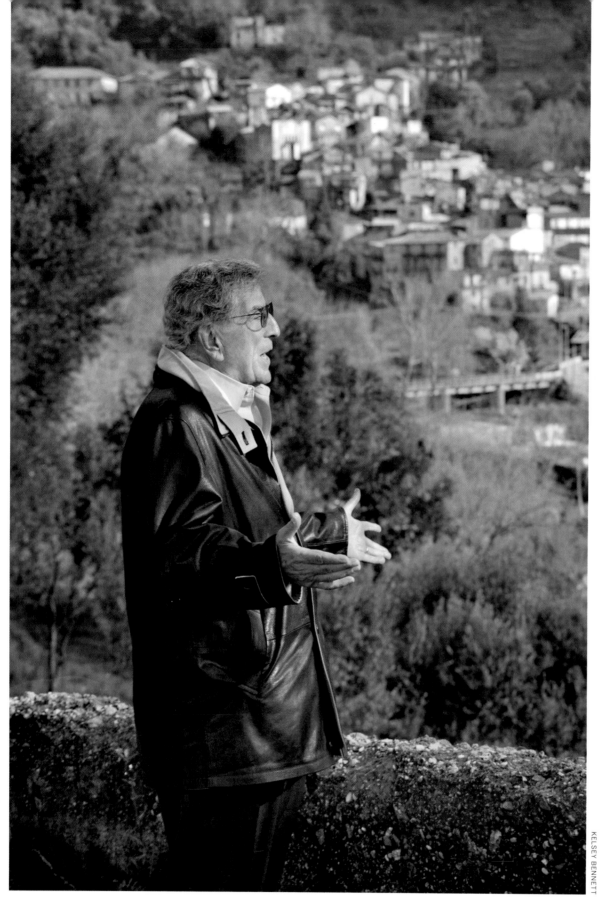

KELSEY BENNETT

JUST ONE MORE

"MY FATHER DIED when I was 10 years old," Tony says more slowly than usual. "Now, in Podargoni, Calabria, Italy, the legend in my family was that he used to stand at the top of a mountain and the whole valley would hear him sing. That did it. When I heard that, it became as clear to me as I'm speaking to you right now—that is the reason I'm singing. I realized, wow, this was my father, the father I never really had. He was very well loved by the family, and he used to sing and the whole valley would hear him. That did it for me—you understand? We're put here to sing—this family was put here to sing. I've always felt that right through my life, right up to today as I speak to you. I just feel that I have to do it . . . The Benedettos had to sing." Here, in 2011, in a photograph taken by his granddaughter Kelsey, Tony sings "'O Sole Mio" on the mountaintop in Calabria.